ESKENAZI

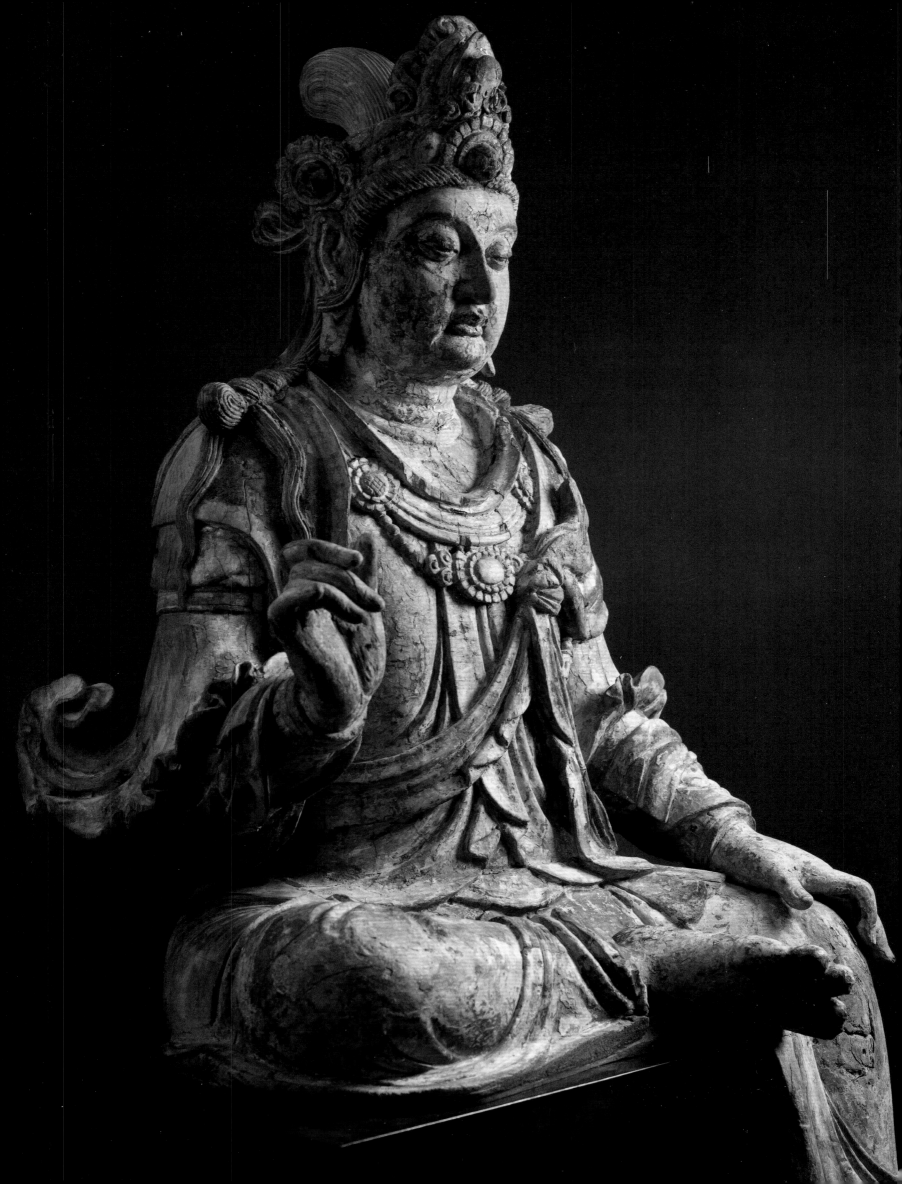

ESKENAZI

Chinese sculpture c. 500 - 1500

15 October - 15 November 2014

10 Clifford Street
London W1S 2LJ
Telephone: 020 7493 5464
Fax: 020 7499 3136
e-mail: gallery@eskenazi.co.uk
web: www.eskenazi.co.uk

Left, catalogue number 18
Large Wood Avalokiteshvara (Guanyin)
Northern Song or Jin period
mid 11th to mid 12th century
Height: 1.75m

ISBN: 1 873609 41 8

Design, typesetting and photography Daniel M. Eskenazi, London
Images of catalogue number 4 kindly supplied by Ben Janssens, London
Printed and originated by Colt Press Ltd, Witham

Foreword

This is the seventh exhibition we have devoted to the subject of Chinese sculpture, much of it reflecting the influence of and interaction with Buddhism as the religion spread throughout China from the third century. Over the course of the past five years, we have assembled twenty-two works representing one thousand years of sculptural endeavour in China from 500 to 1500. They are in a variety of materials – marble, limestone, sandstone, gilt metal and painted and gilt wood – and range in size from a gilt copper Tang plaque, 11.9 cm, to a massive and magnificent wood figure of Guanyin, Northern Song or Jin period, measuring 1.75 m in height, probably the greatest in existence remaining outside a museum. Other remarkable items in the exhibition are a head and shoulders of Buddha from the Yungang caves, a marble stele, dated to 553, showing the Buddhas of the past and the present seated side by side, and an imposing gilt bronze Guanyin dated to 651, formerly part of the fabled Stoclet collection and first exhibited in the West in 1913, that we ourselves have shown and catalogued once before, in 2003. I would also like to draw attention to the two gilt bronze luohans of the Yuan and early Ming periods, one bearing an inscription in Tibetan script, both evidence of Chinese mastery of the lost-wax technique of bronze-casting, and – especial favourites – the pair of painted and gilt wood bodhisattvas formerly in the collection of the French dealer and decorator André Carlhian (1883 - 1967).

In 1978 when we staged *Ancient Chinese Sculpture*, it was seen as a novelty, perhaps the first time a dealer had been rash enough to consecrate an entire exhibition, some twenty-nine items, to such an esoteric subject. It soon became apparent that this rarefied and narrow field was of interest mostly to scholars and museums, less to private collectors. Only a handful of pieces was sold in the course of the exhibition and it took quite a few years to sell the rest. In spite of this we persevered and have held a further five sculpture exhibitions in the last thirty-six years, and a further ten general exhibitions of Chinese art that have included sculptural works. It is undoubtedly now the case that the subject is no longer viewed as 'difficult', that there is a much wider collecting base than thirty-five years ago and that prices have increased exponentially.

Edmund Capon, a leading authority on Chinese sculpture and the very scholar who wrote the catalogue introductions to our first two sculpture exhibitions in 1978 and 1981, has once again most kindly agreed to write an essay for the present exhibition catalogue, for which we are deeply grateful. His frequent visits to China, whether working in the Chinese department of the Victoria and Albert Museum in London or after, as Director of the Art Gallery of New South Wales in Sydney for thirty-two years, have given him unrivalled opportunities to study the cave and temple sites, as well as the increasingly available museum collections in that country.

I would also like to thank Sarah Wong for her fascinating essay - focusing on luohans in Chinese Buddhist art, bringing clarity to a confusing subject - and for her thorough research that has thrown light on many of the items in the exhibition.

Philip Constantinidi has once again overseen the catalogue from an editorial standpoint, and its consistency and accuracy is very much thanks to him. As always, Yuansheng Wang has provided invaluable help with the Chinese translations. On this occasion, the physical appearance of the catalogue is entirely due to Daniel Eskenazi who has not only designed and typeset it, as for many previous exhibitions, but has also photographed all the sculptures with great sensitivity and understanding.

Giuseppe Eskenazi

前言

此乃我公司第七次以中国古代雕塑为主题的展览，主要反映了自公元三世纪起，佛教传入中国后产生的影响及其相互作用。在过去的五年里，我们汇集了二十二件样品，用以展示中国从公元500年到1500年之间，历时千载，殚力竭诚的雕塑历史。这些展品原材料各自不同—大理石，石灰岩，砂岩，鎏金铜质，木质彩绘描金—并有大小排列，从唐代鎏金铜饰牌的十一点九公分，到北宋金代的木雕观音像，魁伟恢宏，精致华丽，高达一米七五，或许这是除博物馆以外，所能见到保存最好的木雕实物。另外一些令人瞩目的展品，包括源自云冈石窟的佛陀头肩像；雕刻于公元553年的理石像碑，上有过去未来双佛并坐；还有造于公元651年的鎏金铜观音像，曾是举世闻名的 Stoclet 收藏中的一件，早在1913年便首次在西方亮相，本公司亦有幸于2003年展出过，并收入图录。敬请注意的还有两尊金铜罗汉像，元及明代早期铸造，其一上刻资料性的藏语经文，两件同时证明了在中国铸造工艺中失蜡法的熟练运用。至于另一对木雕彩绘菩萨，曾经为法国商人，装饰家 André Carlhian (1883 - 1967)所藏，在此愿于诸位共享殊荣。

1978年，我们的 *Ancient Chinese Sculpture* 开幕，那是一次新奇的尝试，或许是古董商鲁莽的举动，第一次用整个展览的二十九件展品围绕着一个深奥的主题。很快结果明了，罕见而狭窄的知识空间中，兴趣大都来自学者和博物馆，很少有私人藏家问津。展销期间，只有屈指可数的几件卖掉，其余的则在往后的许多年中，陆陆续续地脱手。尽管如此，我们锲而不舍，历经三十六载中，五度重来，并将雕塑品十次揉入其他主题的展览中。现在可以毫不怀疑的说'难'字早已不复存在，较三十五年前，收藏范围宽阔多了，价格也数倍增加了。

Edmund Capon，资深中国雕塑艺术专家，他曾于1978年为我公司的雕塑专题展览写过序言，如今，再次慷慨赐教，为本展图录书写导论，上下深感荣幸。先生经常访问中国，无论早期在维多利亚和阿尔伯特博物馆中国部工作时，还是后来三十二年的悉尼新南威尔士艺术馆馆长位上，他把握住难得的机会，从石窟和庙宇遗址，到博物馆中新近收藏，不断学习探索。

我要感谢 Sarah Wong 的精彩论文，以中国佛教艺术中的罗汉为重点，条分缕析，调研全面细致，使展品中的疑窦化浊为清。

Philip Constantinidi 的悉心督查，严格把关，保证了展册的一致性和准确性，对此致谢。一如既往，汪垣生认真完成了中文翻译。在此之际，整个图册的重任都由 Daniel Eskenazi 承担，不单纯是以往的设计和排版，这次还囊括摄影方面，所有的图片均显示出完美的感觉和理解力。

Giuseppe Eskenazi

Chronology
Chinese Dynasties and Periods
中国朝代

		BC 公元前				AD 公元
Xia period	夏	2100c	–	1600c		
Period of Erlitou culture	二里头文化	1900	–	1600		
Shang period	商	1600c	–	1027		
Zhengzhou phase	郑州阶段	1600	–	1400		
Anyang phase	安阳阶段	1300	–	1027		
Zhou period	周	1027	–	256		
Western Zhou	西周	1027	–	771		
Eastern Zhou	东周	770	–	256		
Spring and Autumn period	春秋	770	–	476		
Warring States period	战国	475	–	221		
Qin dynasty	秦	221	–	206		
Han dynasty	汉	206	–			220
Western Han	西汉	206	–			9
Xin dynasty (Wang Mang)	新（王莽）				9 –	23
Eastern Han	东汉				25 –	220
Six Dynasties period	六朝				220 –	581
Three Kingdoms	三国				220 –	280
Western Jin	西晋				265 –	317
Eastern Jin	东晋				317 –	420
Liu Song	刘宋				420 –	479
Southern Qi	南齐				479 –	502
Liang	梁				502 –	557
Chen	陈				557 –	589
Sixteen Kingdoms	十六国				304 –	439
Northern Wei	北魏				386 –	535
Western Wei	西魏				535 –	557
Eastern Wei	东魏				534 –	549
Northern Qi	北齐				550 –	577
Northern Zhou	北周				557 –	581
Sui dynasty	隋				581 –	618
Tang dynasty	唐				618 –	907
Five dynasties	五代				907 –	960
Liao dynasty	辽				907 –	1125
Song dynasty	宋				960 –	1279
Northern	北宋				960 –	1127
Southern	南宋				1127 –	1279
Jin dynasty	金				1115 –	1234

Yuan dynasty	元	1279 – 1368
Ming dynasty	明	1368 – 1644
Hongwu	洪武	1368 – 1398
Jianwen	建文	1399 – 1402
Yongle	永乐	1403 – 1424
Hongxi	洪熙	1425
Xuande	宣德	1426 – 1435
Zhengtong	正统	1436 – 1449
Jingtai	景泰	1450 – 1456
Tianshun	天顺	1457 – 1464
Chenghua	成化	1465 – 1487
Hongzhi	弘治	1488 – 1505
Zhengde	正德	1506 – 1521
Jiajing	嘉靖	1522 – 1566
Longqing	隆庆	1567 – 1572
Wanli	万历	1573 – 1620
Taichang	泰昌	1620
Tianqi	天启	1621 – 1627
Chongzhen	崇祯	1628 – 1644
Qing dynasty	清	1644 – 1911
Shunzhi	顺治	1644 – 1661
Kangxi	康熙	1662 – 1722
Yongzheng	雍正	1723 – 1735
Qianlong	乾隆	1736 – 1795
Jiaqing	嘉庆	1796 – 1820
Daoguang	道光	1821 – 1850
Xianfeng	咸丰	1851 – 1861
Tongzhi	同治	1862 – 1874
Guangxu	光绪	1875 – 1908
Xuantong	宣统	1909 – 1911
Republic of China	中华民国	1911 – 1949
People's Republic of China	中华人民共和国	1949 –

Some Buddhist sites and temples

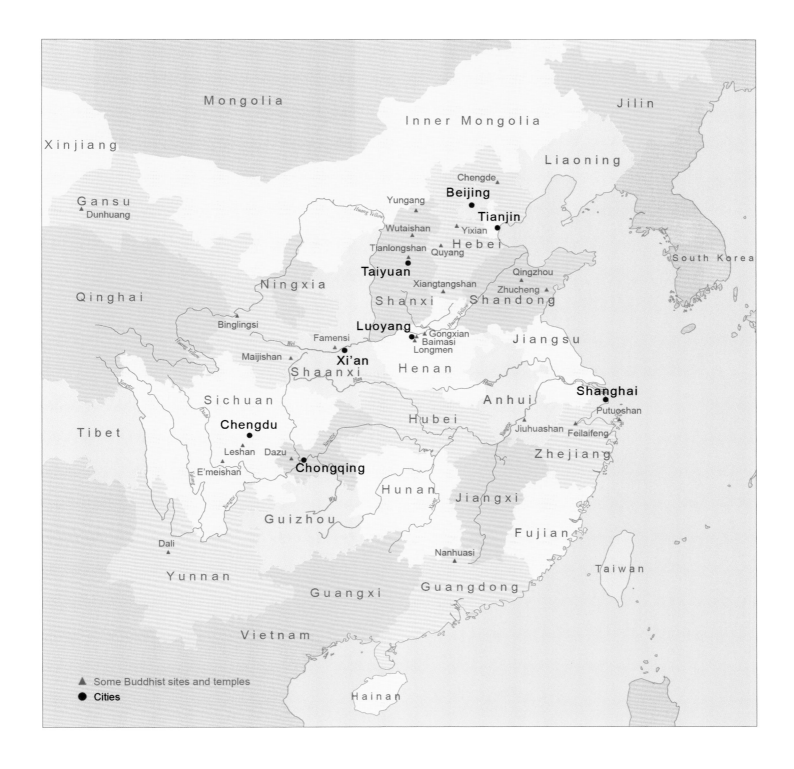

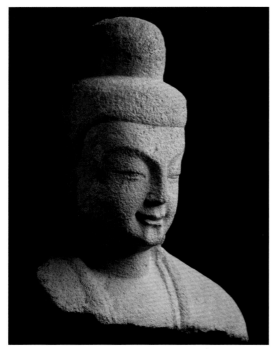

Fig. 1 Cat. no. 1, sandstone head from Yungang.

Fig. 2 Detail of cat. no. 17, wood bodhisattva.

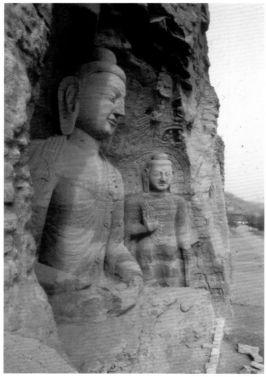

Fig. 3 Yungang, cave 20, Northern Wei, c. 455 - 75,
exterior view.

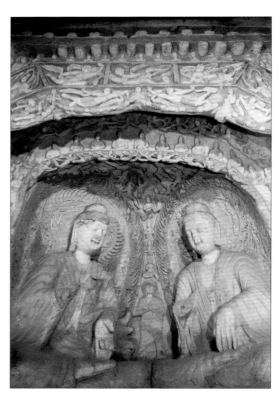

Fig. 4 Yungang, cave 6, Northern Wei, late 5th century,
Shakyamuni and Prabhutaratna, after Su Bai and Li
Zhiguo ed., *Zhongguo meishu quanji, diaosu bian 10,
Yungang shiku diaoke*, (The Great Treasury of Chinese
Art, Sculpture 10, Yungang Caves), Beijing, 1988.

The Evolution of Chinese Buddhist Sculpture
by Edmund Capon

Even the most cursory comparison between the earliest Buddhist sculpture in this selection, the sandstone head of a Buddha from the Yungang cave temples dateable to the second half of the fifth century (cat. no. 1), with one of the latest, for example the pair of standing wood Bodhisattva figures dating from the Northern Song or Jin dynasty period (cat. no. 17), reveals much about the journey of Buddhism and its accompanying art in China over seven centuries (figs. 1 and 2). It was during those centuries that the faith enjoyed the benefits of imperial patronage, widespread acceptance, and occasional setbacks in the form of persecutions, but was nonetheless transformed from a hieratic religion into a faith, quite literally of the people. The evolution of artistic style, from the serene austerity of the Yungang head to the fulsome humanity of the Song Bodhisattvas or the imposing head of the majestic wood figure of Guanyin (cat. no. 18) demonstrates that progression from religious icon to an ideal of human sentiment and sensibility. In essence, the gentle certainty, restraint and authority of the fifth century Yungang image has, seven centuries later, been transformed into an image of human dimension and expression; indeed the Liao period image of Guanyin (cat. no. 15) assumes an almost secular demeanour. Furthermore, it is a journey that illustrates how Buddhism in China adopted the Mahayana creed and, above all, about the role of the Bodhisattva, that generous deity who having achieved enlightenment chose to remain here on earth in order to help us sentient beings in our quest for *nirvana*. This journey of artistic style is, as we view it with the benefit of historical evidence, one of aesthetic evolution but it is equally one that has been determined by the demands and sentiments of an evolving faith.

The immediate post-Han era when north China was under 'barbarian' rule was a propitious time for a 'foreign' faith to insinuate itself into the then vulnerable Chinese psyche and Buddhism found a willing and fertile audience. As the Buddhist institutions flourished so too did their influence and autonomy which inevitably led to resentment and real concerns about the potential threat to the authority of traditional Chinese values. The almost subversive power of the monasteries was beginning to disturb traditional Confucian and Daoist integrity and it was the Northern Wei Emperor Tai Wudi (reigned AD 424 - 452) who initiated persecutions of the faith and its institutions in AD 444 and 446. The vigour of these persecutions is clear in the often alarming language employed in the edicts, for example, the second, issued in AD 446, stated that:

> wherever there are pagodas, images, and barbarian scriptures these are to be utterly destroyed and consumed by fire; and the sramanas are all to be slain without distinction between young and old.[1]

Fiery stuff indeed but such was the level of repentance at what, in retrospect, were seen as over-zealous remonstrations that Wudi's successor, Wencheng (reigned AD 452 - 465), in his first year as emperor, issued a decree restoring Buddhism and furthermore ordered the carving of the five great imperial cave temples at Yungang (fig. 3). The power and influence of Buddhist institutions was to be a continuing issue for dynastic authority and these were by no means the last of such purges: the emperor Wudi of the Northern Zhou in AD 574 decreed the abolition of both Buddhism and Daoism, and then the fervent Daoist emperor Wuzong of the Tang initiated the great anti-Buddhist purge in AD 845.

In many ways, a foreign religion commended itself to the non-Chinese rulers of the third to the sixth centuries who, although seeking to establish their authority and in doing so, to adopt much of Chinese ideological, political and social culture, nonetheless saw Buddhism as an alternative source of potential power and influence. The positive intervention of the emperor Wencheng established, or re-established, that association between church and state that was to be such a feature of Buddhism in China in the sixth century and the succeeding Tang dynasty. Thus it was that the Buddhist faith, especially in north China, was a unifying influence bringing a common factor to alien rulers, Confucian stoics, Daoist adherents and the rural peasantry. Buddhism cut across class lines and hitherto divided peoples. Inscriptions on so many devotional sculptures of the time, from the Wei to the Tang dynasties, reflect the universal acceptance of Buddhism into the mainstream of Chinese society; for example the dedication on the gilt bronze of Maitreya Buddha, dated to AD 512 (cat. no. 3) which, typically, declares that the image was commissioned by the parents of a deceased daughter with a plea for auspicious blessings upon the family. And to reinforce that relationship between Buddhism and the state, the revealing inscription on the Northern Qi marble stele dated AD 553 (cat. no. 6) records that the image, depicting that popular theme from the *Lotus Sutra*, the Buddhas Shakyamuni and Prabhutaratna on Vulture Peak, was commissioned by a monk as an offering to the emperor – the emperor seen almost as an earthly manifestation of the Buddha (fig. 4). That nexus between faith and state is again echoed in the inscription on the back of the gilt bronze image of Guanyin dated to AD 651 (cat. no. 11) in the Tang

dynasty which states that the figure was one of seven cast on the orders of the Gaozong emperor (in the Yonghui reign) to give thanks for relief from plague and drought.

The very admission of Buddhism into the assured and Confucian world of Han dynasty China may be seen as surprising even though it did not exactly challenge any of the principal ways of thought of the time. Indeed Buddhism in its metaphysical notions of rebirth and the afterlife may be seen as complementary to the earthly and pragmatic concerns of Confucianism and the mystic realms of Daoism. Buddhism did not offer conflict with any existing ways of thought; it merely added another dimension to the ever worldly encyclopaedia of Chinese philosophic dialogue. In that process of assimilation, Buddhism in China inevitably acquired its own identity and interpretation. Here the work of the early translators, Dharmaraksha and Kumarajiva (fig. 5) for example, in employing occasional familiar Chinese terminology for those unfamiliar notions of the Buddhist sutras, was crucial. This process of absorption into the Chinese psyche was not one just of artistic style but also of adaptation and interpretation of the faith itself to suit Chinese needs, values and sensibilities.

Fig. 5 Bronze statue of Kumarajiva at the Kizil Buddhist caves, near Kucha.

The earliest manifestations of the Buddhist faith in China, largely in the monastic communities of Xinjiang and Gansu, were overwhelmingly Hinayana in content in which the *jataka* stories and scenes from the life of the Buddha predominate and in which the Buddha appears not as a god but as an earthly mortal who has attained enlightenment. Kucha, in present-day Xinjiang, on the northern silk route was, in the third to fifth centuries, a renowned centre of Hinayana Buddhism (fig. 6). However, as the faith gained recognition and acceptance during its travels eastwards into the heartlands of China, it was the Mahayana school that reigned supreme. The 'greater vehicle' with its promise of salvation through intuition and self-revelation and of course the benefit of guidance from the earth-bound Bodhisattva offered a more attractive path to the pragmatic Chinese than the life-long quest and arduous accumulation of worth and karma of Hinayana. It was as much the adoption and adaption of Buddhism into the Chinese way of thought as it was a matter of aesthetics that influenced and guided the artistic style of Chinese Buddhist art. It is the great texts of Mahayana Buddhism, the *Lotus Sutra* (*The Saddharma-pundarika*) and the Paradise sutras (*Sukhavati Paradise*), that have dominated Chinese Buddhist thought and attitude and it is these texts more than any others that were absorbed into the distinctive form of Chinese Buddhism.

Every work of Buddhist sculpture in this exhibition was made in accordance with these texts that are fundamental to faith in China. Furthermore, these works illustrate the evolution of artistic

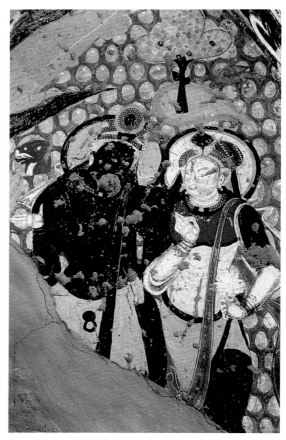

Fig. 6 Kizil, near Kucha, painting on wall of cave 8, Tang period, 7th - 8th century.

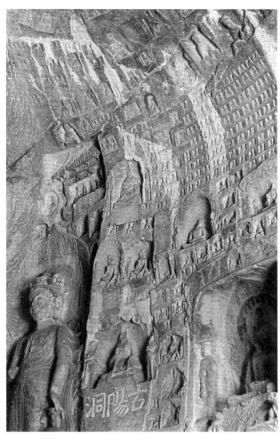

Fig. 7 Longmen, Guyang Cave, Northern Wei, early 6th century.

style, conditioned by prevailing aesthetic, social and ideological conditions. Much is made of that moment in the history of Chinese Buddhist sculpture when a distinctive 'Chinese' style was achieved towards the end of the fifth century; here again we witness the convergence of faith and government. It was the devoutly Confucian emperor Xiao Wen (reigned 471 - 499) who, even though it is recorded that he had a Buddha image made every month, sought to rein in the increasing independence of the Buddhist institutions and thereby bring the church even more into the domain of government. Xiao Wen harboured an ambition to reunite the Chinese realm and to ensure that his administration would conform with traditional Chinese patterns. He evidently saw Buddhism both as an aid to this ambition and at the same time as a potential and divisive threat; one of the areas of his attention was the adoption of traditional forms of Chinese costume for his courtiers and the rebuilding of palaces to reflect the Chinese tradition rather than the image of the Buddhist temple. His decision to relocate the Northern Wei capital from Datong to Luoyang in AD 495 also brought to an end imperial patronage of the Yungang temples, although such patronage continued with the carving of the Longmen caves which, in keeping with imperial ambitions, were of no mean scale (fig. 7). The *Wei Shu* records:

> at the commencement of the Qingming era (502-3) Shi Zong commanded the Lord Chief Justice Bai Zheng to have two caves carved into the rock of Mount Yi Jue south of Luoyang on behalf of his parents Gao Zi (the emperor Xiao Wen) and the Dowager Empress Wen Zhao, to be modelled on the rock-hewn caves of Yungang.......it was planned that these caves' summits should reach 310 feet from the ground...in 505 excavation of the mountain was begun....[2]

It is the style of the later carvings at Yungang and the early sculptures at the Longmen caves that is of interest, for there is a decisive development from the rounded Gandharan inspired aesthetic of the early Yungang, mid to late fifth century idiom, to a more formal and iconographic idiom. That visual metaphor for the artistic style of Chinese Buddhist sculpture, the fall of the robes, assumed a new and more iconographical manner that was quite possibly inspired by imperial edicts on the adoption of the traditional Chinese-style costume of flowing robes. In keeping with this façade-like appearance, the heads of the deities became slightly elongated thus giving the figure a clear vertical emphasis. The head of the Buddha from Yungang (fig. 1, cat. no. 1) with its prominent eye line, flat nose and slight elongation of the head prefaces the characteristic style of early sixth century Chinese Buddhist sculpture. Whatever the reasons, there is no denying this transformation that occurred at the very end of the fifth century, inspiring a truly independent aesthetic which is

demonstrated in the small gilt bronze image of Maitreya dated to AD 512 (cat. no. 3).

The story of Buddhism in China in the sixth century is one of continuing adaptation and an increasing embrace of the Paradise sutras, which combined to have a subtle and humanising effect upon artistic style. The Mahayana creed was absolute with the *Lotus Sutra* as the foundation but there was a growing interest in the Paradise sutras which offered the promise of a sublime afterlife. It has been noted that in the early years of the Longmen caves (at the very beginning of the sixth century to the end of the Northern Wei dynasty in AD 535) that inscriptions refer most often to the present Buddha Shakyamuni, followed by Maitreya, the future Buddha, and then Guanyin (Avalokiteshvara).[3] By the end of the sixth century the most favoured deities in the pantheon were the Buddhas Amitayas and Amitabha and the Bodhisattva Guanyin, the ubiquitous Goddess of Mercy and Benevolence.

The evidence for this gradual acceptance of the faith, the developing interest in the Paradise sutras and their place in the mainstream of Chinese life is provided by the images themselves: for example in such benign and almost sensuous images as the standing Northern Qi Buddha (cat. no. 9). This bears a convincing comparison with the sublime and beautiful images from Qingzhou with its subtle sway to the pose and figure-revealing robes (fig. 8). This is an image not only of faith, but also of spiritual and aesthetic seduction. This diversification of Buddhism brought the earth-bound Bodhisattva into even greater prominence. Whilst the images of the great Buddhas Shakyamuni, Amitabha and Maitreya prevailed in the formal sense, the ever-accessible Bodhisattva Guanyin became the deity which, it seems, spoke most directly to the populace at large. The impressive, in terms of both scale and quality, Song dynasty carved wood sculpture of Guanyin (cat. no. 18) confirms the paramount importance of the Bodhisattava in later Chinese Buddhism; this is no incidental image but an icon of particular scale and beauty that must have held a most prominent position in a major temple probably in Shanxi from which province the majority of such imposing sculptures seems to have originated. The transmission of Buddhism in China into a popular, but far from secular, state is evidenced in the overwhelming predominance of Bodhisattvas in later Tang and post-Tang Buddhist sculpture. The Song and later sculptures in this exhibition are testimony to this almost folkloric popularity of Buddhism in China and also of its iconography assuming the subjective appeal of a sympathetic human demeanour.

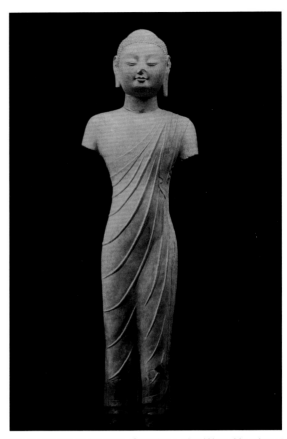

Fig. 8 Limestone Buddha, Qingzhou, after Wang Huaqing et al. eds., *Qingzhou Longxingsi fojiao zaoxiang yishu*, (The Art of the Buddhist Statuary at Longxing Temple in Qingzhou), Ji'nan, 1999.

Notes

[1] Alexander Coburn Soper, 'Literary Evidence for Early Buddhist Art in China', *Artibus Asiae*, Supplementum XIX, Ascona, 1959, page 95.

[2] Ibid., page 102.

[3] J. Leroy Davidson, *The Lotus Sutra in Chinese Art, A Study in Buddhist Art to the Year 1000*, New Haven, 1954, page 51.

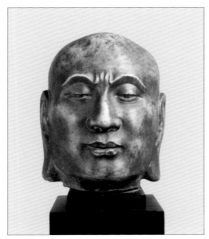

Fig. 1
Marble head of a monk, probably Ananda,
Liao period, 907 - 1125. Cat. no. 16.

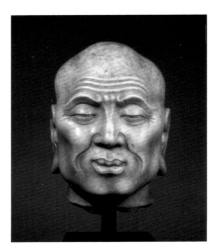

Fig. 2
Marble head of a monk, probably
Kashyapa, Liao period, 907 - 1125, private
collection U.S.A. © Christie's Images.

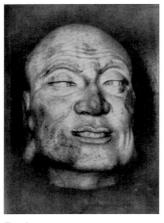

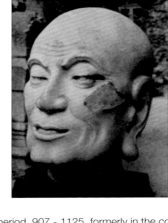

Fig. 3
Marble head of a monk, probably Kashyapa, Liao period, 907 - 1125, formerly in the collection
of General Munthe, Beijing. After Otto Fischer, *Chinesische Plastik*, Munich, 1948, plate 121.

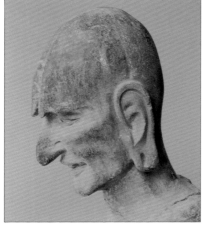

Fig. 4
Kashyapa, Maijishan cave temples, Cave 87,
Gansu province, Northern Wei period, 386
- 535. After *Chugoku bakusekisan sekkutsu
ten,* (Maijishan Caves), Tokyo, 1992, plate 27.

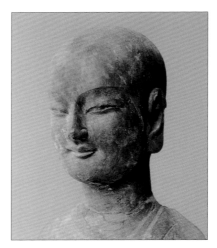

Fig. 5
Ananda, Maijishan cave temples, Cave 102,
Gansu province, Northern Wei period, 386
- 535. After *Chugoku bakusekisan sekkutsu
ten,* (Maijishan Caves), Tokyo, 1992, plate 29.

Buddhist Worthies:
Sculptural Depictions of Luohans and Disciples in Chinese Art, c. 500 - 1500
by Sarah Wong

The depiction of luohans and disciples in Chinese sculpture over a thousand years covers an eclectic range of material and widely ranging modes of expression that defies any easy categorization. This essay attempts to set the examples included in the current exhibition into a brief cultural and historical context, ranging from early depictions of Ananda and Kashyapa, the rise of the cult of the luohan, particularly from the tenth to the fourteenth century, to its assimilation into the culture of an ever-changing China, through periods of disunity with haphazard patronage, to periods of relative stability and lavish patronage, as under the Yongle emperor (1403 - 1424).

Early Sculptural Depictions of Ananda and Kashyapa

Two of the Buddha Shakyamuni's earliest and most important disciples were Ananda and Kashyapa, the youngest and the oldest. Many of the earliest sculptural depictions of Buddha's disciples are of the two of them. Ananda, whose name means 'Bliss', was a cousin of Buddha, born into the same Shakya clan. Ananda was renowned for his devoted attendance on Buddha and saw to all his master's personal needs. Through much of his life, Buddha did not have a personal attendant and it was only twenty years after he achieved enlightenment that he finally asked among the community of monks for a volunteer. Ananda, however, did not volunteer, as he believed that Buddha would choose the right person regardless, as indeed was the case. Ananda is famous for helping to establish an order of nuns, despite resistance from Buddha and for championing the rights of women. He was said to have tremendous powers of recall and was believed to have heard all '84,000 sermon topics'. The disciple was present during Buddha's last days and both he and Kashyapa are often depicted as inconsolable by his 'death-bed' (*parinirvana*). Ananda was initially forbidden to attend the council convened after Buddha's death as he had not yet achieved the status of an *arhat* or luohan – the equivalent of a Buddhist saint of the highest order - but astonishingly managed to achieve personal enlightenment the night before, as he was lying down to sleep and, as a result, was allowed to attend the council and relay the words of Buddha.[1]

Mahakashyapa, or Kashyapa, was a great ascetic who renounced a life of riches and ease to follow Buddha, becoming his leading disciple. Kashyapa begged Buddha to exchange the ragged robes he was wearing for his own fine clothing and when Buddha agreed, it was taken 'as a sign that, after the Buddha's demise, Mahakassapa would preside over the convention of the first Buddhist council. Upon receiving the Buddha's robes, he took up observance of thirteen ascetic practices… and in eight days became an arahant (arhat)'.[2] He was particularly well-known for his supranormal powers and, after Buddha's death, he became one of the pre-eminent monks.

It is likely that the marble head in the present exhibition (cat. no. 16, fig. 1) is a representation of Ananda, while the similar examples cited (figs. 2 and 3) are of Kashyapa. The sculpture of Ananda perfectly captures the balance of youthful vigour and intense contemplation, while the dark pigment applied to the marble points to his Indian origins. Kashyapa, on the other hand, while also shown in deep contemplation with eyes half-shut, in both instances, has the rugged features and deeply drawn furrows and lines of an older man who is steeped in ascetic practices. Carvings of Kashyapa and Ananda are seen from the Northern Wei period (386 - 535) onwards in cave temples such as Maijishan[3], Binglingsi[4] and Longmen.[5] They are often depicted together against the walls of cave temples and as free-standing sculptures (such as cat. no. 13), sometimes flanking the Buddha along with a pair of bodhisattvas and, from the Tang period, also accompanied by a pair of lokapalas, forming groups of either five or seven. In a sense, the pair of disciples may be regarded as an iconographic short-hand representing all of Buddha's disciples.

The early cave temple depictions of Ananda and Kashyapa are important, as they set a standard or stylistic convention for disciple and luohan portraiture in China for centuries afterwards. The pair cited from Maijishan (figs. 4 and 5) from the Northern Wei are particularly well sculpted and sensitively realized. Each is a notable depiction of a disciple who is endowed with supranormal powers and who has attained spirituality through intense personal effort. Also interesting is the Maijishan depiction of Kashyapa as the 'foreigner', in this case an Indian monk, indicated by a specific set of features: beaked nose, long eyebrows and domed cranium. The contrast established between Kashyapa, seen as the 'foreign' older disciple and Ananda, who is often sinicized, with rounded face and Chinese features, is seen in the Maijishan pair and seems to become accepted as a standard formula in many of the cave sculptures from the fifth/sixth century onwards. Indeed, they seem to establish a precedent in China for two central and parallel modes of depicting Buddhist luohans, either

as youthful, fresh-faced and often sinicized or as 'foreign' with exaggerated and, at times, almost grotesque features.

Groupings of Luohans

The Sankrit term, *arhat* or *arhant*, (Chinese: luohan) may be translated as a 'worthy one' and is highest of the four levels of Buddhist 'saints'. A luohan is one who has put aside all worldly attachments, or the ten fetters, that bind ordinary mortals to the cycle of re-birth[6] and has arrived at enlightenment. In doing so, the luohan has achieved *nirvana* in this life and will, at death, achieve liberation from the cycle of re-birth (*parinirvana*). Although the luohan has attained enlightenment in this life, he has chosen, with the help of magical powers, to remain alive on earth indefinitely, putting aside *parinirvana* in order to protect Buddha's Laws until the arrival of the Buddha of the Future, Maitreya. In Mahayana Buddhism however, the enlightenment of the luohan was considered to be of a different order to that of Buddha, which was of the highest level and very rare. The luohan also differs from Buddha in that his enlightenment is achieved through instruction, rather than personal insight.

According to traditional texts translated into Chinese, the transmission of Buddha's teachings was originally entrusted to four principle disciples, or *sravakas,* corresponding with the four cardinal points: Mahakashyapa, Kundopadhaniya, Pindola and Rahula, who were to wait for the arrival of the Buddha of the Future, Maitreya. The apocryphal text in which Buddha instructs Kashyapa may be quoted as follows:

> ..four great *sravakas*, who are able to undertake the mission, whose wisdom is inexhaustible, and whose virtues are plentiful. Who are these four? They are *bhiksu* Mahakasyapa, *bhiksu* Kundopadhaniya, *bhiksu* Pindola and *bhiksu* Rahul. You four great *sravakas* may not enter *parinirvana*. You must wait for my Law to come to its end, then you may enter *parnirvana*. Mahakasyapa, you must not enter *parnirvana*, because you must wait for Maitreya to appear in this world.[7]

Of these four, only Pindola and Rahula, who was the son of Buddha, become incorporated into the later group of widely worshipped sixteen luohans, while Mahakashyapa (Kashyapa), is not listed and maintains a separate status as one of the original disciples. Other listings of arhats or holy men include the 'five ascetics' to whom Buddha preached when he was at the Deer Park at Sarnath, and the 'Ten Great Disciples, who included Rahula, Ananda, Aniruddha, (the latter two being Buddha's cousins), Mahakashyapa, Shariputra, Subhuti, Purna, Mahamaudgalyayana, Katyayana and Upali.[8]

From the Tang period, the popular depiction of the sixteen luohans, charged with remaining on earth to protect Buddha's Law until the arrival of Maitreya, gained momentum and popularity, forming the basis for the luohan cult in China. The text from which the group of sixteen luohans was drawn, *A Record of the Abiding of the Dharma Spoken by the Great Luohan Nandimitra (Da Luohan Nandimiduoluo suo shuo fazhuji)*, was written sometime in the third to sixth centuries and translated into Chinese in 654 by the pilgrim monk Xuanzang (602 - 664 AD), whose travels from China, across Central Asia, to India are well documented.[9] The sutra describes the forthcoming *nirvana* of the luohan Nandimitra, eight hundred years after the death of Buddha. He reassures his followers that Buddha's Law will still be transmitted by sixteen great luohans, who possess magical powers and who reside in mountainous regions and names them as follows:

1) Pindola Bharadvaja
2) Kanakavatsa
3) Kanaka Bharadvaja
4) Subinda
5) Nakula
6) Bhadra
7) Kalika
8) Vajraputra
9) Supaka
10) Panthaka
11) Rahula
12) Nagasena
13) Ingada
14) Vanavasi(n)
15) Ajita
16) Cudapanthaka[10]

According to Lévi and Chavannes, in order to achieve enlightenment, the luohans had to attain numerous spiritual goals, in addition to putting aside the ten fetters, such as the 'Eight Grades of Liberation' (*vimoksa* or *vimukti*);[11] the 'Three Knowledges' (*trividya*);[12] and 'the Six Superknowledges (*abhijna*)'.[13] It is through the latter, that the luohans derive the ability to extend the natural duration of their lives in order to stay on earth. A description of the luohans is provided by Nandimitra:

> These Sixteen Great Lohans are all endowed with the three kinds of insight [Knowledges] (and) the six kinds of transcendent knowledge [Superknowledges]…They have separated themselves from the infection of the three worlds (of desire, form and formlessness) (and) recite and maintain the Tripitaka… As they have received the means of the power of transcendent knowledge they lengthen their own lives. As long as the Buddha's Law will remain (in the world), they will always protect and maintain it;[14]

Also described in detail in the *Record*, is the habitation of each of the sixteen luohans, in which they dwell with their luohan followers.[15] As discussed by Fong and others, the list of sixteen omits both Mahakashyapa and Kundopadhaniya from the original list of four disciples but includes Pindola, now listed as the first disciple and Rahula, listed as the eleventh. The expansion of the group to eighteen became prevalent in the Northern Song period, although the identity of the last two luohans is not entirely clear-cut and may vary. Sometimes they are described as Kasyhapa and Kundopadhaniya, two of the disciples from the original group of four.

The sixteen luohans are recorded as the subject of paintings from the mid-Tang period onwards. Most famously, they were depicted by the Tang monk painter Guanxiu (832 - 912) as rugged individuals with craggy, often foreign features set in exaggerated expressions. Guanxiu's work is now known to us through some later versions in the Japanese Imperial Household Agency, a group of stone engravings preserved in a temple in Zhejiang and also ink rubbings, such as the one in The Art Institute of Chicago.[16] Although the subject of luohan paintings in Chinese art is a separate and major subject that will not be covered in this essay, the work of Guanxiu is noteworthy for its depiction of the grotesque and the exaggerated, embodying the Tang fascination with the 'foreignness' of luohans. A description of Guanxiu's luohan paintings is given in the *Yizhou Minghua Lu* (Biographies of the Painters of Yizhou) of around 1005 AD or earlier:

> His Sixteen Lohans had bushy eyebrows, large eyes, hanging cheeks and high noses. They were seated in landscapes, leaning against pine-trees and stones. They looked and behaved like Hindus or Indians. When someone asked where he had seen such men, he answered: 'In my dream'.[17]

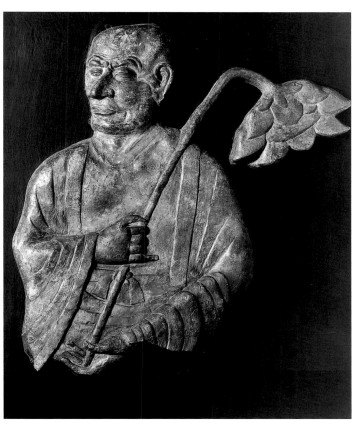

Fig. 6
Limestone figure of a luohan from the Longmen cave temples, Tang period, 618 - 907. Formerly in the National Gallery of Canada, now with the Cultural Relics Bureau, Beijing. (Previously published, Eskenazi, *Ancient Chinese Sculpture*, June 1978, cat. no. 22).

The sculptural equivalent may be seen on the walls of the Longmen caves, at the Kanjing Temple Cave, sponsored by Empress Wu and carved in the Great Zhou dynasty (684 - 705), where twenty-nine life-size figures form a procession around the cave. The low-relief carvings, representing luohans and disciples, are in three-quarter view, running the gamut from youthful and plump figures to older monks with furrowed brows and sinewy neck muscles. Included among the number are some monks who are clearly foreign with rounded, bulging eyes, beaky noses and domed foreheads (fig. 6).

Later Sculptural Representation of Luohans

After the eighth century, the worship of luohans became increasingly prevalent, as witnessed by the surviving depictions in sculpture and painting, most

produced for halls and temples, in sets of sixteen, eighteen, one hundred and even 500. As the groups increased in size, the 'original' Indian monks were joined by Chinese monks and historical figures. While some of the early depictions of Buddha's disciples and luohans may have focused on their 'otherness', as Buddhism became assimilated into the social and religious norm of China, there appears to have been a degree of transformation. The sculptural depiction of luohans appears to have become increasingly natural, in the same way that the depiction of the bodhisattva Avalokiteshvara gradually transformed into the more immediately accessible Guanyin, the goddess of mercy. The level of realism in some luohan sculptures is such that it has been suggested that in some cases, the sculptures were actual portraits. All the same, it is more likely that the sculptures were intended to represent the highest potential – spiritual enlightenment - that might be attained by a human. The intensity of expression and deep concentration seen on the faces of many luohan sculptures – which gives a sense of individuality - is intended to convey the depth of the spiritual struggle.

One of the most well-known groups of luohan statues is the *sancai*-glazed earthenware group from Yizhou (modern day Yixian) in Hebei province.[18] These magnificent large figures, dated to the Liao dynasty (907 - 1125), were part of a group of sixteen or eighteen, some of which are now to be found in museum collections in the west, including the University of Pennsylvania Museum of Archaeology and Anthropology, the Museum of Fine Arts, Boston, the Royal Ontario Museum, the British Museum (fig. 7), the Nelson-Atkins Museum, Kansas City, the State Hermitage Museum, St Petersburg and two in The Metropolitan Museum of Art. The Yixian group is outstanding, not just for the human size of the figures with their fluidly draped robes, but also for the arresting, well-modelled heads with sensitively realized facial features. Part of the debate surrounding these figures is whether they are based on portraits of real monks. Janet Baker has pointed out, for instance, that there are images of monks and disciples modelled after individuals, such as the figure of the monk, Hong Bian, which was discovered at cave 17 at Dunhuang.[19] However, it is generally accepted that while sculptures such as the stone head in the present exhibition (cat. no. 16) and the figures from Yixian, convey a deep sense of humanity and realism, they are unlikely to be 'portraits' as such. Rather, 'A stern but serene face gives the impression of an individual but at the same time suggests a commanding religious belief, embracing all upon whom his gaze falls.'[20] The intention was to create a figure to inspire the devotee to attain the spiritual understanding reached by a luohan.

Another well-known group of luohans includes the series of large painted clay figures (approximately 155cm high) at the Lingyan temple, Changqing county, in Shandong province, dated

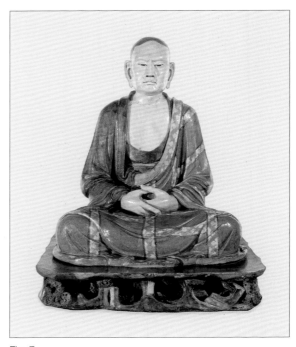

Fig. 7
Glazed ceramic figure of a luohan, discovered at Yixian, Hebei province, Liao period, 907 - 1125. © The Trustees of the British Museum.

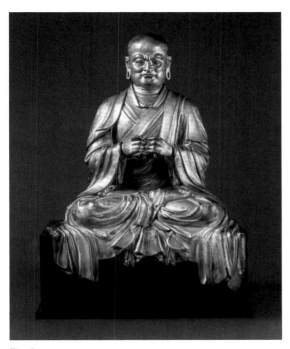

Fig. 8
Gilt bronze figure of a luohan, Yuan - early Ming dynasty,
14th - 15th century. Cat. no. 21.

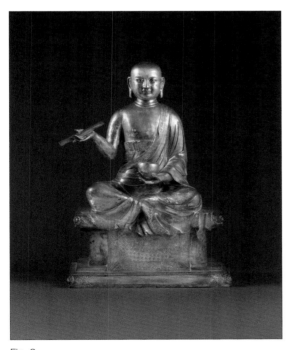

Fig. 9
Gilt bronze seated figure of Pindola Bharadvaja, Ming
dynasty, 15th century. Cat. no. 22.

mostly to the Northern Song period, although some
were added later. There are forty figures in total,
encompassing both luohans and former patriarchs
of the temple, ranging from younger to older monks,
some clearly Chinese and others of foreign origin, all
notable for their life-like, 'individualistic' appearance.
They are arranged on a platform lining the walls
of a hall, in recurring sets of seven seated figures
and five standing figures. Angela Falco Howard has
pointed out that the figures have been arranged
according to the rules laid out for the Chan monastic
order. The Chan philosophy of self-cultivation and
emphasis on discipline and practice to arrive at
enlightenment became increasingly popular after
its introduction to China by Bodhidharma. The
monastic rules were codified in the Tang period
in the *Rules for Life and Daily Routine of a Chan
Monastery* (*Chanmen guishi, or Monastic Rules of
Baizhang*), in which it was required for the monks
to practise their meditation on long platforms:
'The arhat statues in the Lingyan Temple represent
monks meditating in accordance with these rules.'[21]
It is likely that the gilt lacquered bronze luohan in
the present exhibition (cat. no. 21, fig. 8) would have
been part of a group of sixteen or eighteen figures,
placed on the east and west walls of a hall, upon a
platform. As with the group from Lingyan, the luohan
in the present exhibition is depicted in a moment
of deep meditation, focused on the inner world,
indicated both by the seated position of *padmasana*
and by the intense expression of concentration on
his face, conveyed by the furrowed brow and the
fixed stare into the middle distance. Other notable
groups of luohans include the eighteen painted
clay figures in the Dashi Hall in Chongqing Temple,
Zhangzi county, Shanxi province, dated to the
Song period; and the group in Baosheng temple, in
Luzhi, Jiangsu province, of smaller scale, against a
mountainous setting, also dated to the Song.

Gilt Bronze Sets of Luohans

While group sculptures of luohans in different
media, particularly in wood and in clay, are well
documented, surviving groups of gilt-bronze
luohans of the Yuan and Ming periods are rarer. For
instance the figure discussed above (cat. no. 21,
fig. 8) is known only in isolation, although, as cited,
there is a comparable set that was in the Yiguang
temple, published in 1921, and yet another set,
now scattered, one of which is now in a museum in
Czechoslovakia.

In this context, it is useful to examine a partial
group of fifteenth-century gilt bronze luohans,
one of which is included in the present catalogue
(cat. no. 22, fig. 9). The latter, along with six other
known similar examples, are so closely related in
size and detail, that they almost certainly formed
part of a set. All the figures are finely and crisply
modelled, with sensitively cast facial features,
set in expressions of deep contemplation. In all
the examples, the monks wear robes that fall in

naturalistic folds over their strongly modelled torsos. The robes are all edged with a similar floral scroll border to simulate rich embroidery and each luohan holds or held a specific attribute in his hands. Each is seated upon an identical stepped base, the corners ornamented with floral studs against an incised ground. In addition, most are also seated on a prayer mat, with a central cartouche and a wide border. In each case, the lower edge of the base is incised with the luohan's name, and the reverse is inscribed with a Tibetan text and, in Chinese, with its intended location within a particular hall. As discussed, such sets of luohans were placed along the east and west walls of a Buddhist hall, as in this instance, flanking a central figure of Buddha and it is probable that the original set comprised sixteen.

In addition to the present figure, representing Pindola Bharadvaja (inscribed 'Fourth to the East'), the other six examples are:

Angaja, (inscribed 'First to the West') (fig. 10)
Ajita, (inscribed 'Second to the West') (fig. 11)
Kanakavatsa (inscribed 'Ninth to the West') (fig. 12)
Bakula, (inscribed 'First to the East') (fig. 13)
Cudapanthaka, (inscribed 'Third to the East) (fig. 14)
Gopaka (inscribed 'Seventh to the East') (fig. 15)[22]

While it is fascinating to have such a group, particularly as the luohans are identified by name, the complexity of the subject becomes evident as the names do not correspond to the list previously cited. In fact, a grouping of sixteen luohans was adopted by Tibetan Buddhism at an unknown date, that lists them in a different order, changes some of the 'worthies' and has them residing in other places. The 'Tibetan' list of sixteen luohans is as follows:

1) Angaja
2) Ajita
3) Vanavasi
4) Kalika
5) Vajriputra
6) Bhadra
7) Kanakavatsa
8) Kanakabhara Dvaja
9) Bakula
10) Rahula
11) Cudapanthaka
12) Pindola Bharadvaja
13) Panthaka
14) Nagasena
15) Gopaka
16) Abheda[23]

The present group of seven luohans and their names and positions fits neatly into the Tibetan list, if we assume one to eight represent the positions on the west wall of a Buddhist hall and nine to sixteen represent the positions on the east wall. Thus the location inscription on cat. no. 22, Pindola Bharadvaja, 'Fourth to the East', corresponds with his position as twelfth on the list. The question of why this set of luohans, clearly Chinese in

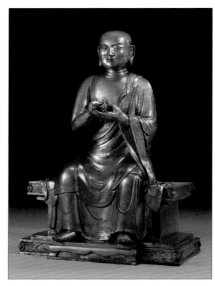

Fig. 10
Gilt bronze seated figure of Angaja, Ming dynasty, 15th century. © Christie's Images.

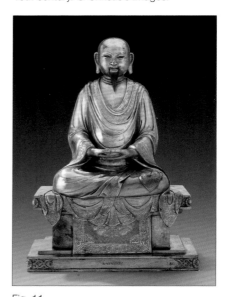

Fig. 11
Gilt bronze seated figure of Ajita, Ming dynasty, 15th century. © Sotheby's/ArtDigital Studio.

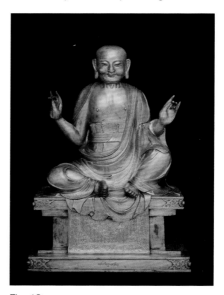

Fig. 12
Gilt bronze seated figure of Kanakavatsa, Ming dynasty, 15th century. After Hans-Joachim Klimkeit et al., *Kunst des Buddhismus entlang der Seidenstrasse*, (Buddhist Art along the Silk Road), Munich, 1992, number 104.

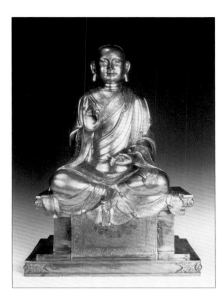

Fig. 13
Gilt bronze seated figure of Bakula, Ming dynasty, 15th century. © Christie's Images.

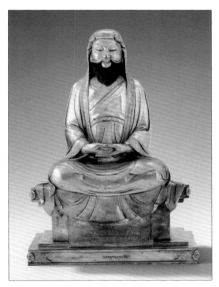

Fig. 14
Gilt bronze seated figure of Cudapanthaka, Ming dynasty, 15th century. © Sotheby's/ArtDigital Studio.

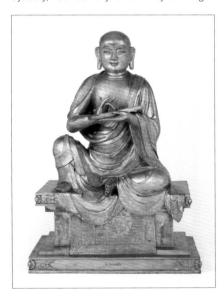

Fig. 15
Gilt bronze seated figure of Gopaka, Ming dynasty, 15th century. © Victoria and Albert Museum, London.

workmanship, should follow the 'Tibetan' list is further discussed below. An additional complication to the 'original list' of sixteen luohans was created by the Qianlong emperor (1736 - 1795), who, in 1757, while on an inspection tour of south China viewed the set of sixteen luohans reportedly painted by Guanxiu at the Shengyin Temple. He then re-named and re-ordered the luohans according to the Tibetan list.[24]

The Yongle Emperor and Tibetan Buddhism

The early fifteenth century date assigned to this set of gilt-bronze luohans, including cat. no. 22, places them in the period of the Yongle emperor (1403 - 1424), in whose life and reign Buddhism played a major part. The strong ties established with Tibet and the Tibetan lamas during the Yuan Mongol rule continued under the Yongle reign. After his accession to the throne in 1403, the Yongle emperor sent a mission to Tibet and in 1407, the Tibetan lama, De-bzin-gsegs pa (known in Chinese as Halima), renowned as a miracle-worker, came to the Ming court in Nanjing and performed religious rites on behalf of the emperor's deceased parents. According to the Ming records, many miracles were performed: 'apparitions of cranes and lions, flowers falling from the sky', after which, 'Richly rewarded, he and members of his retinue were granted resounding official titles and proceeded to Mount Wu-t'ai, the important Chinese Buddhist center in Shansi province…He exchanged gifts with the Ming court on at least three subsequent occasions.'[25] The lavish exchange of gifts and continued relationship with various Tibetan lamas has been portrayed as a central part of the Yongle emperor's policy of border diplomacy, but more recently, his fascination with the religion of Buddhism, in particular Tibetan Buddhism, has been recognized. As has been pointed out by James Watt: 'So few of the products of the Yongle workshops are free of Buddhist symbolism that it almost seems that the workshops existed to produce articles for Tibetan Buddhist rituals. This was particularly the case with metalwork…'[26]

Thus, it would seem a logical assumption that this group of gilt-bronze luohans was produced against a backdrop of Tibetan Buddhism at the Yongle court, either for use in China or as a gift to be sent to Tibet. The stylistic features displayed by the group accord neatly with dated fifteenth-century gilt bronzes, including the finely cast details and carefully finished backs: 'the soft contours of the body, and the naturalistic drape of the cloth… distinguish the Yongle sculpture.'[27] The Tibetan inscription on the present figure was most likely inscribed in a Chinese workshop - the spelling is poor and inconsistent, as if inscribed by a non-native speaker. Finally, the use of the 'Tibetan list' for the ordering of the luohans suggests that this ordering may have been adopted for use, in preference to the 'Chinese list', during this period.

Luohans, Mahasiddhas and Immortals

Although the 'original' group of luohans was loosely based on historical figures from India, others were later added to the group, who were, as previously mentioned, primarily Chinese monks of note or Chinese historical figures. Although the cult of the luohan gained great momentum in China, Japan and Tibet, this was not the case in India or the rest of South-East Asia. Instead, in India, the Buddhist *mahasiddha*s secured a great following: they were religious figures who had attained enlightenment and who were also teachers in their own right with their own followers. The question naturally arises as to why the luohans became such a successful trans-cultural plantation, taking root in China, whereas in India, they were superseded by other figures. One possible reason often cited is that there was a close cultural affinity between the luohans and indigenous beliefs, which allowed the cult of the luohan to take root and flourish. The tradition of shamans or *wu* had been recorded on the oracle bones of the Shang period and from the Zhou period, it appears that there was a gradual transfiguration of the earlier idea of *wu* into the concept of an immortal or *xian*, as discussed by Kiyohiko Munakata:

> It is important to note here that this cult started as an intellectual twist on shamanism, an ingenious transfiguration of the idea of the shaman's ecstatic cosmic trip into the image of the free-flying 'mountain man' (*xianren*) and further, that of the 'achieved man' (*zhenren*) who attained a cosmic vision and life freed from earthly bounds of space and time.[28]

Although it is not possible within the limits of this essay to consider the relationship between Buddhism and Daoism, parallels have been observed between the cult of the Eight Daoist Immortals, as well as other Daoist deities, and that of the luohans. The Daoist adepts or immortals, like the luohans, were famed for their magical powers. The immortals were also considered to be 'perfected beings' who had achieved, through self-cultivation, unity with the *Dao*. Like the luohans, many of the immortals were said to dwell in the mountains; the concept of the central peak, connecting heaven and earth and the worship of the Five Sacred Peaks were central to Daoism. Also, like the luohans, each of the immortals has a colourful history, astonishing abilities and specific attributes associated with them. Like the luohans, some of the immortals are depicted with exaggerated, grotesque features. These many similarities suggest there may already have been a cultural precedent in China in the form of the Daoist immortals which enabled the cult of luohans to develop and flourish.

Notes

[1] Robert E. Buswell Jr and Donald S. Lopez, *The Princeton Dictionary of Buddhism,* Princeton, 2014, pages 38 - 39.

[2] Ibid., page 497.

[3] Annette L. Juliano et al., *Monks and Merchants, Silk Road Treasures from Northwest China*, New York, 2001, catalogue numbers 62 (Kashyapa from Cave 87) and 63 (Ananda from Cave 102).

[4] Dong Yuxiang, *Zhongguo meishu quanji, diaosu bian 9, Binglingsi deng shiku diaosu* (The Great Treasury of Chinese Art, Sculpture 9, Bingling Temple and Other Caves), Beijing, 1988, page 112, number 87 for a Tang figure of Buddha flanked by the disciples, a pair of bodhisattvas and a pair of lokapalas in Cave 28.

[5] Terukazu Akiyama and Saburo Matsubara, *Arts of China, Buddhist Cave Temples, New Researches*, Tokyo, 1969, page 145, number 135 for a sixth century figure of Buddha on the west wall at Pinyang Cave, flanked by Ananda and Kashyapa and a pair of bodhisattvas; page 147, number 137 for a figure of Buddha in Cave 14 also flanked by Ananda and Kashyapa.

[6] Robert E. Buswell Jr and Donald S. Lopez, *The Princeton Dictionary of Buddhism,* Princeton, 2014, page 62, the ten fetters are listed as follows: 1) belief in the existence of a perduring self, 2) sceptical doubt (about the efficacy of the path), 3) belief in the efficacy of rites and rituals, 4) sensual craving, 5) malice, 6) craving for existence as a divinity in the realm of subtle materiality, 7) craving for existence as a divinity in the immaterial realm, 8) pride, 9) restlessness,10) ignorance.

[7] Wen Fong, *The Lohans and A Bridge to Heaven*, Freer Gallery of Art Occasional Papers, volume 3, number 1, Washington, 1958, page 25 and page 31 for the dates of the Chinese translations.

[8] Marsha Weidner ed., *Latter Days of the Law, Images of Chinese Buddhism 850 - 1850*, Kansas, 1994, page 260, where the Ten Great Disciples are listed.

[9] Takayasu Higuchi ed., *The Silk Road and the World of Xuanzang*, Japan, 1999, pages 11 - 33. In the later part of his life Xuanzang received the patronage of the Tang Emperor Taizong, who gave him use of a palace building, Yuhuagong, in which to translate the sutras, while the translation effort continued under his supervision, at Daciensi Temple, built in 648.

[10] For a listing of the sixteen luohans, see Marsha Weidner ed., *Latter Days of the Law, Images of Chinese Buddhism 850 - 1850*, Kansas, 1994, page 206; also, Sylvian Lévi and Édouard Chavannes, 'Les Seize Arhat Protecteurs de la Loi', in *Journal Asiatique*, July - August 1916, page 9; also, Wen Fong, *The Lohans and A Bridge to Heaven*, Freer Gallery of Art Occasional Papers, volume 3, number 1, Washington, 1958, pages 35 - 36.

[11] Robert E. Buswell Jr and Donald S. Lopez, *The Princeton Dictionary of Buddhism,* Princeton, 2014, page 972.

[12] Ibid., pages 925 - 926 for the 'Three Knowledges' (*trividya*): firstly, the ability to recall one's former life, secondly, the insight into the re-birth destinies of other beings and finally, the 'knowledge of the extinction of the contaminants.'

[13] Ibid., pages 8 - 9 for the Six Superknowledges' (*abhijna*): referring to a set of extraordinary powers that are the by-product of meditation, including psychic and magical powers, clairvoyance, clairaudience, ability to recall one's former lives, knowledge of others' states of minds, knowledge of the extinction of contaminants.

[14] Richard K. Kent, 'Depictions of the Guardians of the Law: Lohan Painting in China' in Marsha Weidner ed., *Latter Days of the Law, Images of Chinese Buddhism 850 - 1850*, Kansas, 1994, page 184.

[15] Sylvian Lévi and Édouard Chavannes, 'Les Seize Arhat Protecteurs de la Loi', in *Journal Asiatique*, July - August 1916, page 10 for the list of luohans and their dwelling places.

[16] Marsha Weidner ed., *Latter Days of the Law, Images of Chinese Buddhism 850 - 1850*, Kansas, 1994, catalogue number 15.

[17] Osvald Sirén, *Chinese Painting, Leading Masters and Principles*, volume 1, London, 1956, page 155.

[18] Richard Smithies, 'A Luohan from Yizhou in the University of Pennsylvania Museum', *Orientations*, Hong Kong, February, 2001.

[19] Janet Baker, 'Foreigners in Early Chinese Buddhist Art: Disciples, Lohans and Barbarian Rulers', in *Marg*, volume 5, number 2, December 1998, pages 54 - 55.

[20] Jessica Rawson ed.,*The British Museum Book of Chinese Art*, London, 1992, page 159.

[21] Angela Falco Howard et al., *Chinese Sculpture*, Yale, 2006, pages 389 - 393. See also, Shi Yan ed., *Zhongguo meishu quanji, diaosu bian 5, Wudai Song diaosu*, (The Great Treasury of Chinese Art, Sculpture 5, Five Dynasties and Song), Beijing, 1988, numbers 45 - 54.

[22] See catalogue number 22 for the publication details of the figures in the set.

[23] Sylvian Lévi and Édouard Chavannes, 'Les Seize Arhat Protecteurs de la Loi', in *Journal Asiatique*, July - August 1916, page 190 and page 297.

[24] Marsha Weidner ed., *Latter Days of the Law, Images of Chinese Buddhism 850 - 1850*, Kansas, 1994, page 264.

[25] Frederick W. Mote and Denis Twitchett, *The Cambridge History of China, The Ming Dynasty, 1368 - 1644, Part I*, volume 7, Cambridge, 1990, pages 262 - 263.

[26] James C. Y. Watt and Denise Patry Leidy, *Defining Yongle, Imperial Art in Early Fifteenth-Century China,* New York, 2005, pages 14 - 15.

[27] Ibid., pages 68 - 73.

[28] Kiyohiko Munakata, *Sacred Mountains in Chinese Art*, Urbana and Chicago, 1991, page 11.

Catalogue

Chinese sculpture c. 500 - 1500

The Tibetan and Sanskrit names that appear in this catalogue have been written in the Roman alphabet without diacritical marks or silent letters (except for direct quotations from the literature). Their spelling conforms to their phonetic pronunciation.

1

Sandstone Head and Shoulders of Buddha

Northern Wei period, mid to late 5th century
Height: 43.3cm
Width: 31.5cm

Sandstone Buddha, comprising head, neck and proper left shoulder. The Buddha's face is delicately carved with high cheek-bones, arched brows framing eyes half-closed in contemplation, a well-formed nose and elongated ears. His small mouth is set in an 'archaic smile' above a cleft chin. The hair is neatly arranged in a straight line across his forehead and drawn up over the prominent *ushnisha*. His chest is partially exposed beneath the monk's robes that have narrow raised borders. The weathered sandstone is of a mottled beige tone.

Provenance:

Yungang cave temples, Shanxi province.

Yamanaka Co. Ltd., Tokyo (acquired 1930 - 1935), by repute.

Atsuji Shibusawa (1872 - 1942), adopted son of Eiichi Shibusawa.

Keizo Shibusawa (1896 - 1963) (served as Japanese Minister of Finance after the Second World War), from whom by descent.

Senshutey, Tokyo.

Exhibited:

Possibly Osaka, 1934, Osaka Arts Society.

Published:

By repute, Yamanaka and Osaka Arts Society, *Grand Exhibition of Ancient Chinese and Korean Works of Art*, Tokyo, 1934, number 357 (unillustrated).

Similar examples:

Seiichi Mizuno and Toshio Nagahiro, *Yun-Kang: The Buddhist Cave-Temples of the Fifth Century A.D. in North China*, volume 12, Kyoto, 1954, plates 82 and 86 for Buddha figures from niches of the east reveal of the window in Cave 18; also, Su Bai and Li Zhiguo ed., *Zhongguo meishu quanji, diaosu bian 10, Yungang shiku diaoke*, (The Great Treasury of Chinese Art, Sculpture 10, Yungang Caves), Beijing, 1988, page 167, number 161.

一

砂岩佛头肩像　北魏　公元五世纪中晚期

高 四三·三公分　宽 三一·五公分

佛像砂岩质，含头颈及左肩。佛面雕工细致，高颊骨，弯眉毛，双眼半睐，呈沉思状，鼻形挺直，长耳垂肩。嘴形精致且小，流露微笑，双层下巴。发型梳理整洁，额前平齐，上敛成高肉髻。佛像着僧衣，前胸半敞，襟领细而凸起。经年风化，砂岩显出斑驳的米黄色。

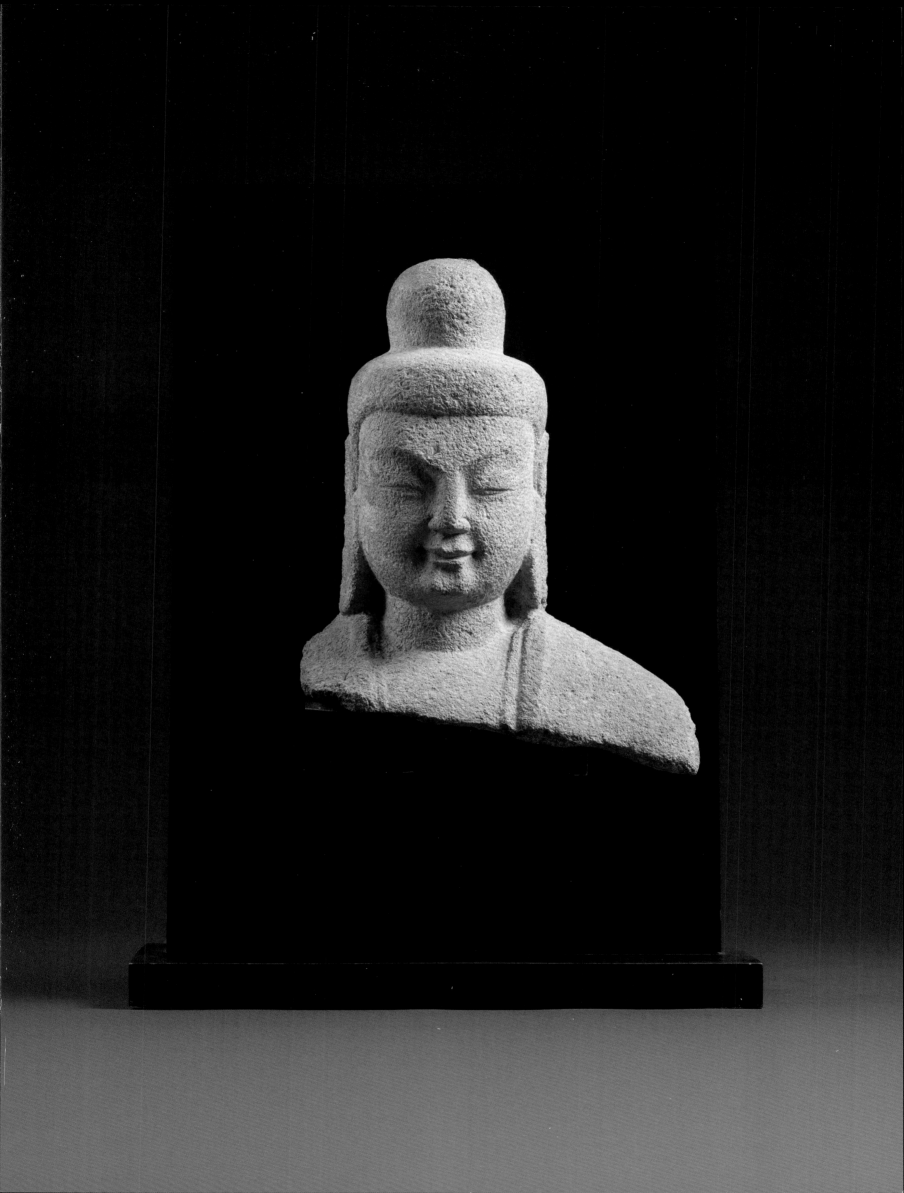

From the mid-fifth century in China, the carving of Buddhist cave temples flourished and, in north China, Yungang was the first imperially sponsored cave temple of the Northern Wei period. Atoning for the persecution of Buddhism by his predecessor, Emperor Wencheng reinstated the Buddhist faith in 452 and ordered five cave temples to be built at Yungang. These five cave temples are the earliest on the site (caves 16, 17, 18, 19 and 20) and are known collectively as *Tanyao wuku*, ('The Five Caves of Tanyao' or 'The Imperial Five'). Tanyao was the chief monk who, in 460, was appointed by the emperor to oversee the Buddhist faith.

The example in the present exhibition is similar to the seated Buddhas cited above from Cave 18, in the proportions of the head, treatment of the hairline, deeply cleft chin and the comparatively plain robes. The size would also seem to be comparable. There are numerous small figures in niches, as well as several larger figures, such as the ones cited here, remaining around the window and entrance of Cave 18, in various states of preservation, although many more appear to have been lost.

For further discussion on the importance of the Yungang cave temples, see pages 12 - 17 of this catalogue, for the essay, *The Evolution of Chinese Buddhist Sculpture*.

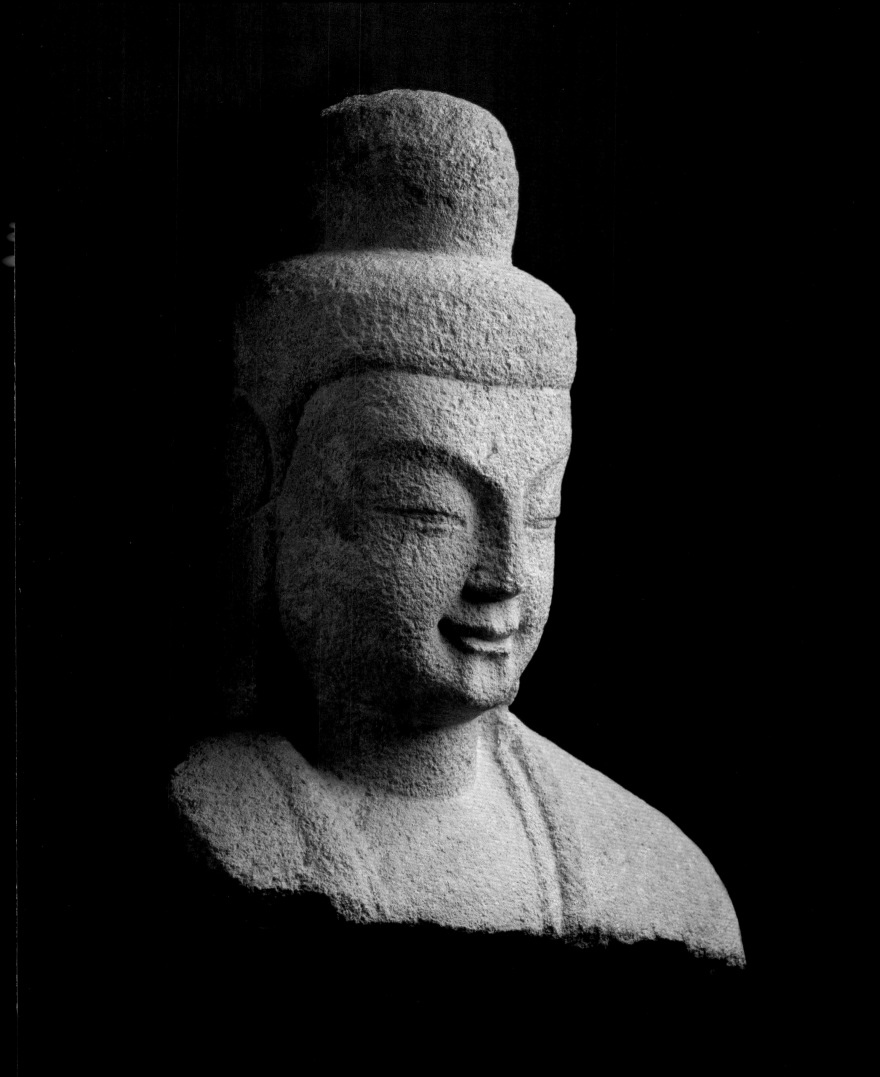

2
Gilt Bronze Avalokiteshvara (Guanyin)
Northern Wei period, late 5th or early 6th century
Height: 23.0cm

Gilt bronze figure of Avalokiteshvara Padmapani standing on a circular lotus petal base, raised upon a four-legged pedestal with proper left hand holding a lotus bud to the shoulder and pendant right hand grasping a scarf. The deity has a finely cast face with delicate features and hair drawn up and encircled by a lotus-petal crown secured with ribbons. The figure is dressed in a tight-fitting robe, draped diagonally across the body and falling in U-shaped folds down the legs; a billowing scarf is wound around the exposed shoulders and arms. The figure is backed by a leaf-shaped mandorla edged with a band of flames. The reverse is incised with a standing figure holding a lotus bloom in the right hand and an ambrosia flask in the left. The pedestal is inscribed on two sides with a sixteen-character inscription (see overleaf).

Provenance:

By repute, Kusaka Shogado, Kyoto, 1930s.

Lin Xiongguang (Lang'an), (1898 - 1971), the Baosongshi collection (acquired 8th October 1938).[1]

Martin Månsson (1880 - 1952) collection, Stockholm, from whom by descent.

[1] The gilt bronze is accompanied by a custom-made, silk-lined, fitted Japanese wood box. The inside of the cover bears an inscription by Lang'an dated to mid-autumn of the Wuyin year, (corresponding to 8th October 1938), with two seals: Lei zhai? and Baosongshi. Lang'an is one of the names of Lin Xiongguang (1898 - 1971), a famous collector, born into a wealthy family in what is now Taiwan. At an early age, he studied in Japan, later graduating from the Imperial College in Japan, and married an aristocratic Japanese woman. In 1945 he returned to Taiwan. He collected mostly paintings and wrote *Baosongshi biji* (Baosongshi Notes).

Published:

Christie's, London, *Fine Chinese Ceramics and Works of Art*, 10 May 2011, number 188.

Similar examples:

Lin Shuzhong ed., *Zhongguo meishu quanji, diaosu bian 3, Wei Jin Nanbeichao diaosu*, (The Great Treasury of Chinese Art, Sculpture 3, Six Dynasties), Beijing, 1988, page 116, number 96 for an example in the Shanghai Museum, dated 514; also, Shanghai Museum, *Ancient Chinese Sculpture Gallery, The Shanghai Museum*, Shanghai, 1996, number 11.

Kuboso Memorial Museum, *Chugoku no Bijutsu, Ichinin No Gan*, (Chinese Art, One Man's View), Izumi, 1984, pages 76 - 77, number 92 and front cover, for an example with a date corresponding to 498; also, S. Matsubara, *A History of Chinese Buddhist Sculpture*, Tokyo, 1995, plates volume 1, plates 88 and 89.

二 鎏金铜观音立像 北魏 公元五世纪晚期或六世纪早期

高 二三·〇公分

观音立于圆形莲台上，四腿底座支撑，观音左手持莲蕾靠在肩上，右手悬握长巾。此像容貌铸造精致，五官清晰，头发上梳，莲冠圈之，丝结固定。身着紧身袍，衣纹斜跨，曲线皱褶，直至腿部。长巾飘逸，环绕肩臂。叶片形背光，火焰纹饰边。背面刻划立姿菩萨像，右手握莲蕾，左手提净瓶。底座两侧刻有十六字铭文。

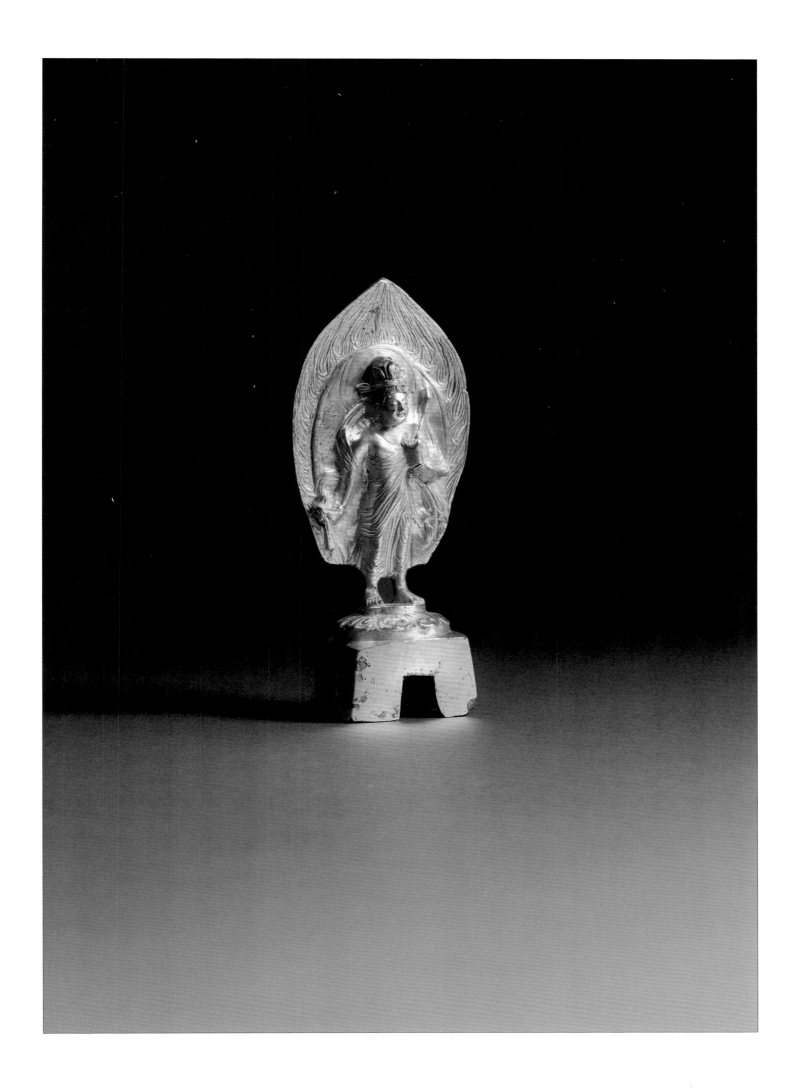

Bodhisattva Padmapani, 'the lotus-bearing manifestation' of the Bodhisattva Avalokiteshvara (Guanyin) was a popular deity in early Chinese Buddhist culture, seen most commonly from around the fifth to the eighth centuries. During the Northern Wei period, there appears to have been a certain amount of variety in the depiction of Padmapani. The present figure wears a robe that covers one shoulder, falling diagonally across the body, with a long shawl looped around the back and arms. The headdress in this case is a simple lotus-petal tiara, secured by ribbons. However, a number of other Northern Wei figures of Padmapani depict the deity wearing a *dhoti* that falls from the hips to the ankles, the bare chest ornamented by necklaces slung diagonally and the head topped with a high crown fastened by ribbons, recalling the costume of an Indian prince, as seen in the second similar example cited above. Padmapani is identified by the lotus attribute that is held in the hand but this again may vary from figure to figure – it is seen held either to the proper left or right shoulder, although the former, as in the present example, is more unusual. For a variety of Padmapani figures from the Northern Wei period see Tokyo National Museum, *Kindo Butsu; Chugoku Chosen Nihon* (Special Exhibition; Gilt Bronze Buddhist Statues, China, Korea, Japan), Tokyo, 1987, numbers 46 - 59.

The inscription on the pedestal reads as follows:

李道胜为亡子告洋（祥）
造观世音像故记之

which may be translated as:

Li Daosheng asked for his deceased son to be blessed and commissioned this statue of Guanyin in his memory.

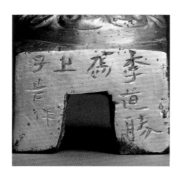

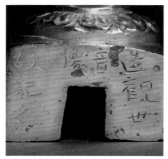

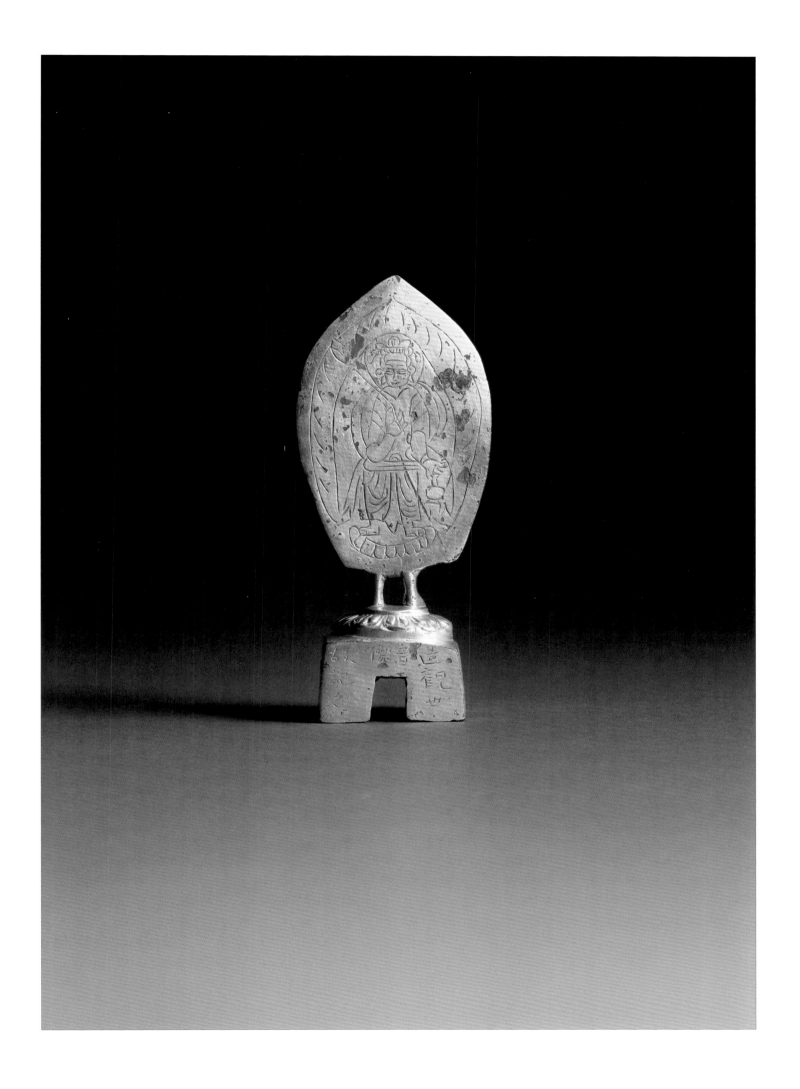

三

鎏金铜弥勒像　北魏　公元五一二年

高　二一・八公分

弥勒佛立于莲台上，下接圆形束腰座，四腿方架支撑，腿外撇构成拱门。立佛双足微分，抬臂举手，施无畏与愿印。身着僧衣，褶纹弯曲，从颈部前垂，简约自然。佛面五官精致勾勒，思维表情，头挽高肉髻。活动叶形背光，前面铸有三尊化佛，顶上一尊，左右各一，均有背光，并衬以火焰纹地。弥勒脑后有莲瓣头光，诸环叠套，亦有平行曲线纹。方形底架有三孔，面板二个，右后腿有一。鎏金厚实，部分孔雀石层及少量锈蚀点。背光后面刻有四十字的铭文。

3
Gilt Bronze Maitreya

Northern Wei period, inscribed with date corresponding to 512
Height: 21.8cm

Gilt bronze figure of Maitreya Buddha standing on a lotus supported by a stepped circular base, itself on a square pedestal with four splayed legs forming petal-shaped arches. The figure stands with feet slightly apart, arms raised and hands in *abhaya* and *varada mudra*. He wears a robe draped in a low U-shape at the neck and falling in stylized pleats down the front. His delicate features are composed in a meditative expression and he has a pronounced *ushnisha* on top of his head. The front of the detachable leaf-shaped mandorla is cast with three stylized meditating Buddhas, one at the apex and one to either side, each with an individual mandorla, all against a ground of flames. The head of the Buddha is backed by a halo of raised lotus petals enclosed by concentric circles, the body with curved parallel lines. The pedestal is pierced with three slots, two on the upper surface and one on the right back leg. The rich gilding has areas of malachite encrustation and minor pitting. The reverse of the mandorla is incised with a forty-character inscription (see overleaf).

Provenance:

Kochukyo Co. Ltd., Tokyo

Published:

Kudanaka Kunihiko, *Rikucho No Bijutsu*, (Arts of the Six Dynasties), Osaka Municipal Museum, Osaka, 1976, number 277.

Jin Shen, *Zhongguo lidai jinian foxiang tudian*, (Illustrated Chronological Dictionary of Chinese Buddhist Figures), Beijing, 1994, page 130, number 87.

S. Matsubara, *A History of Chinese Buddhist Sculpture*, Tokyo, 1995, plates volume 1, plates 112b and c; text volume 3, page 257 (for inscription).

Similar examples:

S. Matsubara, *A History of Chinese Buddhist Sculpture*, Tokyo, 1995, plates volume 1, plates 36 - 37 for an example with five seated Buddhas on the mandorla; also, Seiko Murata, *Shokondoubutsu no miryoku chugoku chosenhantou nihon*, (The Attraction of Small Gilt Bronze Buddhist Statues, China, North and South Korea, Japan), Tokyo, 2004, page 44, number 43; see also, Jin Shen, *Zhongguo lidai jinian foxiang tudian*, (Illustrated Chronological Dictionary of Chinese Buddhist Figures), Beijing, 1994, page 25, number 19.

Miho Museum, *Buddhist Sculptures from Shandong Province, China*, Shigaraki, 2007, number 36 for an Eastern Wei figure excavated from the site of the Longhua temple in Chongde village, now in the Boxing County Museum.

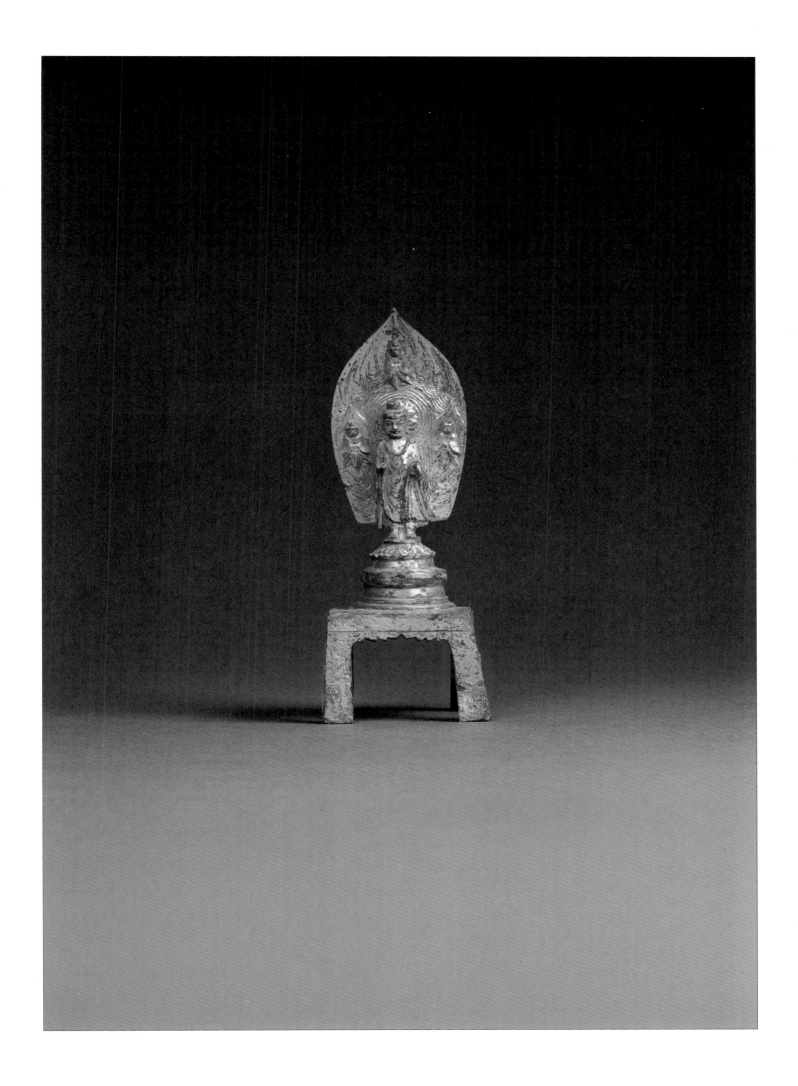

Maitreya is the only deity in Buddhism that is worshipped both as a Buddha and a bodhisattva. He is believed to be the Buddha of the Future, but until the moment of his appearance in this world, he waits as a bodhisattva in the Tushita heaven. The cult of Maitreya was particularly prevalent during the fifth and sixth centuries in China and devotees believed that they would be re-born in the 'Pure Land' or Tushita heaven.

The two slots on the upper surface of the pedestal would have been designed to hold a standing bodhisattva on each side of the Buddha. The second similar example cited is also now lacking the attendant bodhisattvas which, in this instance, would have been attached to the mandorla.

There appear to have been three counties named Pingyuan at various periods in Chinese history. Two, still named Pingyuan, are in present-day Shandong province. Both of these counties, however, were established during the Northern Qi period (550 - 577) and after the casting of the present gilt bronze figure. The Pingyuan referred to here was a county in Gansu province, established in the Northern Wei period. Gansu province in north-west China, at China's border with Central Asia, was a vital link on the Silk Road, connecting Xinjiang and the Kushan Empire in India with the Chinese capital.[1] It also played a vital role in the transmission and establishment of Buddhism in northern China and is home to a number of important Buddhist cave sites including Dunhuang, Maijishan and Binglingsi.

[1] Annette L. Juliano et al., *Monks and Merchants, Silk Road Treasures from Northwest China*, New York, 2001, chapter 1.

The inscription on the reverse of the mandorla reads as follows:

永平五年三月初（?）日平原县人盖县令郝道仙夫妻为亡女敬造弥勒像
一区愿使居家眷属普同期福

which may be translated as:

On the first (?) day of the third month of the fifth year of the Yongping reign (corresponding to 512), the couple, Magistrate Gai and Hao Daoxian, of Pingyuan county respectfully commissioned a figure of Maitreya for their deceased daughter, hoping for blessings for their entire family.

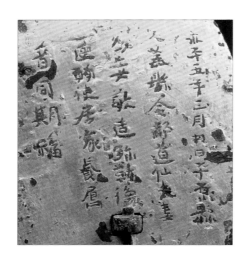

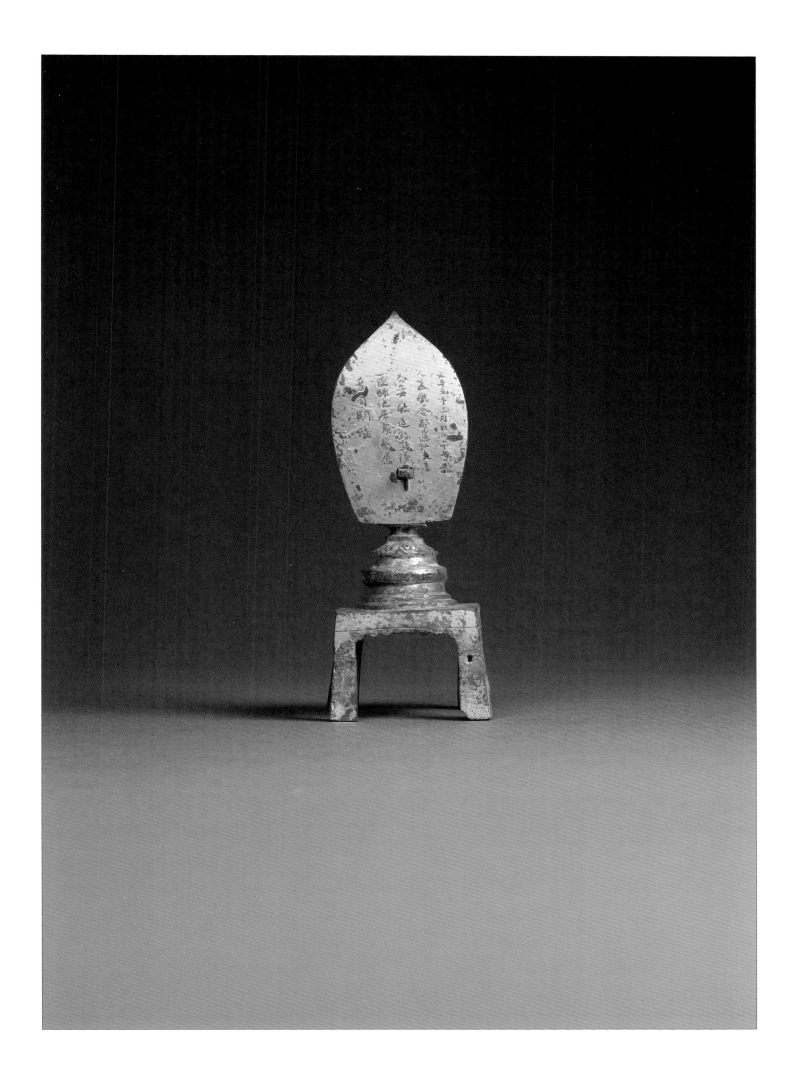

4
Limestone Mortuary Bed Lintel
Northern Wei period, early 6th century
Length: 210.3cm
Height: 49.3cm
Depth: 20.7cm

Carved bed lintel, fashioned from a solid block of dark grey limestone as a rectangular slab on three supporting legs. The front of the slab is ornamented with nine rectangular panels, carved in low relief with lively mythical creatures and motifs, comprising, from left to right: a lion; a mythical bird with hooves; a winged beast; a human-headed bird; a flaming pearl surrounded by lotus petals and scrolls; a human-headed bird; a dragon; a horned bird; and a *qilin* or horned deer. Apart from the central panel, each has a rectangular cartouche in an upper corner where partially legible characters in ink are visible. The panels are bordered by a band of overlapping pendant lotus petals above and a band of waves below, extending down the edges of the supporting legs. The central leg is carved in high relief with a snarling monster mask with pointed ears, bulging eyes and snout-like nose, its furrowed brow topped by curling horns separated by five mountain peaks. A demonic figure squats on each of the supporting legs, with arms extended as if supporting a great weight, surrounded by flaming tendrils. The reverse of the lintel is undecorated and set with a pair of iron rings. There are green, red and white pigments on the front, with some white slip and traces of gilding.

四

石灰岩棺椁楣　北魏　公元六世纪早期

長　二一〇・三公分　高　四九・三公分

深　二〇・七公分

床楣雕饰，以整块石灰岩制成，包括长方形板块与三条腿撑。板块正面饰以九幅长方图案，浅浮雕手法刻出生动的瑞兽及纹样，由左至右依次为：狮子，鸟首蹄足兽，带翼兽和人面鸟，莲瓣绕火焰珠，人面鸟，青龙，带角鸟及麒麟或

角鹿。除了中心图案外，各版面上角均有长方平面，上有墨迹，部分字体可辩。板块上沿通饰重叠的垂莲瓣纹，浪涛纹饰下沿，并顺腿边延至器底。中间腿刻高浮雕兽面，咆哮狰狞，尖耳凸目，宽鼻锁眉，弯角间五顶起伏。左右腿部，均饰小鬼形象，屈膝蹲坐，鼓肚袒露，双臂力挺，如负重物，火苗纹环绕。石楣后部素纹，有两只铁环。楣前图案上留有绿红白色，并有些许白条纹及鎏金痕。

Provenance:

Nicholas Grindley, London.

Private collection, Los Angeles.

Published:

Nicholas Grindley, exhibition catalogue, London, 2000, number 2.

Similar examples:

René-Yvon Lefebvre d'Argencé, *Chinese, Korean and Japanese Sculpture in The Avery Brundage Collection*, Japan, 1974, number 50 for a larger example in the Asian Art Museum, San Francisco; also, Hong Kong Museum of Art, *Gems of Chinese Art from the Asian Art Museum of San Francisco, The Avery Brundage Collection*, Hong Kong, 1983, number 96.

Gilles Béguin, 'A propos du Gang du musée Cernuschi', *Collections parisiennes*, volume 4, Paris, October 1998, pages 17 - 21.

Eileen Hsiang-Ling Hsu et al., *Treasures Rediscovered: Chinese Stone Sculpture from the Sackler Collections at Columbia University*, New York, 2008, number 20.

From around the fifth to the seventh century in north and north-west China, the tomb furniture of aristocrats often included stone elements. A bed was a main feature comprising a central platform and side panels, supported on two stone lintels, usually with three legs. The front lintel would have been ornamented, as in the present example, and the back lintel left undecorated. Complete, intact examples of such funerary beds are rare.[1] An example with the platform and front and back lintels was excavated from a Northern Wei tomb at Tiancun, near Datong, Shanxi province in 1999.[2] The present lintel is unusual in that it incorporates nine decorative panels, whereas the similar examples cited above have twelve panels or more.

Some of the decorative elements on the present lintel owe their origins to Buddhist imagery, such as the flaming pearl in the central cartouche, the lion and the overlapping lotus-petal lappets. Examples of all three may be also found in the Buddhist cave temples of the period and earlier. For instance, lotus-petal lappets may be found used as moulded borders between the central decorative elements on the ceilings and walls at Yungang[3] while the flaming pearl motif may be seen on the walls at the caves at Xiangtangshan.[4]

The main decorative motifs on the lintel, however – the mythical winged creatures and monsters – appear to have their origins in pre-Buddhist art. It is probable that winged beings were believed to possess the ability to move from the present world to the afterlife and that a number had protective qualities as well. The wings, flaming haunches and long tongues were intended to symbolize their supernatural powers. Daoist immortals were often pictured in early Chinese art on winged beasts and winged supernatural animals are known from the Han period, for instance tomb sculpture and spirit road figures.[5] It is possible some of the Animals of the Directions (Green Dragon of the East, White Tiger of the West, Black Tortoise and Snake of the North, Red Vermilion Bird of the South) are represented on the present lintel, although not necessarily in a systematic or prescriptive fashion.[6] The human-headed figures with wings may also represent spirits to guide the deceased in the after-life. Susan Bush, in her extensive discussion of Six Dynasties ornament, suggests that 'In pre-Han and Han mythology, a human-headed bird was an auspicious spirit or a wind spirit.'[7] Also of note are the winged, crouching, pot-bellied figures carved in high relief on the legs at either end of the lintel. Susan Bush has suggested that such creatures are 'thunder monsters'[8] believed to have the power to control the elements. Stone fragments of comparable figures, originally from the caves at Xiangtangshan, are in various museum collections, and Katherine Tsiang has suggested that 'With their frightening qualities, the monsters can be identified as representations of potentially harmful spirits…The depiction of the monsters supporting the stupas in the cave served to reassure people of the power of the wisdom of the Buddha to tame harmful spirits and then place them in the service of the good.'[9]

[1] Li Yin, *Ancient Chinese Sculptures*, Taibei, 2000, number 5 for a complete example with a date corresponding to 527.

[2] Datong Municipal Institute of Archaeology, 'Excavation of the Tiancun Tomb of the Northern Wei in the Southern Suburbs of Datong, Shanxi', *Wenwu*, volume 5, Beijing, 2010, page 6, plate 3.

[3] Su Bai and Li Zhiguo ed., *Zhongguo meishu quanji; diaosu bian 10; Yungang shiku diaoke*, (The Great Treasury Of Chinese Art; Sculpture, volume 10; the Yungang Caves), Beijing, 1988, number 124 for the north wall of Cave 12 at Yungang.

[4] Katherine R. Tsiang, *Echoes of the Past, The Buddhist Cave Temples of Xiangtangshan*, Chicago, 2010, page 58.

[5] Ann Paludan, *Chinese Sculpture, A Great Tradition*, Chicago, 2006, page 132, figure 82.

[6] The inked characters in the flat cartouches appear to identify some of these creatures. Reading from left to right, the cartouches are inscribed as follows:

a) *bixie* ('chimera')
b) illegible
c) *baihu* ('white tiger')
d) *qianqiu*, inscribed twice ('1000 Years' or possibly the name of a mythical beast)
e) not inscribed
f) *qianqiu* ('1000 Years' or possibly the name of a mythical beast)
g) *qinglong* ('green dragon')
h) *jili* ('auspicious')
i) illegible

[7] Susan Bush, 'Thunder Monsters, Auspicious Animals, and Floral Ornament in Early Sixth-Century China', *Ars Orientalis*, volume 10, 1975, pages 19 - 34.

[8] Bush, op. cit.

[9] Katherine R. Tsiang, *Echoes of the Past, The Buddhist Cave Temples of Xiangtangshan*, Chicago, 2010, page 177 and catalogue number 9 for the example in the Cleveland Museum of Art; 10, 11, 12 and 13 for the examples in the Freer Gallery of Art.

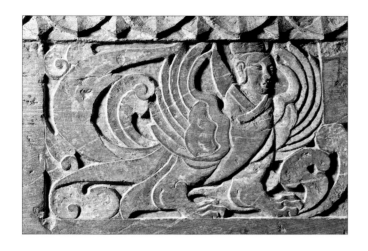

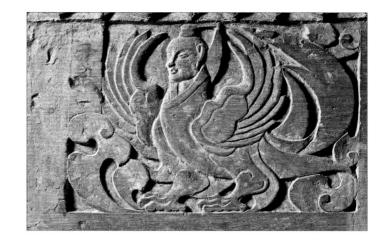

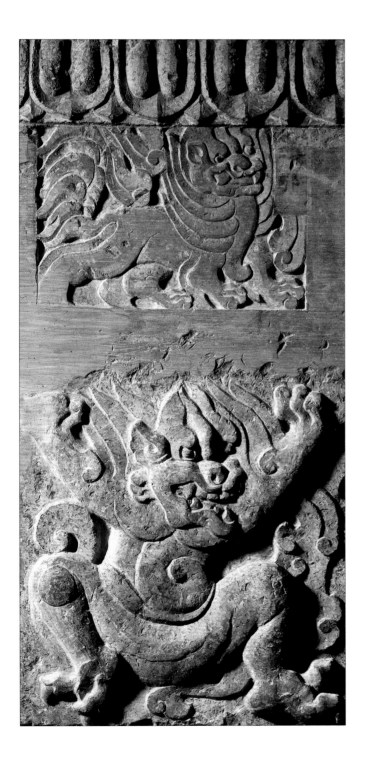

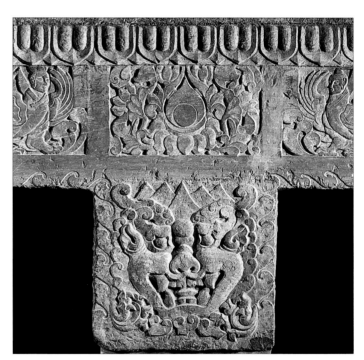

五

白理石观音像　东魏　公元五四一年

高　三二・〇公分

小型雕像碑，汉白玉质，观音立于莲台上，长方基座，叶形背光。观音右手抬起，握住莲蕾，左手向下挽起长袍。面容丰腴，五官清秀，表情和善。发际梳理整洁，聚敛到垂耳前，高冠圈住，冠前饰花，飘带坠于两侧。颈部珠链，长袍交衽胸前，腰间系带，摺纹弯曲，垂落及踝。身侧长帛，叠迭数层，沿身顺下，止于莲台。理石呈乳白，间杂红绿黑色痕。基座背面刻有二十四字铭文。

5
Marble Avalokiteshvara (Guanyin)
Eastern Wei period, inscribed with date corresponding to 541
Height: 32.0cm

Small white micaceous marble stele carved with the figure of Avalokiteshvara Padmapani standing on a lotus-petal base, supported by a rectangular plinth and backed by a leaf-shaped mandorla. The deity holds a lotus bud in his raised right hand and the folds of his robes in his lowered left hand. The heart-shaped face, with small neat features, wears a benign expression. The hair is neatly dressed, tapering to points in front of the pendulous ears and encircled by a high diadem with a half-florette at the front and ribbons descending from the sides. The figure wears a beaded torque around the neck. His robes cross diagonally at the chest, are fastened by a sash at the waist and fall in U-shaped folds down the legs to the ankles. Scarves descend in layers on either side, the ends curving around the lotus base. The marble is of a creamy-white tone with traces of red, green and black pigments. The reverse of the plinth is incised with a twenty-four-character inscription (see overleaf).

Provenance:

Private collection, Bonn (acquired in the late 1940s).

Similar examples:

Yang Boda, 'Quyang Xiude si chutu jinian zaoxiang de yishu fengge yu tezheng', (The artistic style and features of small sculptures unearthed at the Xiude temple in Quyang, Hebei), *Gugong Bowuyuan yuankan*, Beijing, 1960, volume 2, pages 54 and 55, numbers 17, 18, 19 and 20, all dated to the Eastern Wei period (reign of Wuding).

Palace Museum ed., *Compendium of Collections in the Palace Museum, Sculpture 7*, (Buddhist Figures Unearthed at the Site of Xiude Temple in Quyang, Hebei Province), Beijing, 2011, numbers 43 and 77 for two examples also dated to the third year of the Xinghe reign (corresponding to 541); number 82 for an example dated to the second year of the Wuding reign (corresponding to 544); number 84 for an example dated to the fifth year of Wuding (corresponding to 547); and numbers 86 - 88 for three further examples of the Eastern Wei period.

Poly Art Museum, *Selected Works of Sculpture in the Poly Art Museum*, Beijing, 2000, pages 190 - 193, for an example excavated in Dingzhou, Hebei province, with extensive remains of pigments and the reverse painted with a pensive Maitreya, dated to the first year of the Wuding reign (corresponding to 543).

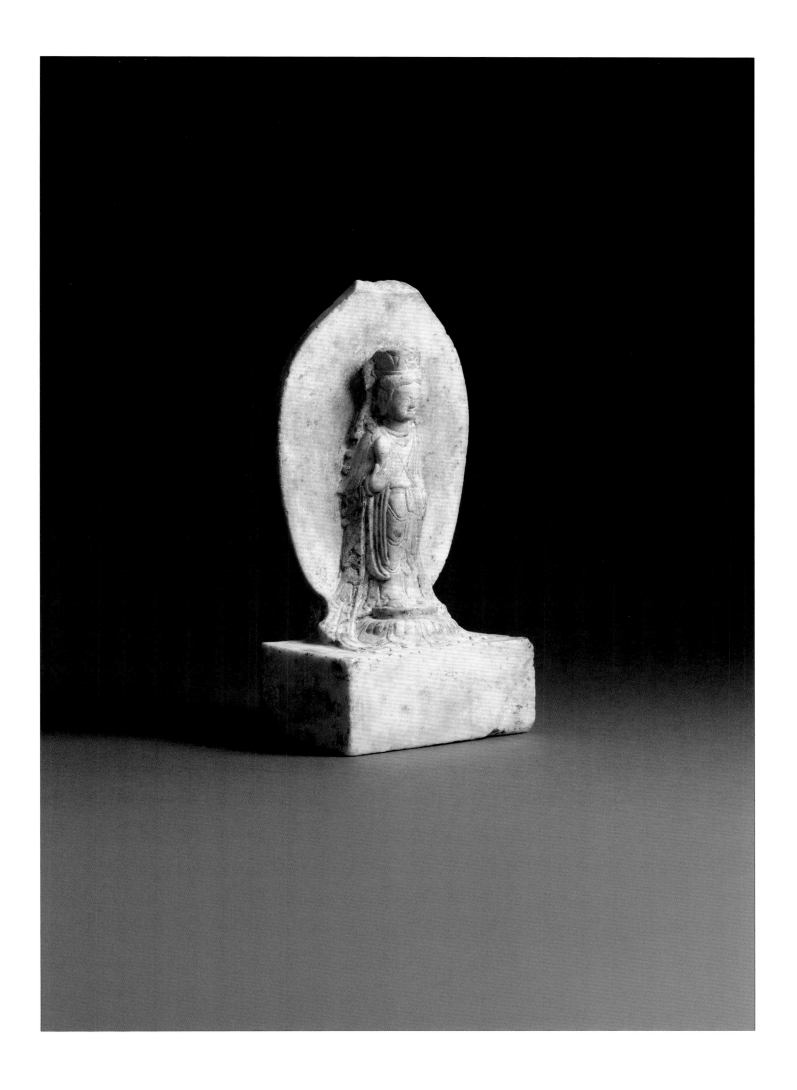

Over 2200 marble figures, mostly of Buddhas and bodhisattvas, dating from the Northern Wei to the Tang period, were unearthed from an excavation at the Xiude Temple, Quyang county, Hebei province, near Dingzhou, in 1953 - 1954;[1] many of these figures are now in the collection of the Palace Museum, Beijing. Most of the figures are of white marble, probably from the Yellow Mountains in Quyang. Amongst the group are a number of single figures of the Bodhisattva Padmapani, 'the lotus-bearing manifestation' of the Bodhisattva Avalokiteshvara or Guanyin, closely resembling the present example and mostly dated to the Eastern Wei period (spanning the reigns of Xinghe, Yuanxiang and Wuding). For the most part little of the painted decoration on the figures remains; a notable exception is one of the figures of Padmapani where red and black details depicting a bodhisattva are discernible on the reverse.[2] The popularity of the subject matter and the continuity of style is evident in the fact that the hoard also contains very similar figures dated to the Northern Qi, Northern Wei[3] and the Sui periods,[4] with only minor stylistic differences.

Subsequently, several hoards of white marble Buddhist sculptures have been discovered around Dingzhou, the largest being at the Northern Qi Yongxiao Monastery at Shanggangzi, containing around one hundred figures.[5]

[1] Yang Boda, 'Quyang Xiude si chutu jinian zaoxiang de yishu fengge yu tezheng', (The artistic style and features of small sculptures unearthed at the Xiude temple in Quyang, Hebei), *Gugong Bowuyuan yuankan*, Beijing, 1960, volume 2, pages 43 - 60.

[2] Palace Museum ed., *Compendium of Collections in the Palace Museum, Sculpture 7*, (Buddhist Figures Unearthed at the Site of Xiude Temple in Quyang, Hebei Province), Beijing, 2011, number 86.

[3] Ibid., numbers 91 and 92.

[4] Ibid., number 114.

[5] Xiaoneng Yang ed., *New Perspectives on China's Past, Chinese Archaeology in the Twentieth Century*, volume 2, New Haven and London, 2004, page 343, number 107.

[6] Jiumen county is near present day Gaocheng city, Hebei province.

The inscription on the reverse of the plinth reads as follows:

兴和三年九月十日九门成（城）东村张加和为息造官（观）音像一区（躯）

which may be translated as:

On the tenth day of the ninth month of the third year of the Xinghe reign (corresponding to 541), Zhang Jiahe of Chengdong village, Jiumen county, commissioned a figure of Guanyin to be made for (his) children.[6]

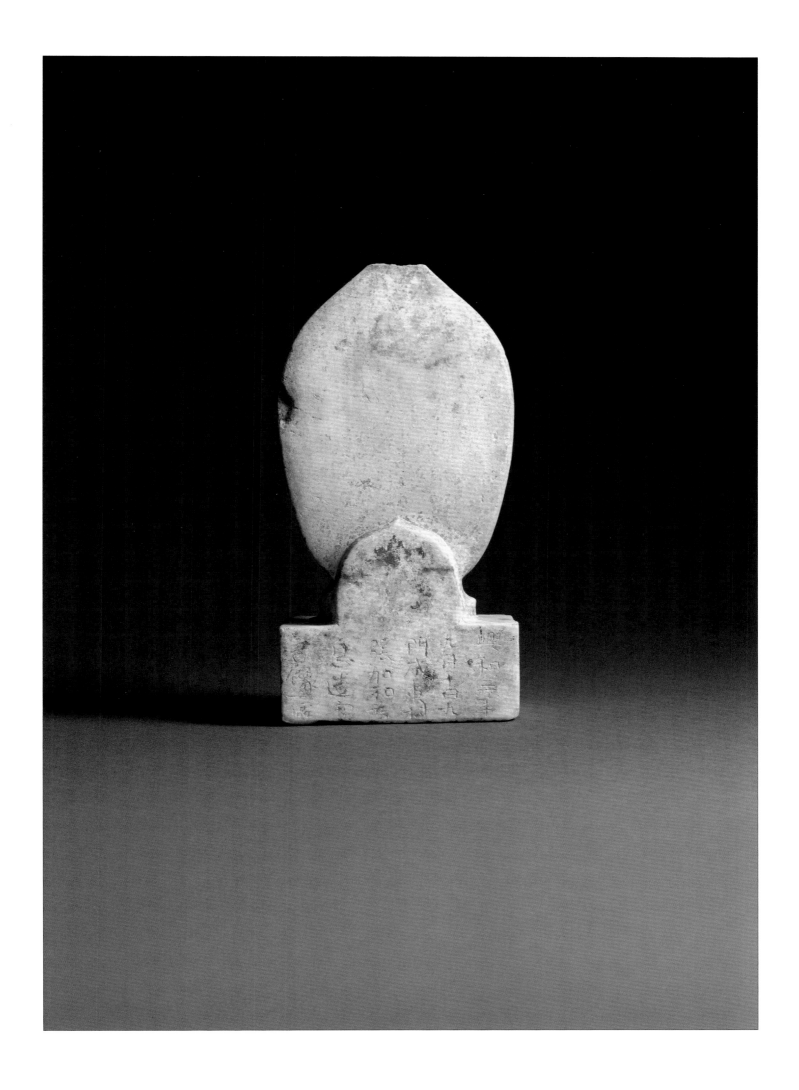

6
Marble Stele
Northern Qi period, inscribed with date corresponding to 553
Height: 69.2cm

White micaceous marble stele in the form of a leaf-shaped mandorla supported on a rectangular plinth, the principal scene carved to show the Buddha of the past, Prabhutaratna and the Buddha of the present, Shakyamuni, side by side. The two figures are seated cross-legged in *virasana* on low stepped thrones in a shallow niche, one with the hands in *dhyana mudra*, the other with hands in *abhaya* and *varada mudra*. Their heads are backed by circular haloes. They both wear monk's robes that cascade over their thrones in folds and pleats, the body of one Buddha entirely clothed, the other with bare torso partly revealed. The niche is composed of two columns supporting an arched canopy decorated with lotus flowers, to either side of which stands a bodhisattva on a lotus pedestal. *Apsaras* wearing floating garments kneel above the bodhisattvas and at the top of the arch sits a small Buddha, flanked on his right by two kneeling acolytes shown in profile and on his left by three kneeling acolytes facing outwards. Four *apsaras* fly above, their legs tucked behind them, their clothes streaming and billowing in the air, each holding a lotus bud, accompanied by two dragons that support a stupa at the apex of the stele. The upper half of the mandorla is carved all around the edge with stemmed, finely scalloped fan-shaped leaves interspersed with lotus buds.

The front of the plinth is carved with an elaborate lotus-form incense-burner supported by two kneeling youthful figures, flanked to each side by a long-tailed lion with ruff-like mane and a standing bodhisattva. Four small figures kneel on a narrow ledge above, holding lotus buds. The proper right short side of the plinth is carved with two figures in shallow niches meditating under a tree with fan-shaped leaves, a similar scene on the proper left short side differing by the addition of a second tree. The surface of the marble has weathered to a creamy-beige colour and bears traces of red pigment. The reverse of the plinth is incised with a six-column inscription (see overleaf).

Provenance:

Hermann Karl August Trick (1894 - 1952), Esslingen, from whom by descent.

Similar examples:

Hans-Joachim Klimkeit et al., *Kunst des Buddhismus entlang der Seidenstrasse*, (Buddhist Art along the Silk Road), exhibition catalogue, Munich, 1992, number 84, for the example in the Museum für Völkerkunde, (State Museum of Ethnology), Munich, where the stele is dated to the end of the sixth century and the height is given as 70cm; also, Gabriele Fahr-Becker ed., *Ostasiatische Kunst*, volume 1, Cologne, 1998, page 105, right, where the stele is dated to around 500 and given a height of c.50cm.

René-Yvon Lefebvre d'Argencé, *Chinese, Korean and Japanese Sculpture in the Avery Brundage Collection*, Japan, 1974, pages 152 - 3, number 69, for a later example dated 595; also, René-Yvon Lefebvre d'Argencé ed., *Asian Art, Museum and University Collections in the San Francisco Bay Area*, Montclair, New Jersey, 1978, number 66; see also Robert L. Brown et al., *Light of Asia, Buddha Sakyamuni in Asian Art*, Los Angeles, 1984, number 141.

六

白理石双佛像碑　北齐　公元五五三年

高　六九·二公分

汉白玉碑，叶片背光型，长方基座，主台双佛并坐，多宝佛示过去，释迦佛示现在。浅层佛龛，矮束腰台，双佛均交腿而坐，一做禅定印，一施无畏与愿印，脑后均有圆形头光。佛着僧衣，皱褶顺畅，覆盖座面，一佛衣衫完整，另一佛则胸微坦露。佛龛双柱，拱门额饰荷花，两侧菩萨立于莲座。菩萨顶部，飞天屈膝，裙带飘逸。拱尖雕小化佛，信徒右两左三，分跪两侧，右侧的面佛，而左侧的面众。飞天四铺，腿绻身后，衣衫轻曼，缨姿绰约，各持莲蕾，碑顶双龙托塔。背光上沿雕饰扇形叶，并间插以莲蕾纹。

基座前精雕莲花香炉，底部两者跪撑，各侧均有长尾环鬃狮子与立姿菩萨相守。其上有四跪者，皆手持莲蕾。座右面刻划二人，背依定印，一施无畏与愿印，一侧菩萨立于莲座。

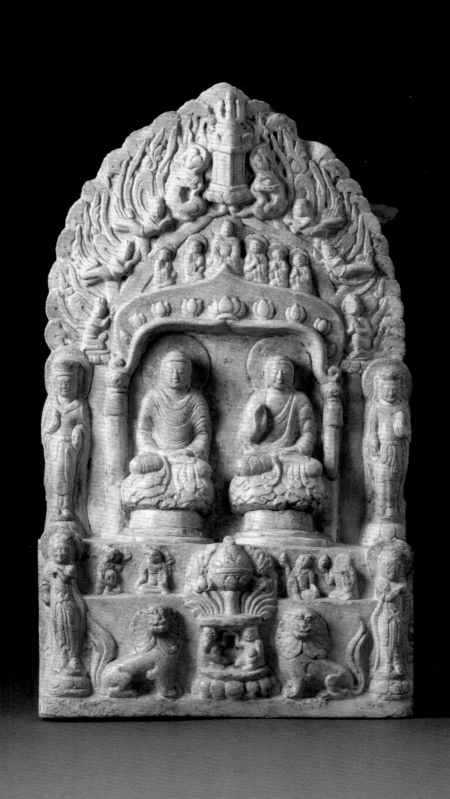

浅龛，树下沉思冥想，座左面图案相同，但多一树。经年累月，碑表成米黄乳色，并有少量红色痕迹。石座背面刻有六行铭文。

The representation on the present stele of the miraculous meeting of the two Buddhas, the Buddha of the past, Prabhutaratna and the Buddha of the present, Shakyamuni, is a key episode in the *Lotus Sutra* (*Saddharmapundarika sutra*, or *Sutra of the Lotus of the True Dharma*), a text which became increasingly popular during the Northern Qi period and, indeed, this scene may have come to symbolize the *Lotus Sutra* itself in Chinese Buddhist art of this period. The stele depicts a moment during a sermon by the historical Buddha Shakyamuni when a stupa miraculously appears in the sky. Shakyamuni then explains to the congregation that the stupa (carved on the apex of the present stele) contains the relics of the Buddha Prabhutaratna, who had taken a vow to appear whenever the *Lotus Sutra* was preached. According to the text, Shakyamuni used his finger as a key, unlocking the door to the stupa, to reveal Prabhutaratna. The two Buddhas then seated themselves side by side in the stupa.

The *Lotus Sutra* was one of the most influential texts of Mahayana Buddhism. A version translated into Chinese may have existed as early as the mid-third century but the most important version dates from 406, from the workshop of Kumarajiva, an Indian missionary, who dedicated his life to the translation of Buddhist texts into Chinese. A later version was made by Jnanagupta (523 - 600) and Dharmagupta (d. 619).[1] The description of the stupa appearing in the sky is a key episode in the *Lotus Sutra* and the elaborate description is in keeping with the miraculous nature of the event:

> the Stûpa, a meteoric phenomenon, stood in the sky sparkling,
> beautiful, nicely decorated with five thousand successive terraces
> of flowers, adorned with many thousands of arches, embellished
> by thousands of banners and triumphal streamers, hung with
> thousands of jewel-garlands and with hour-plates and bells, and
> emitting the scent of Xanthochymus and sandal.[2]

The image of the twin Buddha figures corresponds with the concept of numerous Buddhas existing at the same time in different periods and space. According to Davidson:

> The seating of the two Buddhas on the same platform symbolizes
> their mystical identity, a concept which reinforces the statements
> of Sakyamuni that he is eternal and manifests himself in many
> different forms.[3]

It is probable that the figure on the proper left of the present stele with his hands in *abhaya* (have no fear) and *varada mudra* is intended to be Shakyamuni, as this hand gesture is most commonly used to indicate his preaching of the *Lotus Sutra*. The image of the two Buddhas seated side by side is, in the late fifth/sixth century, also depicted in a number of Buddhist cave temples of the period, such as at Dunhuang[4] where, in fact, manuscripts of the *Lotus Sutra* were preserved.

[1] J. Leroy Davidson, *The Lotus Sutra in Chinese Art, A Study in Buddhist Art to the Year 1000*, New Haven, 1954, page 2.

[2] Ibid., page 5.

[3] Ibid., page 15.

[4] Basil Gray, *Buddhist Cave Paintings at Tun-Huang*, Chicago, 1959, plate 2, for a niche with seated figures in the late fifth/early sixth century Cave 259 at Dunhuang.

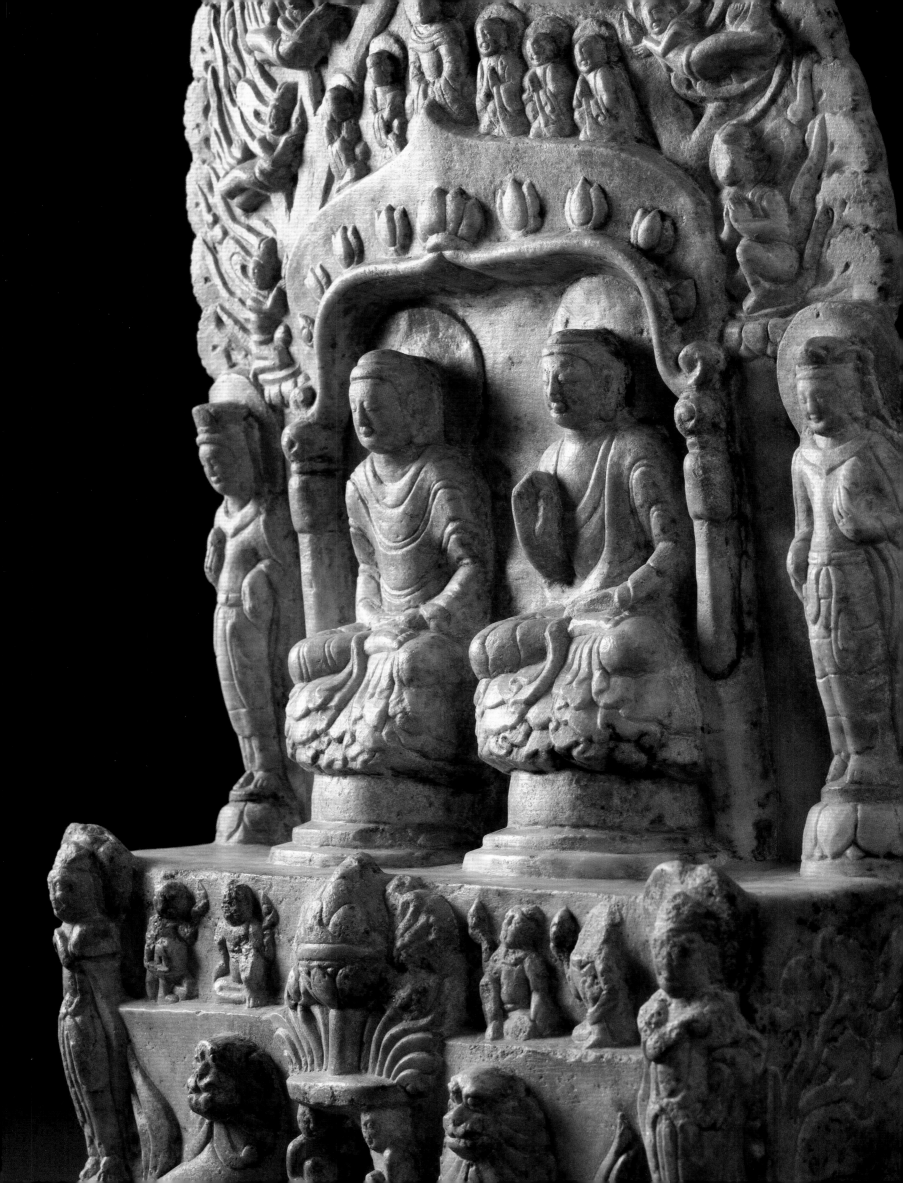

The inscription on the reverse of the plinth reads as follows:

天保四年四月八日郎山寺比丘法昙敬造多宝玉像一区仰为国主郎
僧父母内外眷属并及亡生刘长姊阿婴夫妻眷属等

which may be translated as:

In the fourth year of Tianbao, on the eighth day of the fourth month (corresponding to 553), a monk of the Langshan Temple, Fa Tan, respectfully commissioned a precious (jade) marble image, to offer to the Emperor, his parents, all his relatives, also to the deceased couple Liu Changzi and Arying, as well as their relatives.

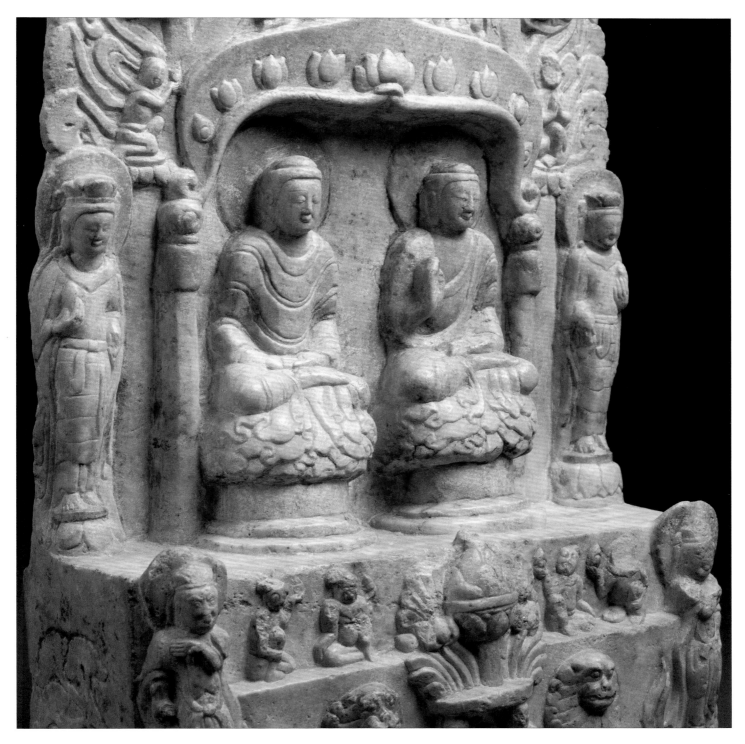

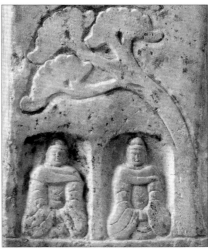

7
Limestone Buddha
Northern Qi period, 550 - 577
Height: 82.8cm

Dark grey mottled limestone figure of Buddha standing on a circular base tapering to a conical post, the missing right hand once raised in *abhaya mudra,* the left hand in *varada mudra*. The Buddha has a rounded face with arched brows over eyes half-closed in meditation, a straight nose, a small bud-like mouth and elongated ear-lobes. The hair is arranged in tight spiral curls over a conical *ushnisha*. The deity wears a long-sleeved robe which clings to the body, the folds indicated by U-shaped incised lines and the undergarment falling to the ankles, revealing the fleshy feet. The back of the body is plain. The grey limestone has extensive inclusions and bears traces of red, black and green pigments.

Provenance:

Norman Fox (born 1888), Wareham, U.K.

Private collection, U.K.

Similar examples:

Wang Huaqing et al. eds., *Qingzhou Longxingsi fojiao zaoxiang yishu*, (The Art of the Buddhist Statuary at Longxing Temple in Qingzhou), Ji'nan, 1999, number 82 for a figure lacking its head and number 119 for a similar head.

Poly Art Museum, *Selected Works of Sculpture in the Poly Art Museum*, Beijing, 2000, pages 96 - 99.

七

石灰岩立佛像　北齐　公元五五○年—五七七年

通高　八二‧八公分

深色石灰岩佛像，立于圆锥座上，右手残缺，原应无畏印，左手施与愿印。佛面圆满，弯眉眯眼，呈思维状，鼻梁直挺，嘴形精致，耳朵长垂。头发螺卷式，聚成上锥形肉髻。佛身着长袖僧衣，贴身合体，褶皱弯曲，刻纹清晰，内袍顺体垂落，止于踝部，肥脚外露。佛像背部素纹。岩料杂质繁多，并有红黑绿色痕。

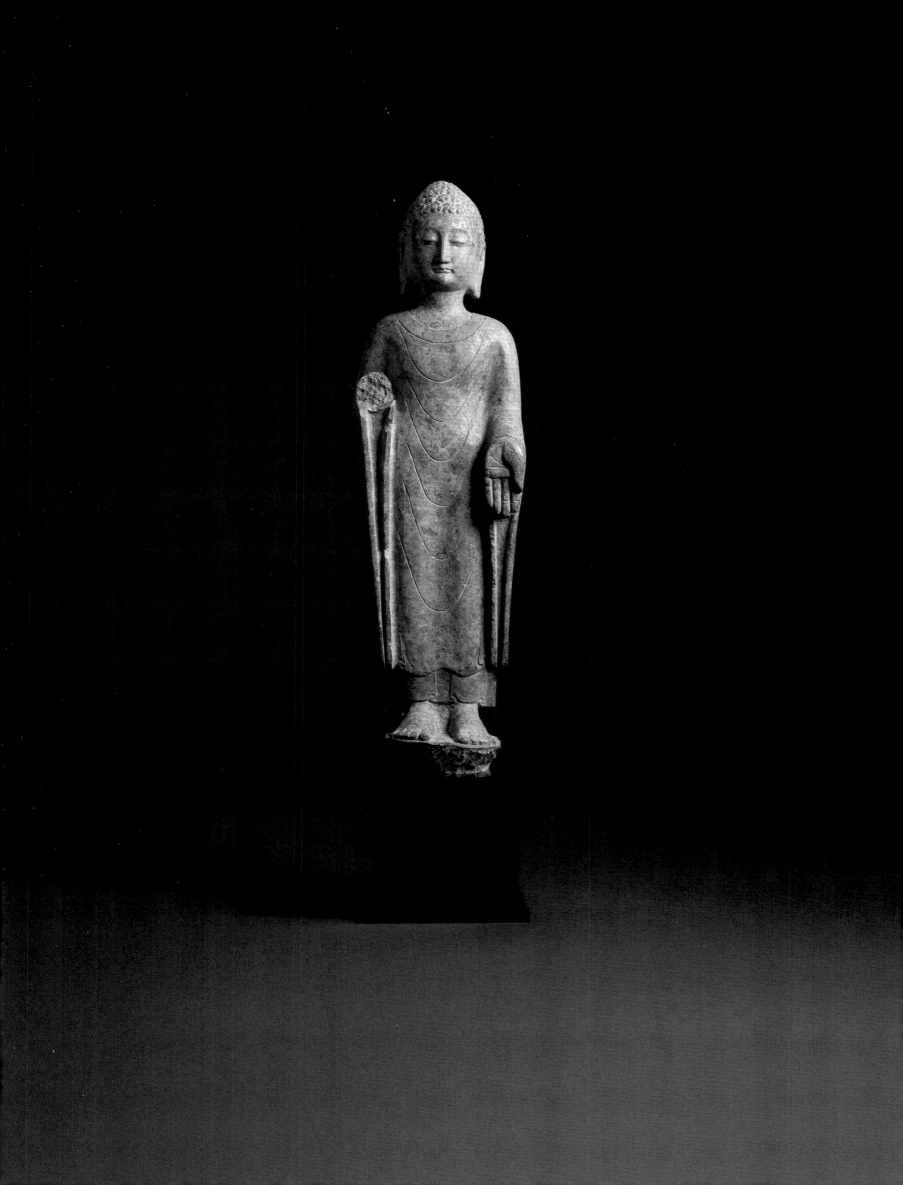

Although this figure distinctly resembles sculptures discovered in the Qingzhou region of Shandong province dated to the Northern Qi period, the mottled stone of which it is carved is not typical of the finds either at the Longxing Temple or the Longhua Temple at Boxing. It is therefore not possible to pinpoint the exact province where this figure was made. In any event, it is likely that the style now so closely associated with Qingzhou extended beyond the borders of Shandong.

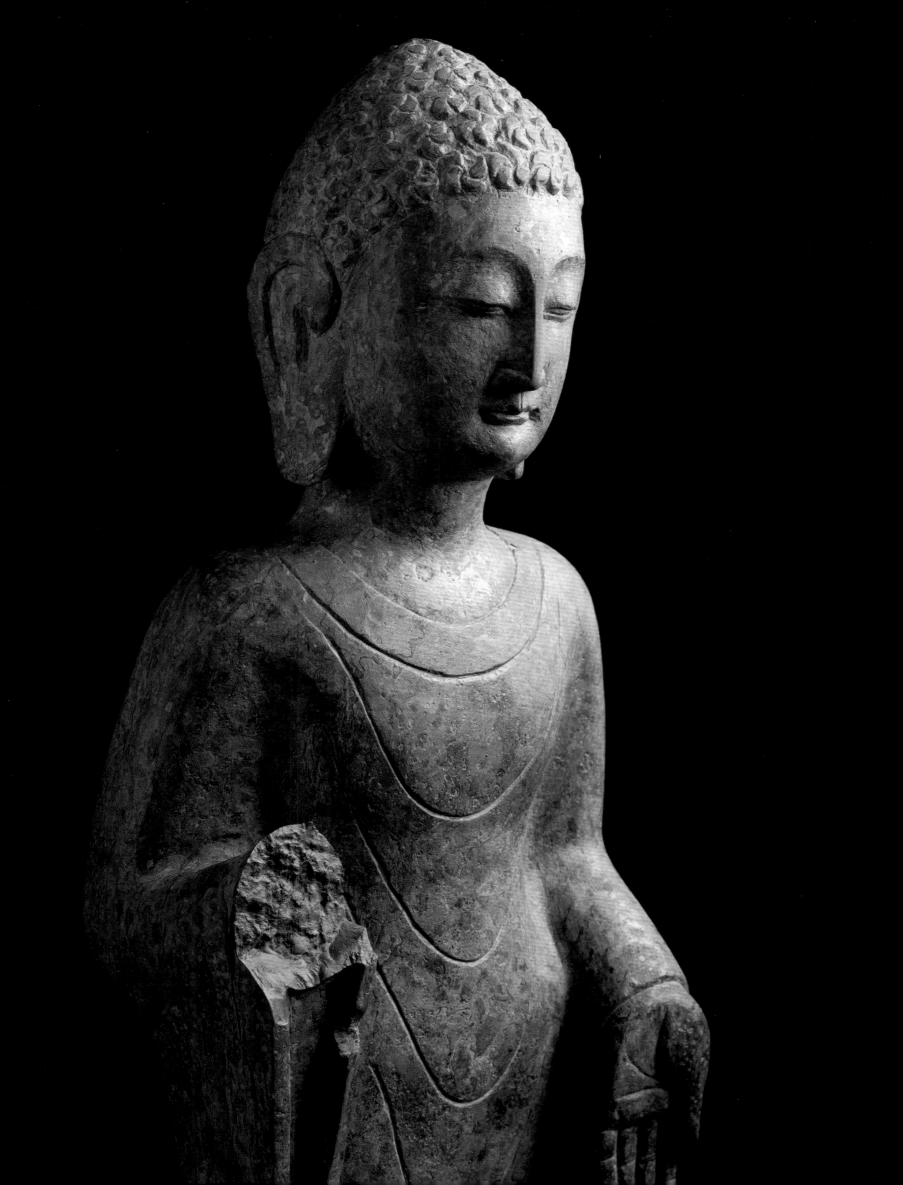

8
Limestone Buddha
Eastern Wei or Northern Qi period, mid 6th century
Height: 49.5cm

Limestone figure of Buddha, probably originally carved into the wall of a cave and backed by a halo, the remaining fragments of which are attached to the back of the head. The deity is seated in *virasana* on a dais or throne, his right hand resting in his lap in a variant of *varada mudra*, the left hand now missing but probably once raised in *abhaya mudra*. The Buddha has a rounded face with downcast eyes, slightly smiling lips and the long ears denoting his princely heritage. His hair is arranged in tight curls and covers the cranial bump or *ushnisha*. He wears monk's robes, open at the chest, that fall in heavy folds over his arms and crossed legs – leaving the left foot bare – to hang in cascading pleats over the front of the dais. The surface of the stone bears considerable traces of red and white pigments.

Provenance:

Private collection, Mechelen, Belgium.

Similar examples:

Wang Huaqing et al. eds., *Qingzhou Longxingsi fojiao zaoxiang yishu*, (The Art of the Buddhist Statuary at Longxing Temple in Qingzhou), Ji'nan, 1999, numbers 91 and 92 for two larger Buddhas seated in *virasana* on lotus bases.

八　石灰岩坐佛像　东魏或北齐　公元六世纪中期

高　四九・五公分

石灰岩佛像，原本是雕刻在石窟壁上，从脑后遗留残迹推测，应有头光衬映。佛陀交腿而坐，或于台座上，右手置膝部，施与愿印，左手残缺，应为无畏印。佛面圆满，双目低垂，唇露微笑，长耳通灵。螺纹发髻，遍布肉髻。身穿开胸僧衣，摺纹厚重，弯曲下垂，顺肩过腿，衣皱流畅，覆盖座前，但左脚外露。石料表面保留大量红白色。

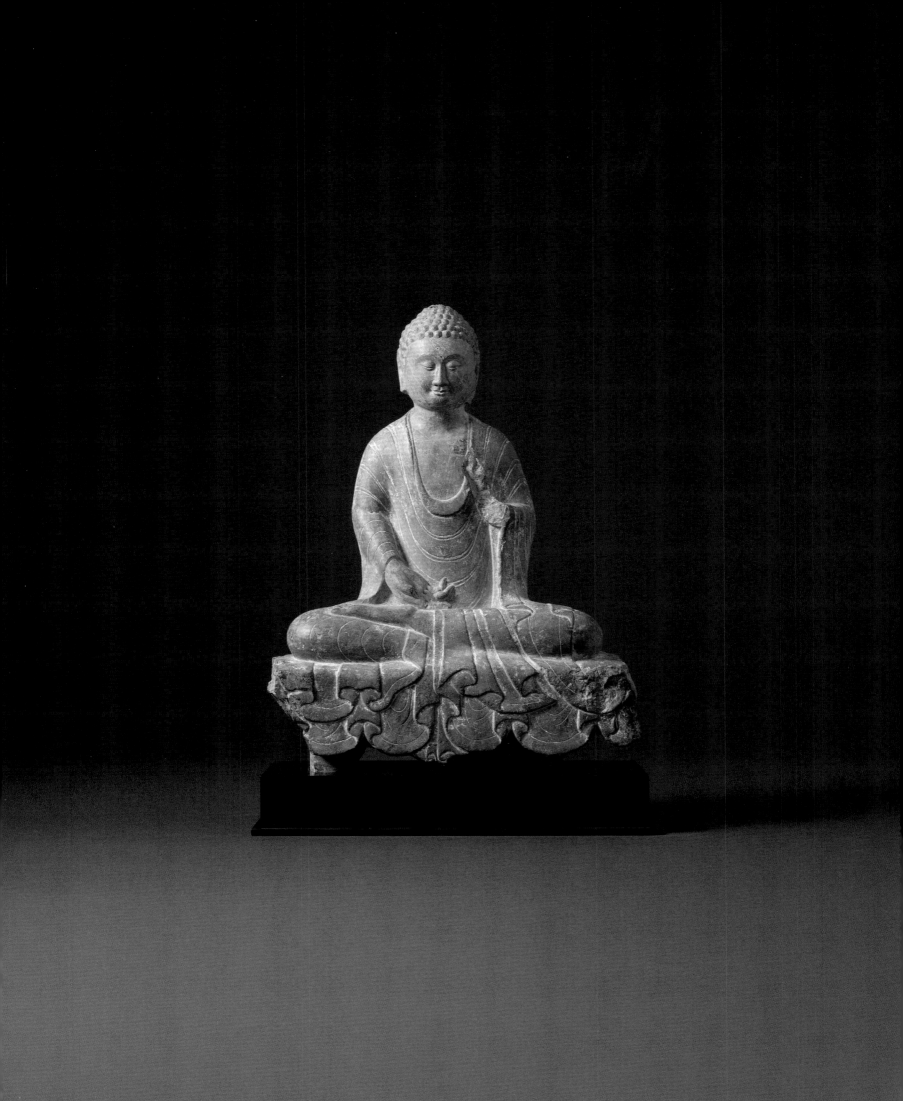

Although intended for frontal viewing and almost certainly carved into the wall of a cave temple, the three-dimensional treatment of the limbs and face are perhaps indicative of the movement towards the production of free-standing Buddhist sculptures for temples and shrines as the sixth century progressed.

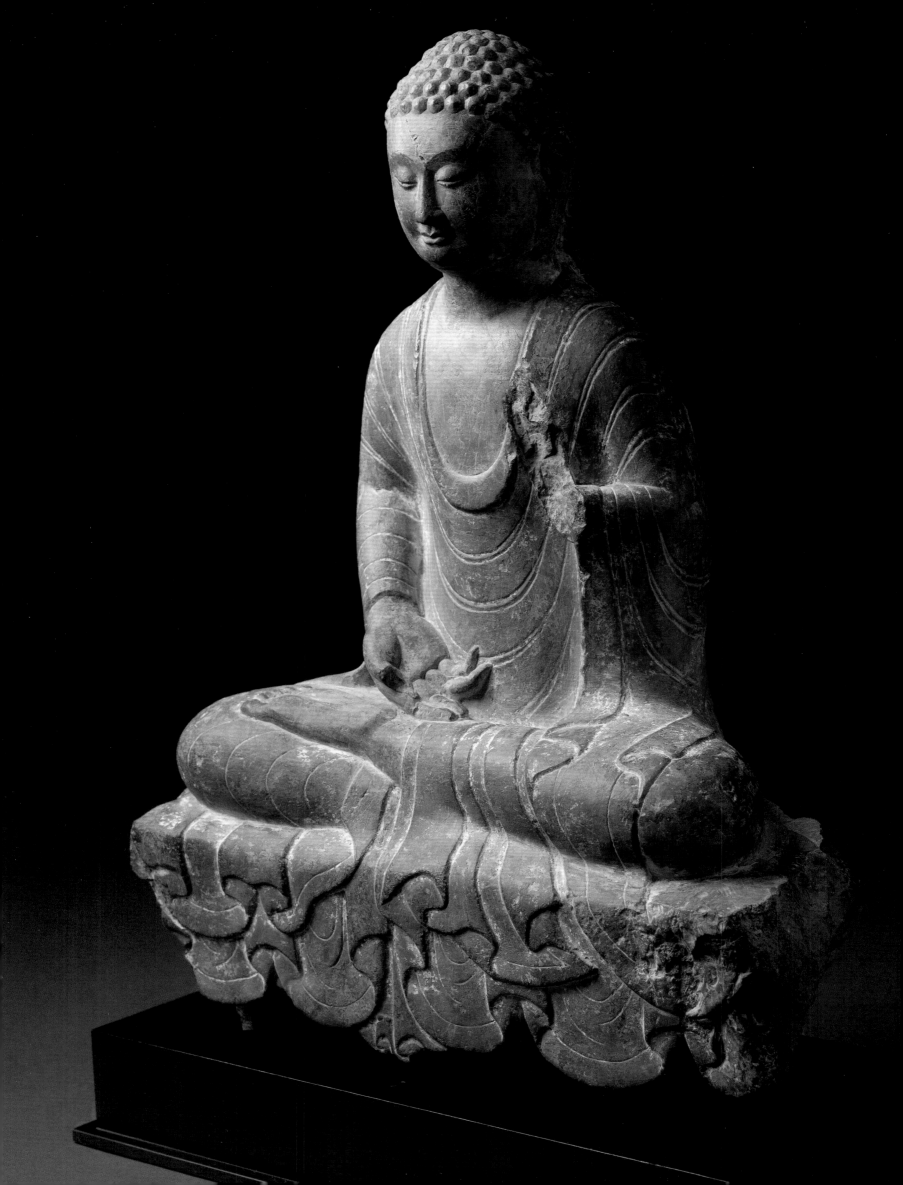

9
Limestone Standing Buddha

Northern Qi period, 550 - 577

Height: 98.0cm

Limestone fragmentary figure of a standing Buddha of life-size proportions. The slender figure is carved fully in the round and stands with right knee slightly forward, with an almost imperceptible sway to the hips. The missing right arm was probably originally raised in *abhaya mudra* and the left lowered in *varada mudra*. The clinging robe leaves the chest bare and falls in regular, shallow pleats and folds, both front and back, to model the form of the body. The surface of the stone bears some areas of encrustation.

Provenance:

Chris Frape, Hong Kong.

Exhibited:

Asian Civilisations Museum, Singapore, on loan 1996 - 1999.

Similar examples:

Wang Huaqing et al. eds., *Qingzhou Longxingsi fojiao zaoxiang yishu*, (The Art of the Buddhist Statuary at Longxing Temple in Qingzhou), Ji'nan, 1999, plates 56 and 80.

九

石灰岩立佛像　北齐　公元五五〇年—五七七年

高　九八·〇公分

石灰岩残像，真人大小。立姿圆雕，体型修长，右膝前趋，臀部微移。右臂损失，原件手应为无畏印，左手应为与愿印。紧身僧袍，胸部袒露，前后衣摺浅显，垂纹整齐，勾勒出身体形状。石料表面有些许结壳处。

The sensuous quality so evident in the present sculpture, despite the missing head and limbs, is characteristic of many stone carvings datable to the Northern Qi period and is in marked contrast to the more hieratic appearance of much Buddhist statuary of the Northern and Eastern Wei periods (386 - 549). In an introductory essay to the catalogue for the *Return of the Buddha* exhibition held at the Royal Academy of Arts in London in 2002, Su Bai writes:

> The most striking differences between the sculpture of the Northern Qi dynasty and that of the Northern and Eastern Wei dynasties occur in the garments depicted and in the treatment of the body. In the first half of the sixth century the Buddha wears a monk's robe with a sash, and a mantle of thick material. In the second half of the century this typically Chinese attire, inspired by the robes of Confucian officials, is replaced by a close-fitting monk's garment of thin, light material, clearly influenced by Indian dress...The bodies of the figures in Chinese dress are static and restrained in treatment. In contrast, the figures of the Northern Qi dynasty emphasise the three-dimensional fullness of the body and sometimes appear with a slight indication of movement.[1]

Su Bai suggests that the thinly-clad body forms of the Northern Qi sculptures derive from '...Mathurā and Sārnāth in northern India, the two great centres of Buddhist art during the Gupta period in the fourth and fifth centuries.' Unlike the Tuoba Xianbei rulers of the Northern Wei, who identified strongly with Han Chinese customs and culture and 'enthusiastically adopted a policy of sinicisation ... the Northern Qi rulers, originally members of a non-indigenous, nomadic people belonging to the Xianbei culture, admired all things foreign and are said to have treated even humble Indian monks with deference.'

[1] Su Bai, 'Sculpture of the Northern Qi Dynasty and its Stylistic Models', in Lukas Nickel ed., *Return of the Buddha: The Qingzhou Discoveries*, London, 2002, pages 54 - 59.

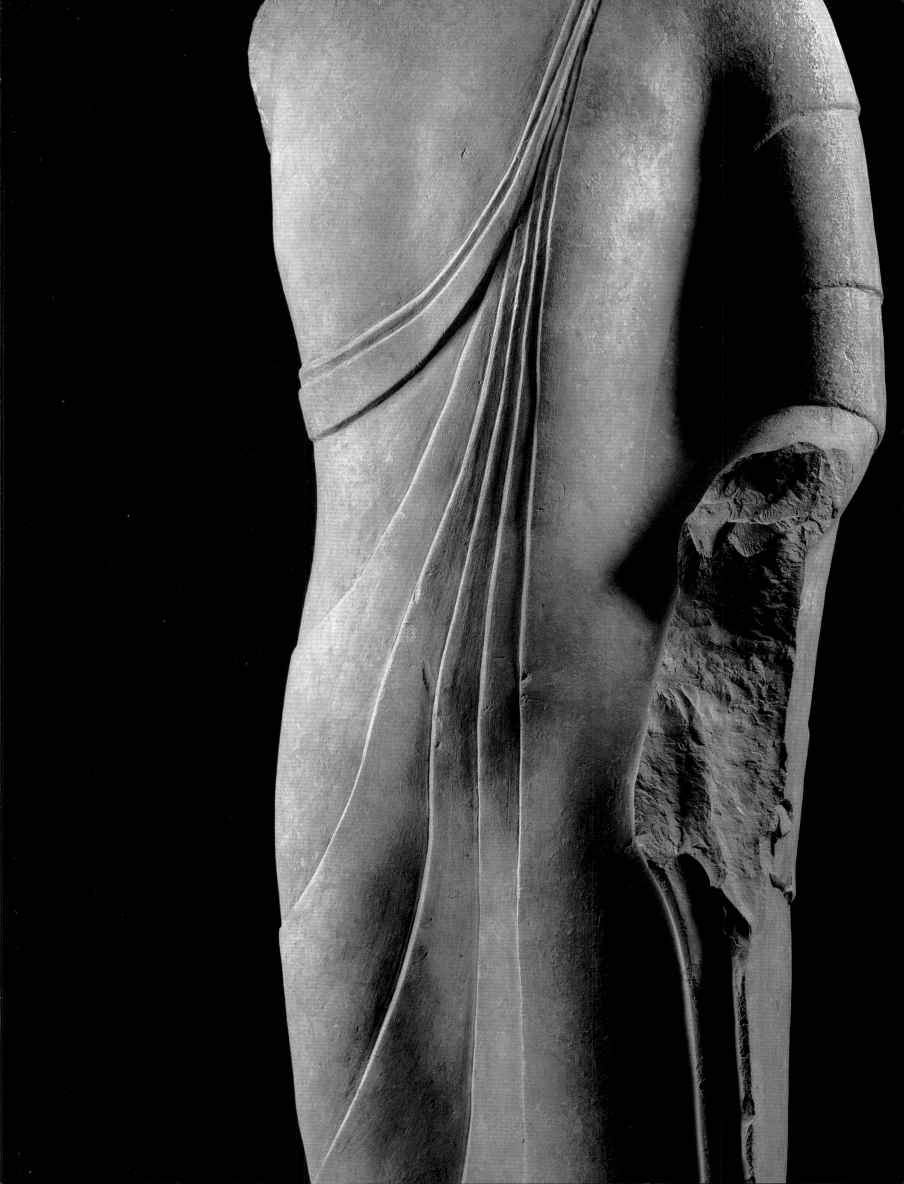

Pair of Gilt Bronze Figures of Buddha
Sui period, inscribed with date corresponding to 589
Height: 24.9cm and 25.0cm

Pair of gilt bronze figures of Buddha, each standing upon a circular base, supported on a square pedestal with four splayed legs, with right hand raised in *abhaya mudra* and left hand lowered, grasping the folds of the robes. Each deity has an elongated face with neat features and a high *ushnisha* and wears monk's robes, falling in vertical folds to the ankles, over which is draped a cape over the shoulders, crossing diagonally at the front. Each figure is backed by a leaf-shaped mandorla with pointed apex, incised with a petal-form halo encircling the head and vertical lines surrounding the body, all bordered by flaming tendrils. The reverse of the mandorla is undecorated. In each case, the pedestal is incised on two sides with a twenty-five-character inscription (see overleaf).

Provenance:

Kochukyo Co. Ltd., Tokyo.

Yamada Takeji, Ashiya city, Japan (acquired from the above in 1945).

Similar examples:

University of Michigan, The Museum of Art, *Chinese Buddhist Bronzes*, Ann Arbor, 1950, number 41, figure 11a, for an identical figure, also dated 589.

René-Yvon Lefebvre d'Argencé, *Chinese, Korean and Japanese Sculpture in the Avery Brundage Collection*, Japan, 1974, pages 148 - 9, number 66 for an identical figure in the Asian Art Museum of San Francisco, also dated to 589 and also dedicated by Wang Yuanchang.

Yamato Bunkakan Museum, *Tokubetsu-ten; Chugoku no kindo butsu*, (Special Exhibition; Chinese Gilt Bronze Statues of Buddhism From Japanese Collections), Nara, 1992, number 54 for an identical figure, also dated to 589, with a very similar inscription, dedicated by Wang Yuangchang, in the Kosanji Temple Museum, Hiroshima prefecture; also, Seiko Murata, *Shokondoubutsu no miryoku chugoku chosenhantou nihon*, (The Attraction of Small Gilt Bronze Buddhist Statues, China, North and South Korea, Japan), Tokyo, 2004, page 56, number 68.

一〇

鎏金铜佛像一对　隋　公元五八九年

高　二四·九公分和二五·〇公分

一对铜质鎏金佛，均立于圆形台上，下有方形底座支撑，四腿外撇。佛右手抬起，施无畏印，左手低垂握袍。佛均长脸，五官清晰，肉髻高耸，身着僧衣，垂纹竖直，止于脚踝，披肩覆盖，顺肩向下，胸前交叉。每尊佛都衬以叶形背光，光顶尖锐。脑后刻瓣形头光，并有竖纹环绕身体。背光边缘均饰火苗纹，背后素纹。两像亦同，各有二十五字铭文刻于底座两侧。

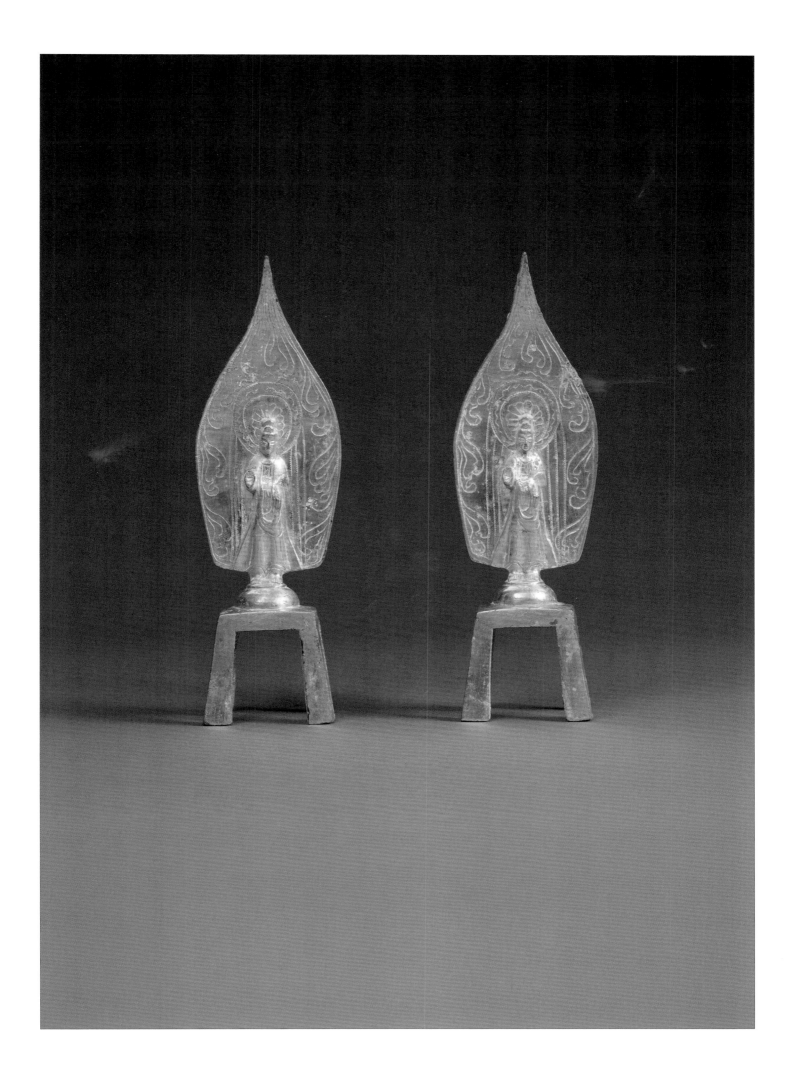

The three similar examples cited are virtually identical in appearance and size to the present pair. The three examples are also dated to the ninth year of the Kaihuang reign, corresponding to 589, although there appears to be some variation in the month and date of the dedication. Two of the three examples are known to have been commissioned by Wang Yuanchang, the inscription of the third not being published.

Such votive gilt bronze figures appear to have been commissioned by devout Buddhists in order to gain merit for themselves and their ancestors. It is unusual to find a group of five identical images with nearly the same inscriptions and they may have been commissioned as a set by a very wealthy donor.[1]

[1] Another wealthy donor, this time an emperor of the Tang period, was responsible for ordering a set of seven gilt bronze figures of Avalokiteshvara, one of which is catalogued in the present exhibition as number 11.

The identical inscription on each pedestal reads as follows:

开皇九年十一月十日佛弟子王元长
为祖父母造像一区立愿

which may be translated as follows:

In the ninth year of the Kaihuang reign, on the tenth day of the eleventh month, (corresponding to 589) the Buddhist disciple Wang Yuanchang commissioned a statue on behalf of his paternal grandparents, may they receive these prayers.

Inscription on gilt bronze figure, see page 71 (top).

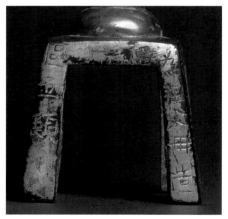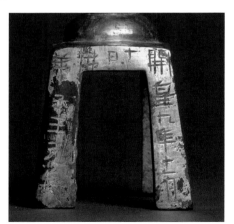

Inscription on gilt bronze figure, see page 71 (bottom).

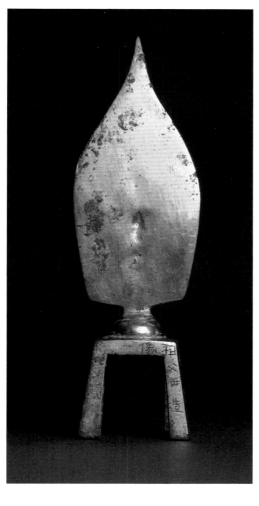
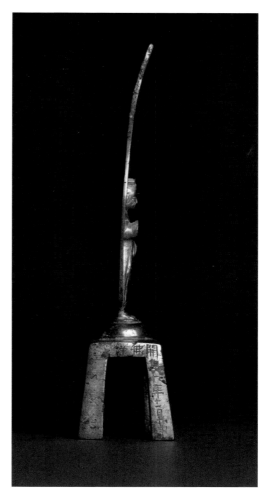
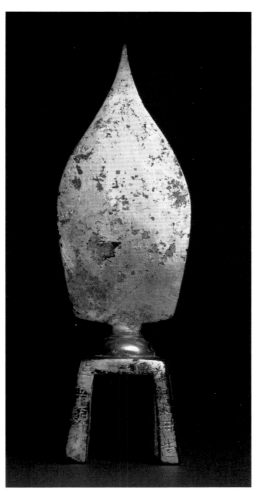
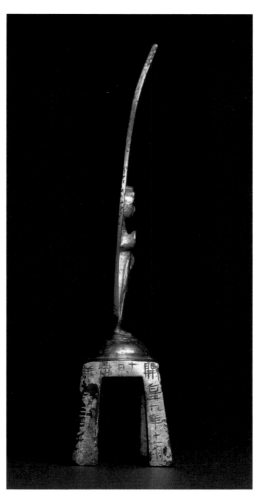

11
Gilt Bronze Avalokiteshvara (Guanyin)
Tang period, inscribed with date corresponding to 651
Height: 30.8cm

Gilt bronze figure of Avalokiteshvara (Guanyin) cast standing in typical slightly swaying posture (*tribhanga*), the right hand raised in a variant of *vitarka mudra*, the left hand by the side holding an ambrosia flask. The figure stands on a lotus base, itself supported by a four-legged pedestal with openings in the form of lotus petals between the slightly splayed legs. Avalokiteshvara is attired as an Indian prince – clinging robes that leave the upper body and arms mostly bare, long looping necklaces and draped scarves; the hair is piled high, set with diadems and bound into tresses that fall over the shoulders. The head is backed by a leaf-shaped mandorla engraved with a nimbus of radiating lotus petals contained within a toothed circle, all surrounded by flames. The reverse of the mandorla is incised with a fifty-two character inscription, still legible but obscured in a few places by patches of encrustation that have broken through the rich gilding (see overleaf).

Provenance:

L. Rosenberg.

Adolphe Stoclet, Brussels (acquired from the above, 23 January 1911).

Madame Féron-Stoclet, Brussels.

Jane and Leopold Swergold, U.S.A.

Exhibited:

Paris, 1913, Musée Cernuschi.

London, 1935 - 36, Royal Academy of Arts.

New York, 2003, Eskenazi Ltd at PaceWildenstein.

Published:

H. d'Ardenne de Tizac, *L'Art Bouddhique au Musée Cernuschi*, Paris, 1913, number 485.

E. Fuhrmann, *China, Erster Teil: Das Land der Mitte*, volume I, Hagen, 1921, plate 109, right hand image.

International Exhibition of Chinese Art, London, 1935 - 36, number 807.

Georges A. Salles and Daisy Lion-Goldschmidt, *Collection Adolphe Stoclet*, Brussels, 1956, pages 394 - 396.

Eskenazi Ltd., *Chinese works of art from the Stoclet collection*, exhibition at PaceWildenstein New York, London, 2003, catalogue number 13.

Giuseppe Eskenazi with Haijni Elias, *A Dealer's Hand, The Chinese Art World through the Eyes of Giuseppe Eskenazi*, London, 2012, page 209, plate 87.

Leopold Swergold, *Thoughts on Chinese Buddhist Gilt Bronzes,* New Hampshire, 2014, number 25.

Dorothy C. Wong, 'The Plethora of Guanyin Images in the Seventh and Eighth Centuries' in Shi Shouqian and Yan Yuanying eds., *Transformation in Chinese Visual Culture - with a Focus on Changes that Occurred during the Wei-Chin and T'ang-Sung Periods*, Taibei, 2014, pages 203 - 232, figure 1.

一一

鎏金铜观音像　唐　公元六五一年

高　三〇・八公分

观音立姿，呈典型的三段屈曲式，右手施以说法印，左手握净瓶。足踏莲台，下接四腿高座，腿间券口。观音身穿紧身裙袍，袒胸露臂，饰以项圈及垂缯。发束高髻，花冠饰之，垂辫至肩。叶片形头光，内刻莲花图案，外绕火焰纹。头光背后刻有五十二字铭文，除几处锈蚀外大都清晰可辨。

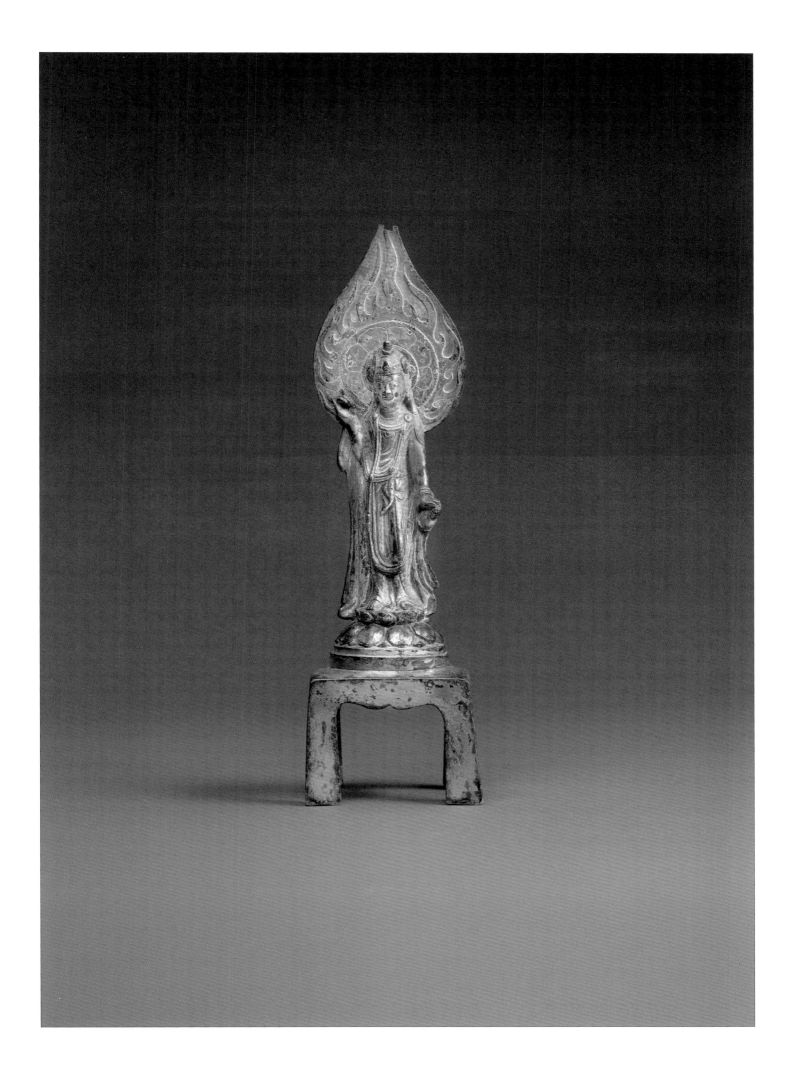

Similar examples:

Laurence P. Roberts, *The Bernard Berenson Collection of Oriental Art at Villa I Tatti*, New York, 1991, pages 66 - 67, number 16 for a very similar figure, with the same inscription.

Hamada Kosaku, *Senoku seisho*, (The Collection of Old Bronzes of Baron Sumitomo, Bronze Vases 3), Kyoto, 1918, plate 170 for another closely related figure.

Both the similar examples cited above are extremely close to the present example exhibited here, differing only in minor details. All the figures vary slightly in the arrangement of the right hand. The present figure has the hand in a form of *vitarka mudra* - with the thumb, and the middle and ring fingers touching – while the Sumitomo figure has the right hand in a variant, with the index and middle fingers extended and the thumb and ring finger inclined towards each other. On the Berenson figure, the arm is turned the other way with the palm facing inwards. The details of the mandorla on all three figures also differ very slightly. All three figures are raised on high-legged stands but on the present and Berenson examples the openings are of bracket-form.

The inscription on the Berenson example seems to be very close, if not identical, to the present inscription, both in content and style. The Sumitomo figure has a different and apparently spurious inscription.[1]

[1] Hamada Kosaku, *Senoku seisho*, (The Collection of Old Bronzes of Baron Sumitomo, Bronze Vases 3), text volume, Kyoto, 1918.

The inscription on the reverse of the mandorla reads as follows:

永徽二年有疫不雨七十余日留祯酷苦上筑壇祈祷七日夜疫弭雨大至下民攸喜上使僧法纯造金铜像七躯天下平安祥祯无极

which may be translated as:

In the second year of the Yonghui reign (corresponding to 651), a plague spread and no rain fell for more than seventy days. The people and the crops suffered severely. The Emperor [ordered] an altar to be built and prayers to be said. After seven days and nights, the plague stopped and rain fell abundantly. The people were delighted. The Emperor asked a monk, Fachun, to make seven gilt bronze Buddhist figures to wish his kingdom peace and happiness forever.

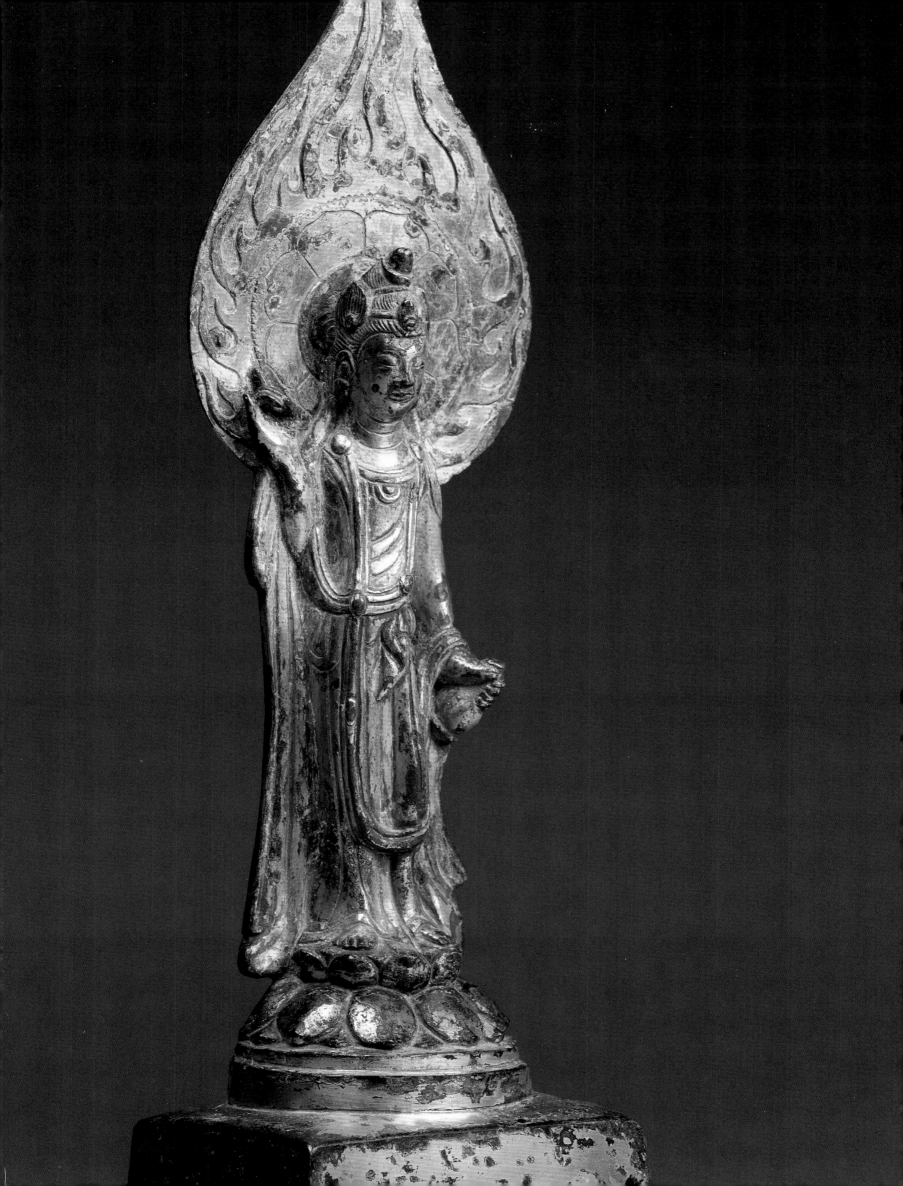

Gilt Copper Plaque
Tang period, 618 - 907
Height: 11.9cm
Width: 10.9cm

Gilt copper repoussé rectangular votive plaque. The central figure of Buddha is seated cross-legged in *virasana* on a lotus dais, the right hand raised in *abhaya mudra*, the left held against his stomach. He wears clinging monk's robes that leave his right shoulder and chest bare. His head, with prominent *ushnisha*, is backed by a leaf-shaped halo engraved with lotus petals and a flame design. To either side, each on a linked lotus dais, sits a bodhisattva cross-legged in *virasana* holding up a flaming pearl (*chintamani*) in one hand, dressed in flowing scarves, *dhoti* and jewellery, their crowned heads backed by circular haloes. Flanking the Buddha, attendants stand wearing monk's robes, the one to his right with hands clasped in *anjali mudra*, the one to his left with hands hidden in long sleeves. Above, two *apsaras* fly over clouds, their draperies streaming behind them. Each corner of the plaque has a hole punched through for attachment.

Provenance:

Private collection, U.S.A.

Published:

Christie's, New York, *Fine Chinese Ceramics and Works of Art*, 30 March 2005, number 237.

Similar examples:

Hugo Munsterberg, *Chinese Buddhist Bronzes*, Tokyo, 1967, plate 120 for the larger example in the Harvard Art Museums.

S. Matsubara, *A History of Chinese Buddhist Sculpture*, volume 2, Tokyo, 1995, for four votive plaques dated to the Sui period, all larger and now in Japan: numbers 547a (Hakutsuru Fine Art Museum) and 547b (private collection), and 548a (MOA Museum of Art) and 548b (Eisei-bunko Museum); and volume 3, Tokyo, 1995, number 713, for another larger plaque dated to the Tang period, in the Nezu collection, Tokyo.

This plaque, and the others like it, may have formed part of portable shrines, of which the other constituent elements were made of a perishable material such as wood. An interesting comparison can be made to a much later Korean gilt bronze portable shrine, dated to the fourteenth century, now in the collection of the Harvard Art Museums.[1] Here, 'The case replicates, in spatially compressed form, the Buddha Hall ... of a temple ... An inset repoussé plaque at the back features at its center a Buddha seated on an open lotus blossom...' Another type of portable Buddhist shrine, dated to the Tang period, consists of three wood plaques set in a metal tri-partite shrine case.[2]

[1] James Cuno et al., *Harvard's Art Museums, 100 Years of Collecting*, Cambridge, Massachusetts, 1996, pages 68 - 69.

[2] Osaka Municipal Museum, *Chugoku Bukkyo Chozo*, (Chinese Buddhist Sculpture), Osaka, 1984, number 119.

一二

鎏金铜饰牌　唐　公元六一八年—九〇七年

高　一一·九公分
宽　一〇·九公分

佛教饰牌，长方鎏金，锤碟而成。主佛交脚，端坐莲台，右手施无畏印，左手贴腹，身着贴身僧袍，胸及右肩袒露。头上肉髻突出，后衬叶形背光，上刻莲瓣与火焰纹。两侧有莲台相接，上有菩萨，坐式同佛，一手捧火焰珠，身披长帛，穿兜提，戴珠宝，冠后有圆形头光。侍者立于佛旁，身著僧袍，右侧的双手合十，左侧的藏手袖中。饰牌顶部两个飞天，腾驾祥云，裙袍飘逸。牌角各有洞孔，应为固定之用。

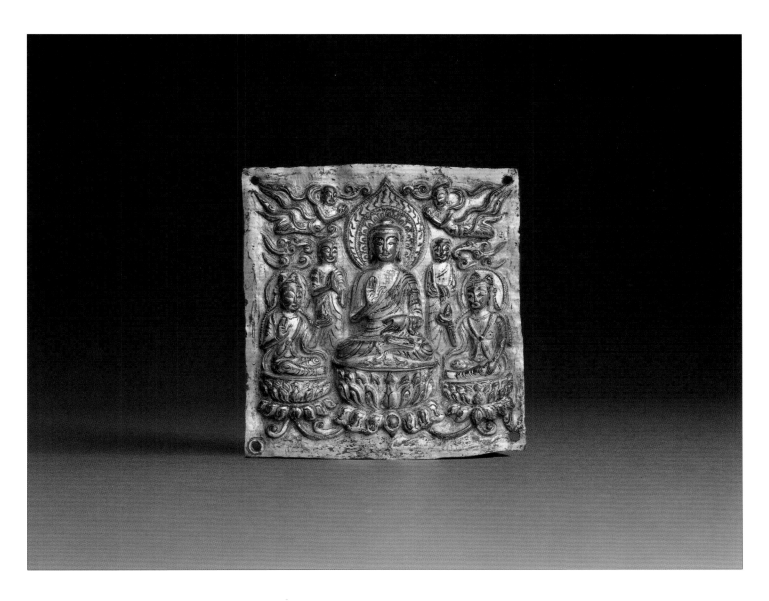

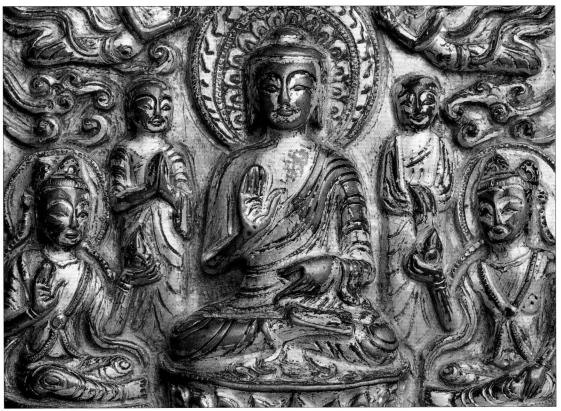

13
Marble Monk or Acolyte

Late Tang - early Song period, 10th - 11th century
Height: 54.0cm

White marble figure of a monk or acolyte, possibly Ananda, now lacking the head, standing on a circular lotus pedestal with bulbous, lobed stem and octagonal, petalled base. The figure is carved fully in the round and wears layered, full-sleeved monk's clothing, including a tunic-like garment that is fastened behind his left shoulder and wrapped and draped over his left arm. Robes, open at the chest, fall in front in well-modelled folds to his plump feet and behind in ordered pleats. His hands, with interlocking thumbs, are clasped flat to his stomach, left over right. The seed-pod on which he stands is depicted in semi-naturalistic fashion, surrounded by anthers or filaments, contained within overlapping petals. The surface of the marble is of softly polished creamy tone and bears minute traces of pigments and gilding.

Provenance:

Osvald Sirén, Stockholm, (by repute).

S. H. Hoo, New York, 1963.

Fong Chow (1923 - 2012), New York.

Published:

Christie's, New York, *Fine Chinese Ceramics and Works of Art Part I*, 24 March 2011, number 1303, where dated to the Tang dynasty.

Similar examples:

Shaanxi Provincial Museum ed., *Shaanxi sheng bowuguan cang shike xuanji*, (Selected Sculptures from the Shaanxi Provincial Museum), Beijing, 1957, page 52, number 49 for a larger figure now in the Beilin Museum.

Osvald Sirén, *Chinese Sculpture from the Fifth to the Fourteenth Century*, volume III, London, 1925, plate 371B, for a figure formerly in the Grenville Winthrop collection and 374A, for a figure formerly in the Rousset collection, Paris.

Osvald Sirén, *Kinesiska Och Japanska, Skulpturer Och Målningar I Nationalmuseum*, Malmö, 1931, plate 25 for a figure now in the Ostasiatiska Museet; see also *China Cultuur Vroeger en Nu*, Gent, 1979, page 196, number 342.

一三　白理石佛弟子　唐晚期—宋早期　公元十世纪—十一世纪

高　五四・〇公分

汉白玉像，应是佛弟子阿难，头部残缺，身体立于圆形莲座之上，座体束腰，八角形底，复叶纹面。像身圆雕，穿多层长袖僧袍，帔帛系左肩后，垂盖左臂。长袍开胸，皱褶整齐，顺畅而下，止于足面，背后衣纹亦规整。双手拇指交叉，左上右下，平贴腹部。莲座雕刻种荚，风尚趋于自然，花丝相间，叶瓣叠迭围绕。理石表面有软磨后的乳白色调，有少量的色斑与鎏金痕迹。

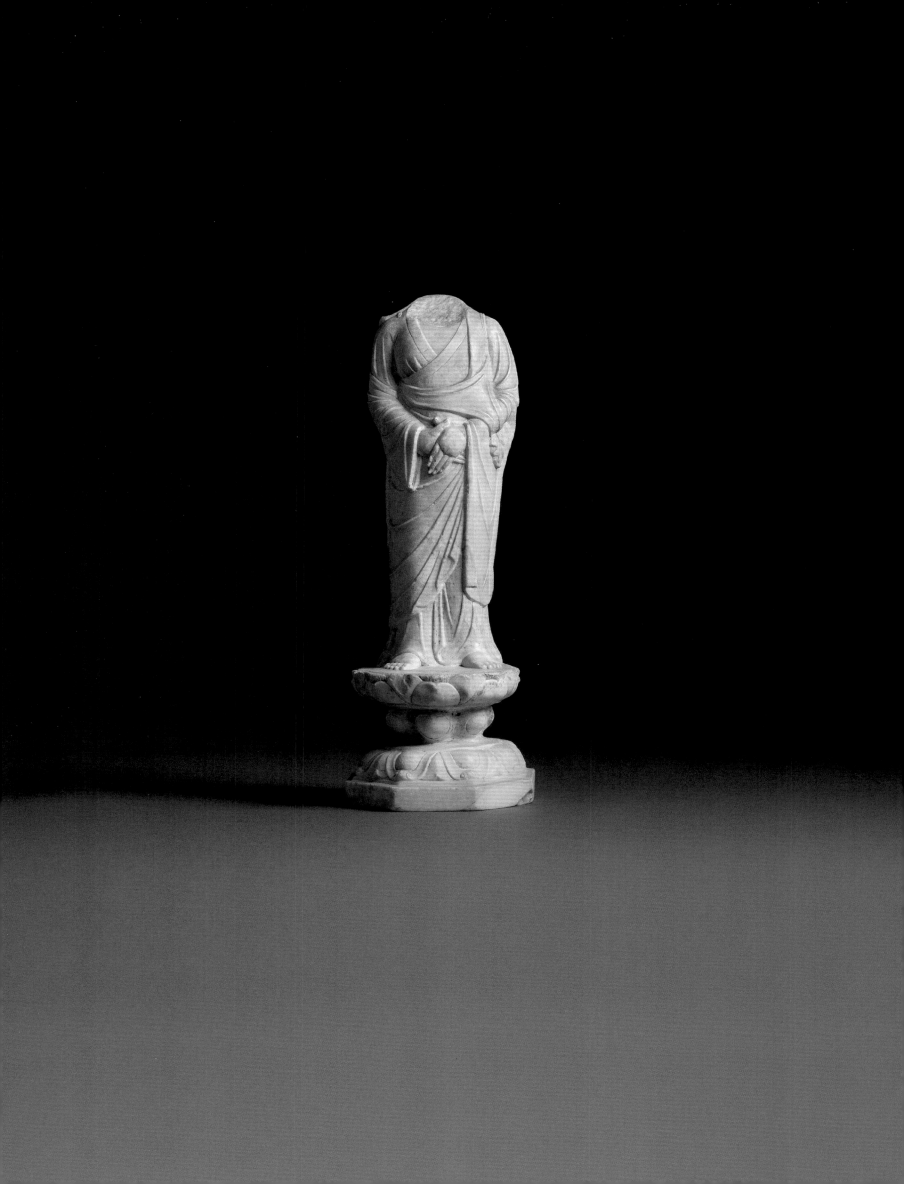

For further discussion on monks and luohans, see pages 18 - 27 of this catalogue for the essay, *Buddhist Worthies: Sculptural Depictions of Luohans and Disciples in Chinese Art, c. 500 - 1500*.

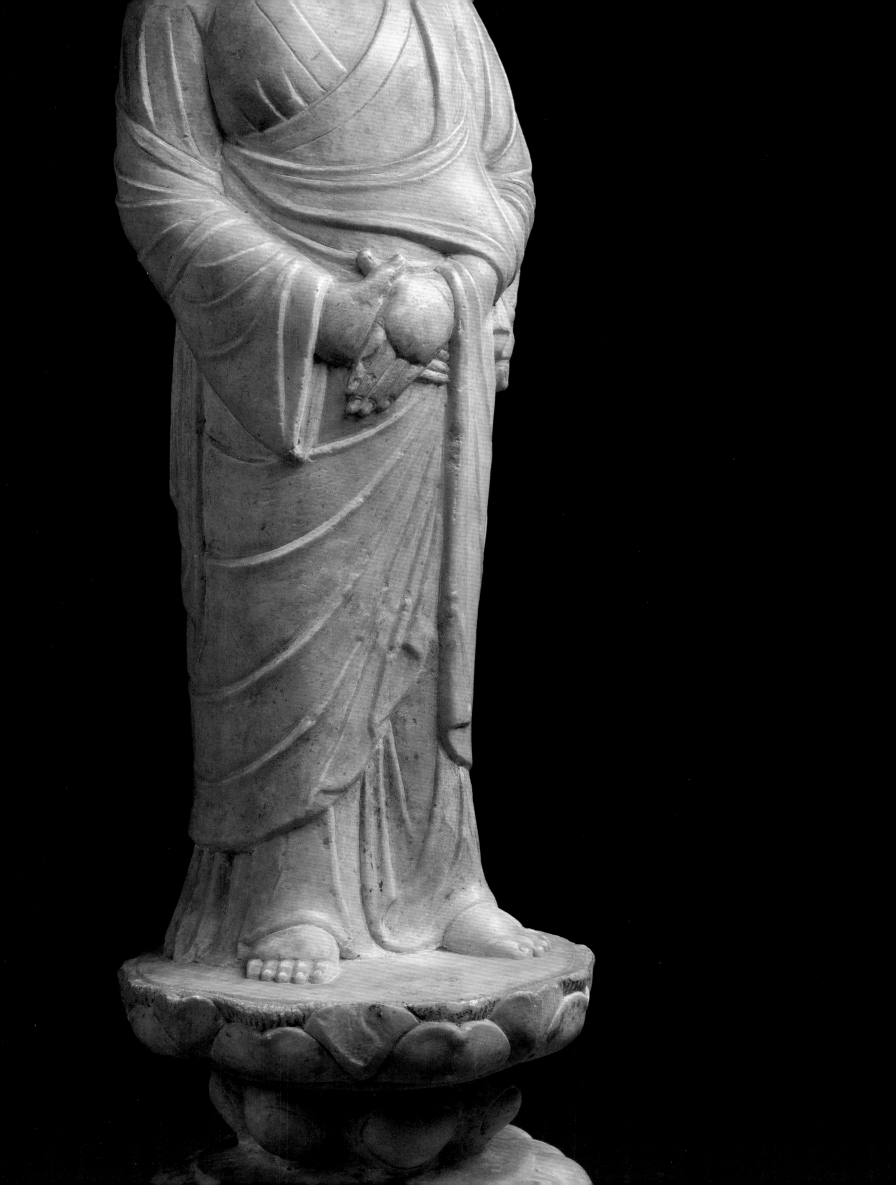

14
Pair of Limestone Musicians
Five Dynasties period, 907 - 960
Height: 30.4cm and 30.7cm
Width: 38.6cm and 37.6cm

Pair of limestone panels, each finely carved in high relief with a seated female musician playing an instrument, one a harp (*konghu*), the other a gong (*luo*). Each of the figures wears a dress, belted at the midriff, with elaborate double sleeves: short ruffled sleeves over long wide ones, billowing out to either side in wide loops. Each wears a long scarf draped in U-shaped folds over the chest and shoulders. The harp player has her hair dressed in an elaborate coiled top-knot ornamented by a single bud to the front while the gong player wears a pointed hat with a curved brim. Both women have rounded faces with delicate features – arching brows over narrow eyes, straight noses and tiny mouths – set in serene expressions. The gong player, turning to her right, supports her instrument on a stand with her right hand while striking it with a stick with her left. The harpist faces left and supports her instrument on her left leg while plucking with her right hand. The dark brown stone has a smooth patina with areas of pitting and wear.

一四　石灰岩乐伎饰牌一对

五代　公元九〇七年—九六〇年

高　三〇·四公分和三〇·七公分

宽　三八·六公分和三七·六公分

石灰岩饰牌一对，精刻女乐伎，高浮雕式，盘腿而坐，均着长裙，系带胸部，各奏乐器，一位弹箜篌，另一敲锣。

双袖套叠，竖纹短袖于外，袖带起伏，飘逸回旋。人披长帛

，皱褶弯曲，覆盖胸肩。箜篌女发式缜密，盘卷结顶，单髻朝前。敲锣女则头带尖顶帽，发边曲卷。两人都面容丰满，五官清秀，弯眉细目，直鼻小嘴，神态安详。敲锣女身体右侧，右手提锣，左手击槌。箜篌女面左，左腿撑琴，右手拨弦。石料深褐色，外层光滑，部分点蚀及伤损。

Provenance:

Schoeni Gallery, Hong Kong, 1985.

Private collection.

Similar examples:

Shi Yan ed., *Zhongguo meishu quanji, diaosu bian 5, Wudai Song diaosu*, (The Great Treasury of Chinese Art, Sculpture 5, Five Dynasties and Song), Beijing, 1988, pages 20 - 21, numbers 18 - 22 for comparable musicians on the sarcophagus of Wang Jian dated to the Shu dynasty of the Five Dynasties period; also, Angela Falco Howard et al., *Chinese Sculpture*, Yale, New Haven, 2006, page 145, figure 2.43.

It is possible that the present panels were part of a set intended to decorate a tomb or a sarcophagus. The similar examples cited are from the sarcophagus in the red sandstone mausoleum of Wang Jian of the Former Shu, 907 - 925 (one of the kingdoms of the Five Dynasties) in Chengdu, Sichuan. The sarcophagus is raised on a platform, the sides of which are set with panels, ten on the long sides and four on the short sides. Apart from four containing lotus blooms, all the panels depict female performers, either dancers or musicians. Among the instruments played are the *pipa*, the panpipes, the zither, the cymbals and the drums. The faces of the present musicians, like those on the sarcophagus of Wang Jian are rounded, with plump cheeks, in continuation of high Tang style. The dresses of the present figures, with double sleeves, short ruffled ones over wide, flaring ones, also recall the dresses worn by the musicians on the Wang Jian sarcophagus.

The ritual of music and the accompaniment of the deceased by musicians, was clearly of importance in the after-life and features in a number of tombs of this period. The theme of accompanying musicians is also seen to great effect on the white marble bas-relief carvings from the tomb of Wang Chuzhi, a prince of Beiping, who was buried in Quyang, Hebei, in 924. A panel comprising twelve female musicians was found on the western wall of the tomb; the figures are grouped in two overlapping rows, elaborately costumed and playing a variety of instruments, including the *konghou*.[1] The theme of musicians in celestial realms was also part of the Buddhist vocabulary of the early cave temples such as Yungang and it is possible that the numerous *apsaras*, painted and carved, playing musical instruments, sometimes flying aloft, sometimes seated in niches,[2] were the early forerunners of the present more earthbound musicians.

[1] Angela Falco Howard et al., *Chinese Sculpture*, Yale, New Haven, 2006, page 146, figure 2.45.

[2] Su Bai and Li Zhiguo ed., *Zhongguo meishu quanji; diaosu bian 10; Yungang shiku diaoke*, (The Great Treasury of Chinese Art; Sculpture 10; Yungang Caves), Beijing, 1988, pages 128 - 129, number 124 for fourteen *apsaras* musicians seated in niches in the front chamber, north wall in Cave 12.

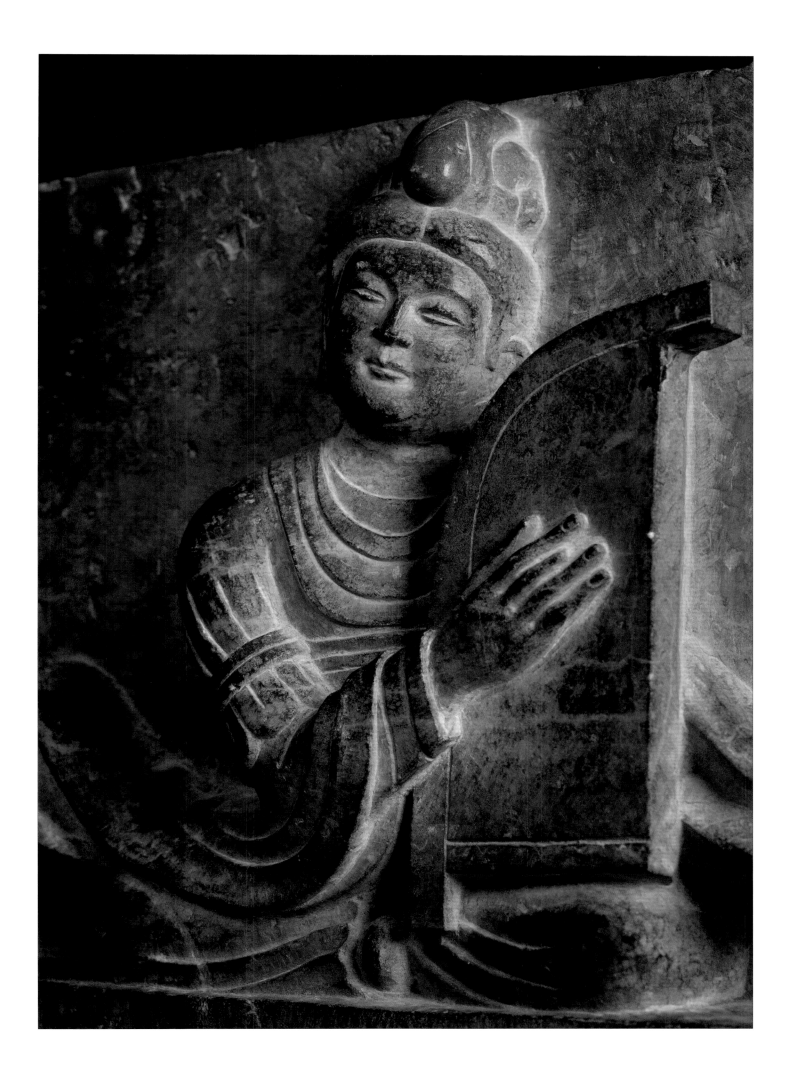

15
White Marble Avalokiteshvara (Guanyin)
Liao period, 907 - 1125
Height 95.4cm

White marble figure of the bodhisattva Avalokiteshvara, standing on an irregularly shaped base, arms held at the waist, hands now missing. The rounded face is carved with delicate features: arched brows framing almond-shaped eyes, straight nose and bow-shaped mouth above a dimpled chin. The hair is neatly pulled up to reveal a high forehead with incised *urna* and is encircled by a high crown set with a seated Amitabha Buddha, against a ground of foliate scrolls carved in high relief. An elaborate three-stranded necklace with rosettes and tassels hangs against the bare chest, passes through a disc at the waist and continues downwards. The deity wears a *dhoti,* fastened at the waist by a sash with flaring ends, descending in V-shaped folds to the ankles to reveal a pleated underskirt that partly covers the bare feet. A cowl is loosely draped in undulating folds over the crown, covers the shoulders and is gathered at the crook of the arms before falling in parallel folds from the forearms to the shins. The softly polished creamy marble retains extensive green, red and black pigments.

Provenance:

Private collection, Europe.

Published:

A. and J. Speelman, *Chinese Works of Art*, London, 2008, number 24.

Sotheby's, New York, *Fine Chinese Ceramics and Works of Art*, 15 September 2010, number 300.

Similar examples:

Osvald Sirén, *Chinese Sculpture from the Fifth to the Fourteenth Century*, volume IV, London, 1925, plate 601 for an almost life-size figure of Guanyin at the cave entrance, Yanxia cave temple in Hangzhou, Zhejiang.

Osvald Sirén, *Chinese Sculpture from the Fifth to the Fourteenth Century*, volume IV, London, 1925, plate 577 for a large gilt bronze figure in the University Museum, Philadelphia; also, Horace H. F. Jayne, *The Chinese Collections of the University Museum, A Handbook of the Principal Objects*, Philadelphia, 1941, page 41, figure 33.

一五

白理石观音立像 辽 公元九〇七年——一一二五年

高 九五·四公分

汉白玉观音，立于不规则底座，两臂置于腰间，双手缺损。面容圆满，五官清秀：弯眉杏目直鼻，嘴唇线条分明，颏有酒窝。头发整齐上敛，前额显露，毫光居中。高冠束顶，弥勒端坐其上，衬以高浮雕花枝纹纹地。项圈下分三股，华丽精巧，璎珞缤纷，沿着裸胸，经腰间圆璧，继续垂落。观音穿兜提，长巾系腰，两端松散。摺纹伸展，直击脚踝，底裙皱起，赤脚显露。身着披风，罩住高冠，从头飘落，覆肩盖臂，聚于肘弯，然后顺前臂落下，纹线平行垂直，直至胫骨处。理石料经软磨呈乳白色，并存有大面积的绿色红色和黑色。

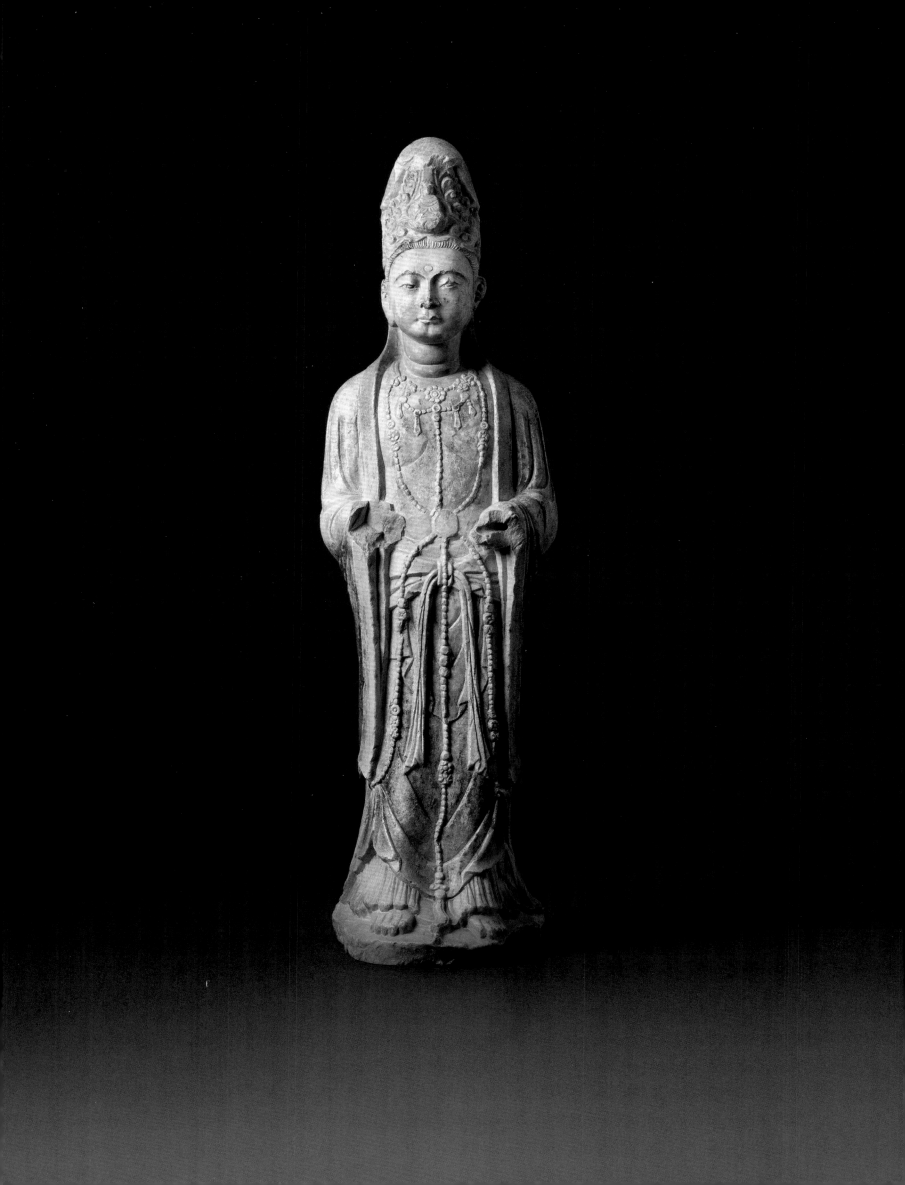

From around the tenth century, an increasingly popular version of Guanyin or Avalokiteshvara, was the White-Robed Guanyin, distinguished by a long white robe with a hood covering the head. The origin of this cult is obscure. It has been suggested that the bodhisattva may have been introduced as part of early tantric ritual texts, possibly as a form of the tantric goddess Pandaravasini.[1] However, as has been pointed out: 'Even if she was originally introduced into China through tantric ritual texts, her eventual success in China was due to a group of indigenous scriptures that promoted her as a goddess capable of granting children.'[2]

During the tenth century, the founding myths of a number of temples and monasteries were associated with the White-Robed Guanyin. Chün-fang Yü cites Qian Liu (851-932), the founder of the Wu Yue kingdom who dreamt of a woman in white who 'promised to protect him and his descendents if he was compassionate.' After his accession to the throne, he dreamt of her again and subsequently patronized a monastery on Mount Tianzhu that contained an image of her.[3] Marilyn Leidig Gridley has suggested that the White-Robed Guanyin was in fact worshipped by the Liao as 'their family deity', relating the deity to a god in white clothing who appeared to the second Liao emperor, Taizong (r. 926 - 47) in a dream:

> In Liao Nanjing, Taizong had discovered an image of the White-robed Guanyin which he identified with the god in his dream. He took the image back to Shangjing and established it as his family deity.[4]

[1] Chün-fang Yü, 'Guanyin: The Chinese Transformation of Avalokiteshvara' in Marsha Weidner et al., *Latter Days of the Law, Images of Chinese Buddhism, 850 - 1850*, Kansas, 1994, page 169.

[2] Ibid., page 172. According to Yü, a number of indigenous texts – generically called *Baiyi Guanyin jing* or *zhou* (Sutra or Mantra of the White-robed Guanyin) – were in use in China by the eleventh century. The chanting of texts was thought to bring relief to her devotees, although Yü believes that the bodhisattva was not properly regarded as the 'giver of children' until the Ming period.

[3] Ibid., page 171.

[4] Marilyn Leidig Gridley, 'A White-Robed Guanyin as the Embodiment of a Liao Ideal', *Orientations*, Hong Kong, February, 2001, pages 47 - 50. See also, Marilyn Leidig Gridley, *Chinese Buddhist Sculpture Under the Liao*, New Delhi, 1993, pages 105 - 108.

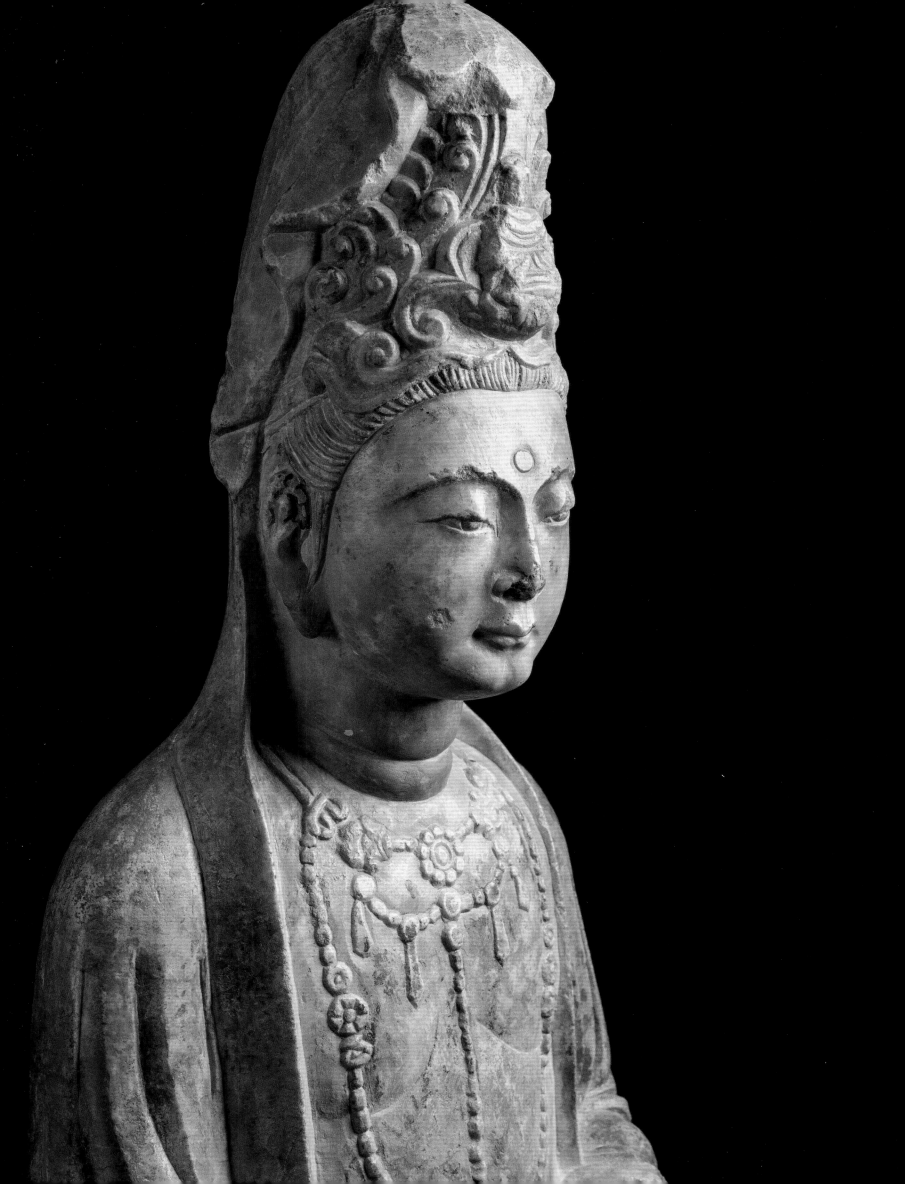

16
Marble Head of a Monk
Liao period, 907 - 1125
Height: 33.5cm

Large marble head of a monk, possibly Ananda, powerfully and realistically carved in the round. His domed, bony cranium is shaven and the finely arched eyebrows are furrowed in an expression of intense contemplation. His eyes are lowered, with hooded lids over incised pupils. The monk's features are pleasingly proportioned, with well-formed nose, ears with long fleshy lobes, high cheekbones and full lips above a square, strong chin. The creamy-white marble has been covered with a brown pigment, now rubbed.

Provenance:

J. Gordon Amende (by repute, purchased in Paris).[1]

Bertocchi, partner of Gordon Amende (by repute, inherited in 1960).

By descent in the Bertocchi family.

[1] Gordon Amende was an antiques dealer who had a shop on rue Visconti, in Paris, from 1933 to 1936. During the war, he moved back to the United States, but later returned to Europe, where he settled in Italy.

Similar examples:

Christie's, London, *Fine Chinese Ceramics and Works of Art*, 11 June 1990, number 109 for a related head, probably representing Kashyapa (see page 18, figure 2 of the present catalogue).

Otto Fischer, *Chinesische Plastik*, Munich, 1948, plate 121 for two views of a marble head of a luohan, formerly in the collection of General Munthe, Beijing (see page 18, figure 3 of the present catalogue).

一六　理石罗汉头像　辽　公元九〇七年——一一二五年

高　三三・五公分

理石罗汉，头像硕大，神态肃穆，惟妙惟肖，圆雕成型。头顶剃度，骨感圆滑，双眉拱形紧锁，表情若有所思。双眸刻划有神，眼帘低垂。罗汉五官适中，比例协调，鼻梁挺直，长耳垂肩，颧骨凸起，嘴唇丰满，方形脸盘。乳白色理石表面曾覆盖褐色，现已摩擦殆尽。

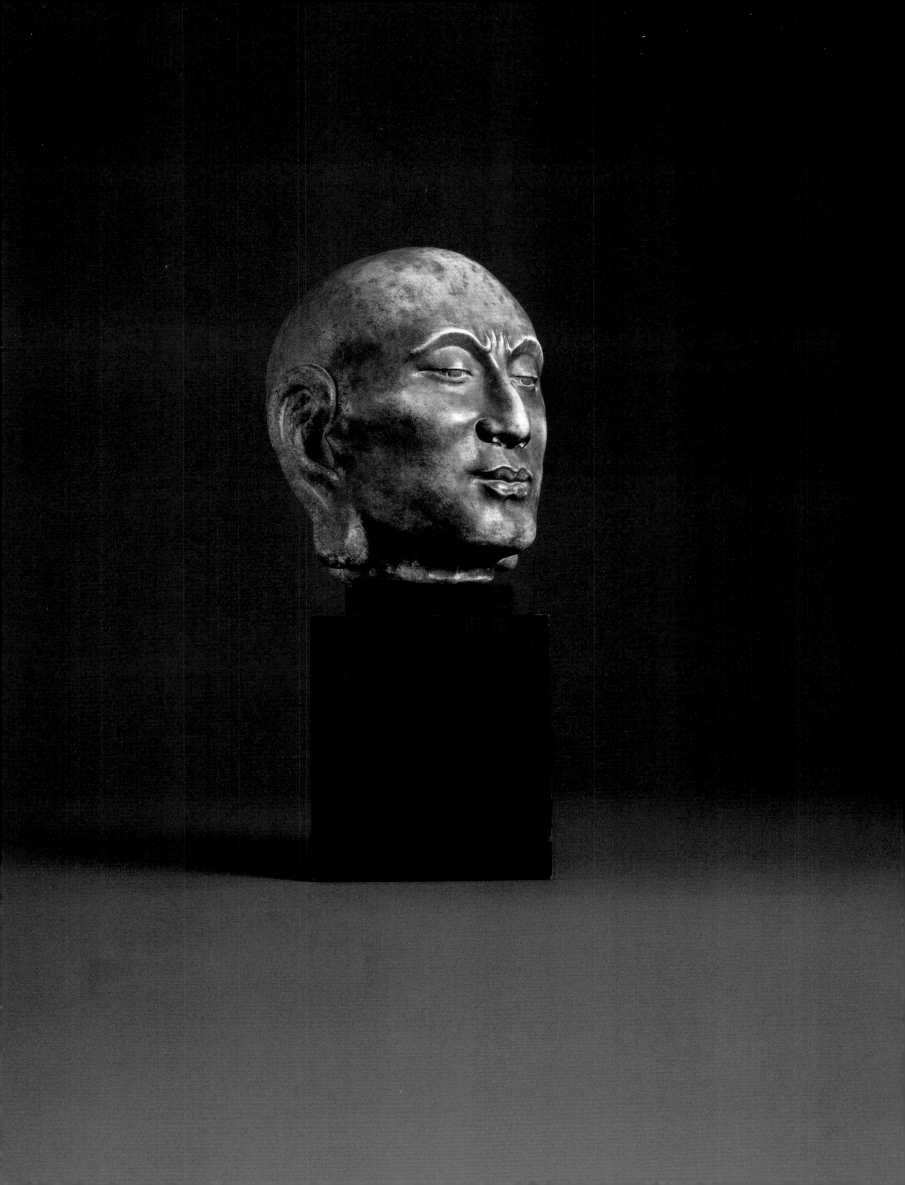

Such large and realistic portrait carvings of monks' heads, while rare, are not unknown. It is likely that the present sculpture represents Ananda. Ananda and Kashyapa were two of the more significant disciples of the Buddha Shakyamuni. Ananda, the youthful monk, was a cousin of Shakyamuni and acted as his attendant. He was famous for his power of recall, for establishing an order of nuns and for championing women's rights. Kashyapa, on the other hand, possessed exceptional 'magical' powers. The marble similar examples cited are of Kashyapa, suggesting that these figures may have been made in sets, depicting the older and younger monks together. The brown pigment, still largely extant on the present head, may well have been intended to indicate Ananda's Indian origin.

Stylistically, these sculptures also appear to be closely related to the group of *sancai*-glazed *luohan* figures, dated to the Liao dynasty, reputedly from Yixian, Hebei province, and now in museum collections around the world, such as the examples in the Metropolitan Museum of Art, New York.[2]

For further discussion on monks and luohans, see pages 18 - 27 of this catalogue for the essay, *Buddhist Worthies: Sculptural Depictions of Luohans and Disciples in Chinese Art, c. 500 - 1500.*

[2] Denise Patry Leidy and Donna Strahan, *Wisdom Embodied, Chinese Buddhist and Daoist Sculpture in the Metropolitan Museum of Art*, New York, 2010, pages 112 - 116, numbers 23a and 23b.

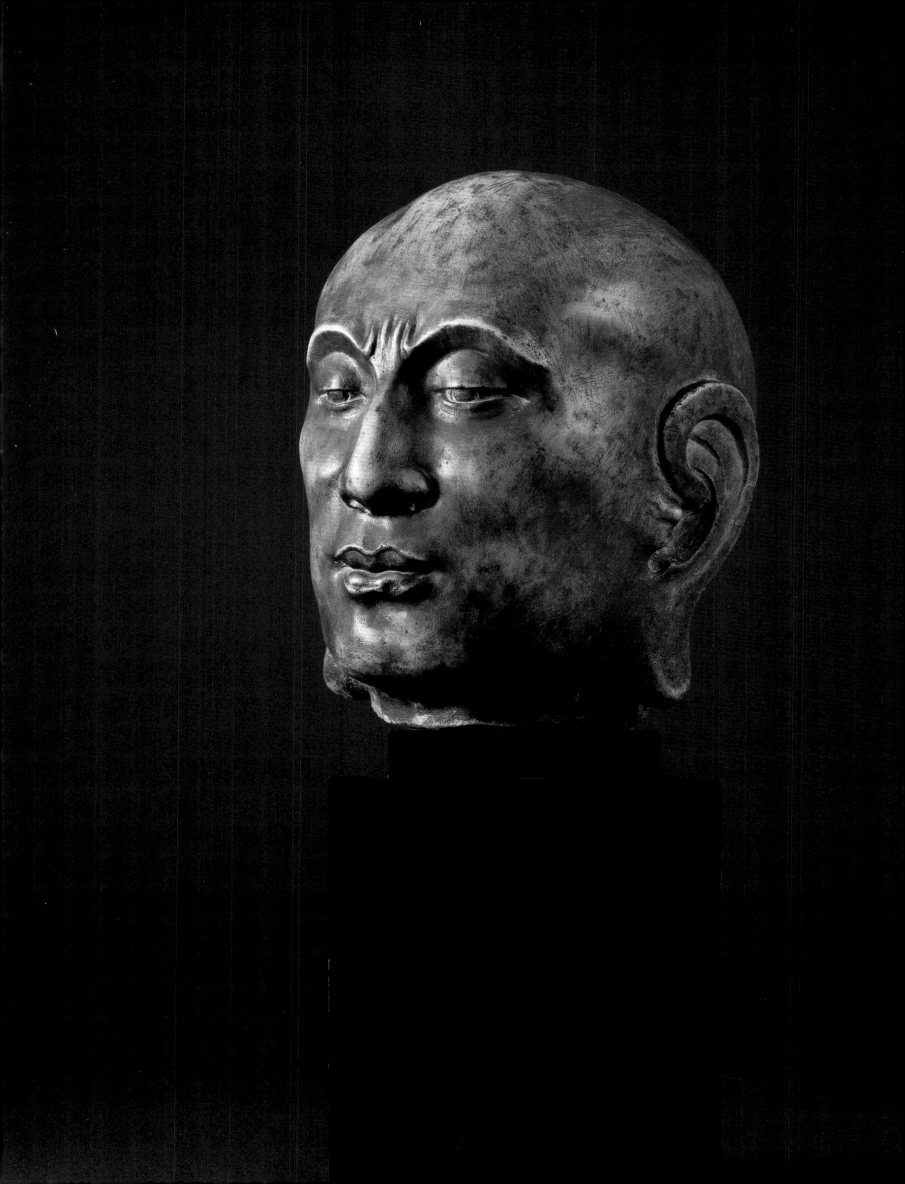

17
Pair of Polychrome and Gilt Wood Bodhisattvas
Northern Song or Jin period, mid 11th to mid 12th century
Height: 135.5cm and 134.5cm

Pair of willow wood bodhisattvas standing in *tribhanga*, covered in polychrome and gilt decoration. Each has facial features carved with great refinement: arched brows, elongated downcast eyes with black-painted pupils, aquiline nose, full lips, small chin and plump jowls and neck. The hair of each is combed off the face into a high top-knot contained by a *ruyi*-form coronet, with strands that are looped over the long ears and knotted at the shoulders where they divide into three tresses. The taller bodhisattva has head turned a little to the left and wears layered robes: a cape or stole around the shoulders; a high-collared jacket that is drawn up in pleats at the front; a short overskirt tied with a sash below the waist and draped over the hips and thighs; and a long skirt falling to the ground, carved in high relief with overlapping folds. An openwork necklace with central flowerhead hangs at the chest and, on the reverse of the figure, at the nape of the neck, dividing into two strands through a circular ornament at the small of the back. The companion bodhisattva has head turned slightly to the right and a pronounced bend to the right knee but is of similar appearance in most respects, with the exception of the garments on the upper body that leave the chest and stomach partly bare; they are bordered by a strap over the left breast and are additionally secured by a knotted sash above the waist. Both figures are painted almost entirely in cream, red, green and blackish pigments with areas of gilding, the overskirts at the hips additionally decorated with interlocking lozenge patterns consisting of hexagonal elements on the taller bodhisattva and diamond shapes set with flowerheads on the companion. Each figure is painted with a dragon over the stomach, now much worn. This layer of polychrome decoration, perhaps applied to thin paper, has flaked in areas to reveal traces of at least one earlier scheme.

Provenance:

André Carlhian (1883 - 1967), Paris, from whom by descent.[1]

[1] André Carlhian was a noted antiques dealer and decorator, specializing in the French eighteenth century but also at home in a more contemporary style. He, his brother Paul (who died in 1914) and his sons, Robert and Michel ran or participated in, at various times, establishments in Paris, New York, Buenos Aires, London and Cannes. The firm of R. and M. Carlhian was dissolved in 1974. The Carlhian archive is now deposited at the Getty Center for the Humanities, Los Angeles.

Similar examples:

Paul Houo-Ming-Tse, *Preuves des Antiquités de Chine*, Beijing, 1930, page 298; also, *L'Illustrazione Italiana: Testimonianze d'arte orientale*, year 1, number 3, Milan, Autumn, 1974, page 15, number 18 for a figure in the National Museum of Oriental Art, Rome.

Hôtel Drouot, *Objets d'Art de la Chine: Collection Paul Houo-Ming-Tse*, Paris, 15, 16 and 17 February 1932, number 77.

Hôtel Drouot, *Objets d'Art de la Chine: Collection Paul Houo-Ming-Tse*, Paris, 15, 16 and 17 February 1932, numbers 84 - 85 for a pair of bodhisattvas; also Eskenazi, *Chinese Buddhist Sculpture from Northern Wei to Ming*, exhibition at PaceWildenstein New York, London, 2002, number 16 for one of the pair; and Eskenazi, *Chinese Buddhist Figures*, exhibition at PaceWildenstein New York, London, 2004, number 5, for the companion bodhisattva. Both are now reunited in the same private collection.

一七　彩绘木雕菩萨立像一对　北宋或金早期　公元十一世纪中期—十二世纪中期

高　一三五·五公分和一三四·五公分

菩萨立像一对，柳木雕成，呈三屈式，通体彩绘和金饰。面容五官，雕工细腻：拱形眉头，长目低敛，瞳仁黑亮，高鼻厚唇，颏小颊肥，颈部丰腴。头发上敛，聚成高髻，戴如意形冠，数缕弯卷，经长耳散落，打结于肩部，并分成三条辫发。其中高者，头微向左，身穿叠层禅袍，帔帛绕肩，高领夹克，衣摺集于胸前。短外裙系腰下，褶皱覆盖臀腿部，长裙直落到地，折纹重叠，顺畅自然。项圈透雕，有团花饰，悬挂胸前，此像颈后，分成两缕穿过圆形饰件。另一尊像，头略朝右，右膝明显弯曲，但与前者外形相比，除胸腹部分祖露外，颇为相似，且镶边带，从左胸前过，由丝巾结扣，加固腰上。两尊像几乎通体彩绘，乳色红绿及黑色块，加之部分镀金。外裙臀部加饰环扣

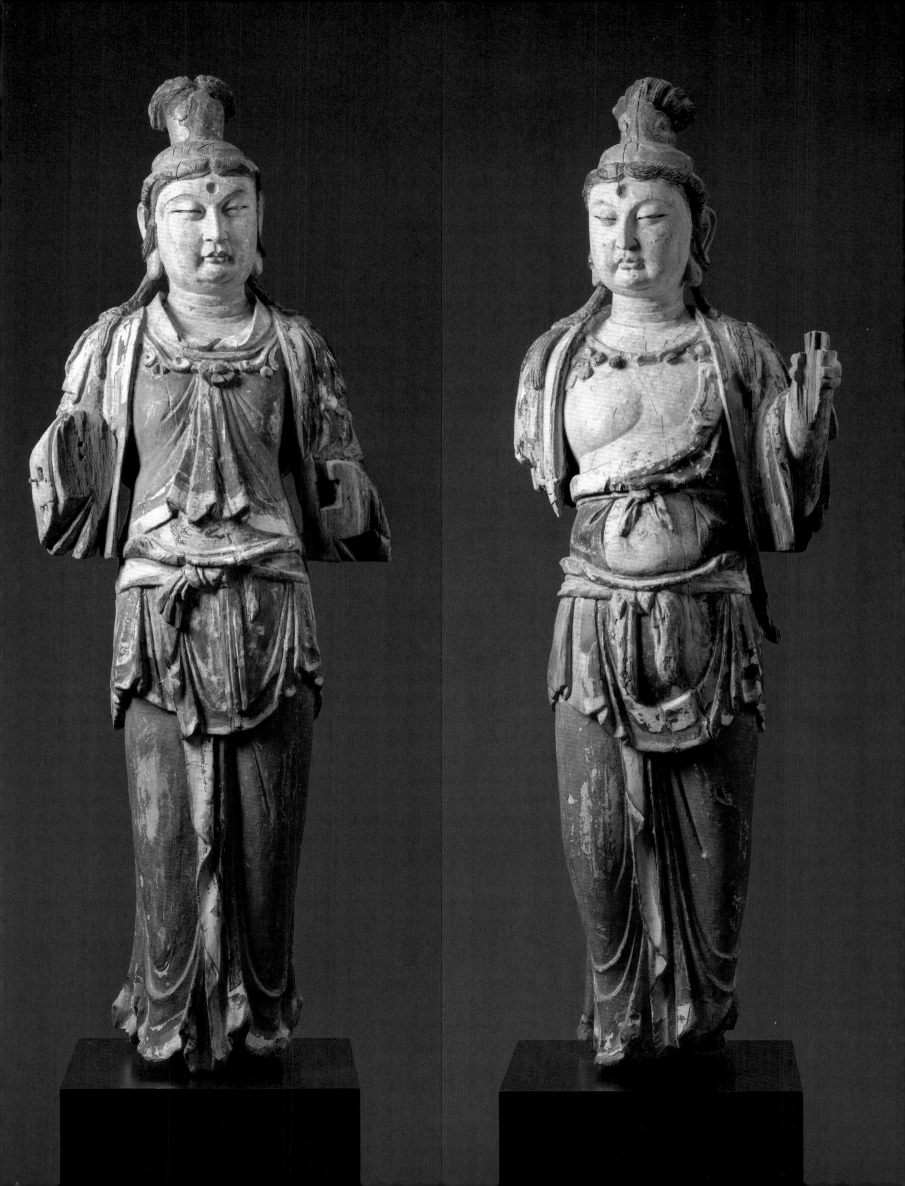

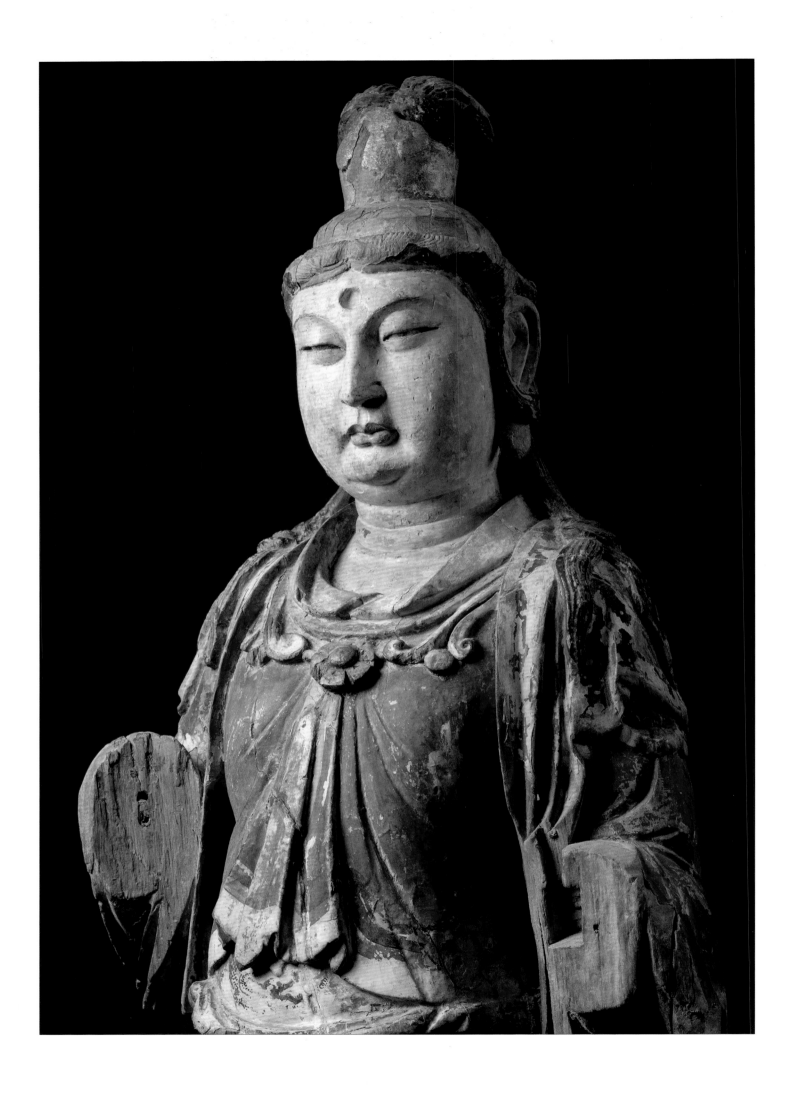

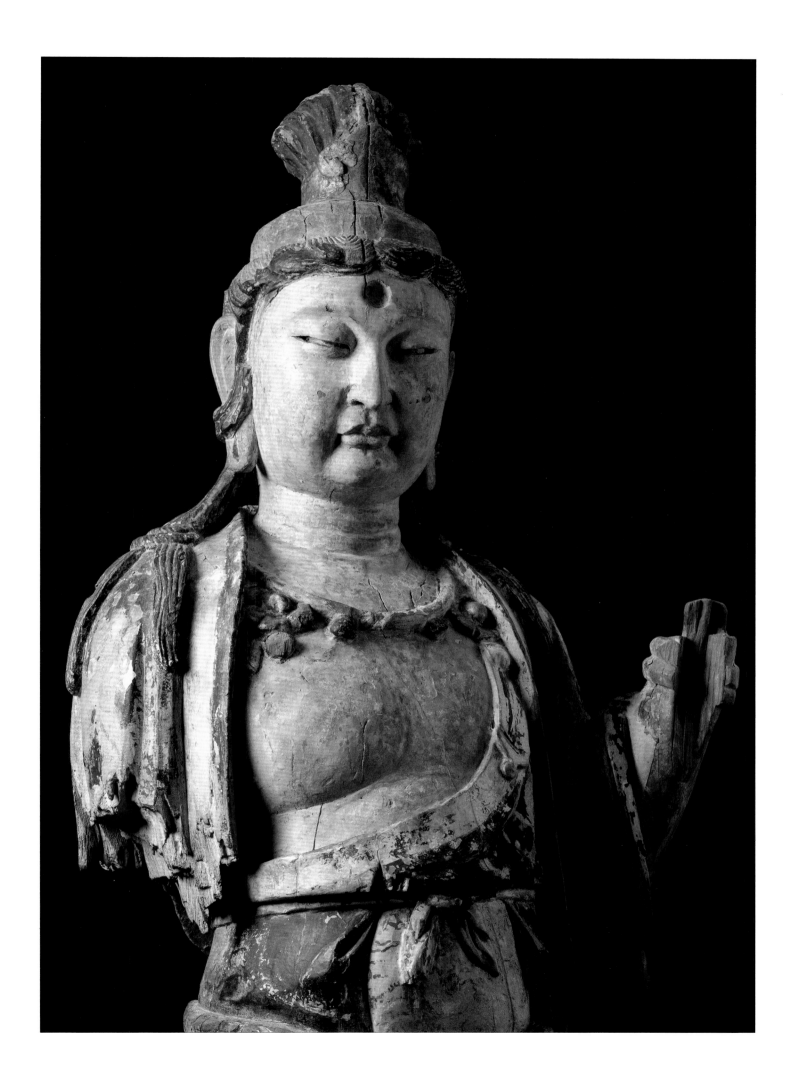

的菱形纹，高者辅以六角图案，另一则加以钻石纹，相得益彰，各得其所。两尊腹部绘有龙纹，但已磨损，湮漫不清。这层彩饰，或施予薄纸上，虽已斑驳，但仍可一窥原貌。

Denise Patry Leidy and Donna Strahan, *Wisdom Embodied: Chinese Buddhist and Daoist Sculpture in the Metropolitan Museum of Art*, New York, 2010, page 180, number A47; and page 181, number A50 for a smaller example in willow.

It is rare to find a surviving pair of bodhisattvas, the most famous example being the pair of Avalokiteshvara and Mahasthamaprapta, now in the Royal Ontario Museum, Toronto[2]; another pair is in the British Museum, London.[3] The ROM figures were originally intended for a temple in what is now Linfen prefecture, southern Shanxi province and dedicated in 1195, according to an inscription written on the inside of a panel that formed part of the skirt of Avalokiteshvara. The pair in Toronto can be identified as Avalokiteshvara (Guanyin) and Mahasthamaprapta (Dashizhi) by the attributes of Amitabha Buddha and a vase-like form respectively in their headdresses. Although now lacking such attributes, it is likely that the bodhisattvas in the present exhibition also represent Avalokiteshvara and Mahasthamaprapta. These two deities alone accompany representations of Amitabha Buddha, Avalokiteshvara embodying his compassion and Mahasthamaprapta his wisdom, assisting at the welcome of the faithful to the Western Paradise or the Pure Land. Mahasthamaprapta is rarely depicted alone and is almost always seen in a triad with Amitabha and Avalokiteshvara, whereas the latter became an object of worship in his own right.

[2] Royal Ontario Museum, *Chinese Art in the Royal Ontario Museum*, Toronto, 1972, number 112.

[3] Giuseppe Eskenazi with Haijni Elias, *A Dealer's Hand, The Chinese Art World through the Eyes of Giuseppe Eskenazi*, London, 2012, page 98, figure 92.

Samples taken from the two figures and sent to RCD RadioCarbon Dating date the figures to the period AD 1017 - 1155 and AD 1022 - 1155 with 95% confidence.

The wood of the sculptures has been confirmed as willow by the Royal Botanic Gardens, Kew.

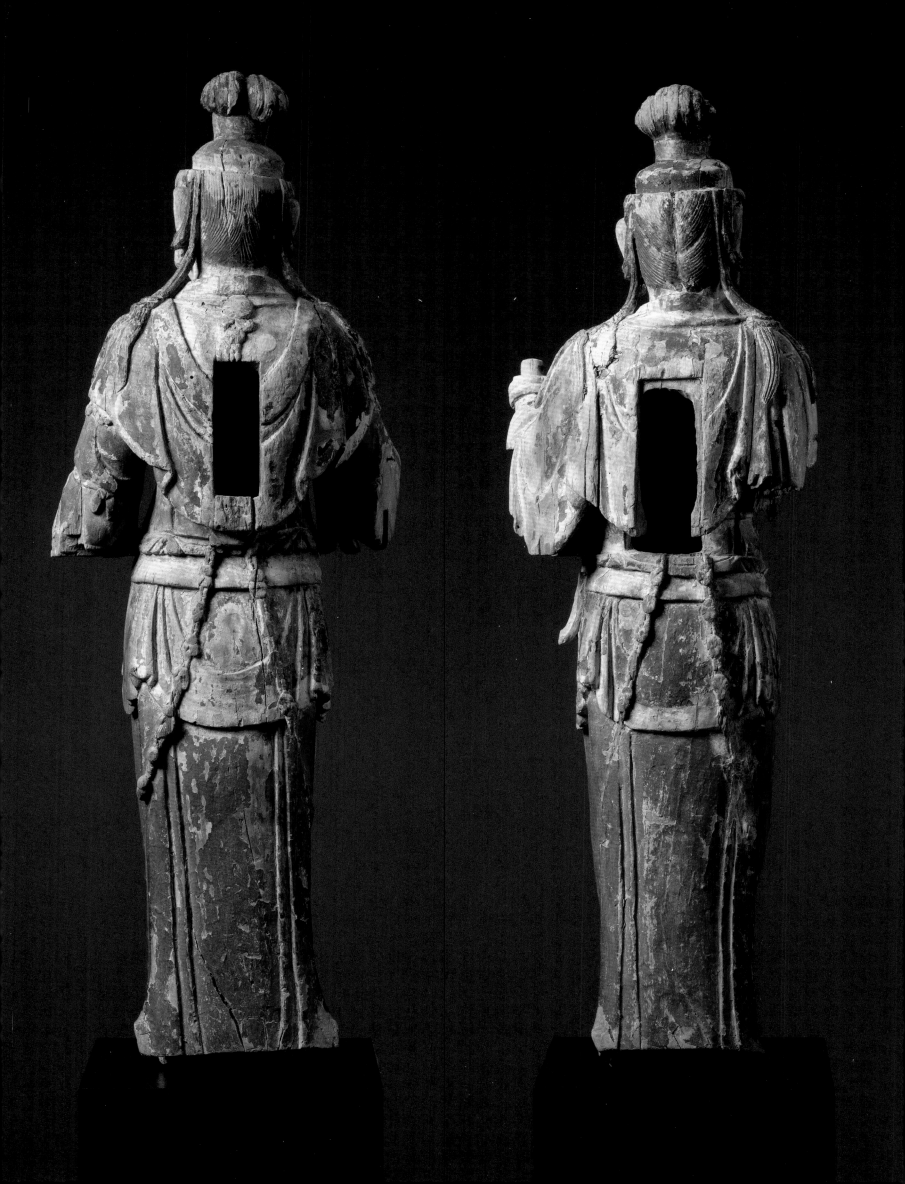

一八　大型木雕观音像　北宋或金　公元十一世纪中期－十二世纪中期

山西省　高　一七五・〇公分

观音菩萨像，泡桐木雕，体态雄伟，气势宏大。半跏趺坐，左腿悬挂，右手抬施无畏印，左手置左膝上。神祇面相清奇，五官精致，弯眉在上，双目低敛，嘴唇厚实，下巴丰满，耳廓长垂，颈部丰腴。发际上收，盘成高髻，辫发顺肩流落，系结并分为三缕。头冠正面高耸，弯中心曾有弥勒化佛，三莲花环绕。菩萨衣着多重，雕工精湛绝伦，上身穿禅衣，硬领缠袖，帔帛飘逸，绕过肘弯，如同翼展于右侧（左侧相同处缺损）。扎结长巾瀑落肩臂，斜挂胸前。下身着兜提，深摺垂至脚踝。精美项圈加团花饰，戴在前胸，左胸下有一串刻佛塔的小珠链，另带宽手镯于两腕。手脚雕塑细腻，圆润如是，右脚拇指叉开，或许是那种深刻思索，冥想忘我的表现。

18
Large Wood Avalokiteshvara (Guanyin)
Northern Song or Jin period, mid 11th to mid 12th century
Shanxi province
Height: 175.0 cm

Magnificent carved paulownia wood figure of a bodhisattva, probably Avalokiteshvara, seated in *lalitasana*, left leg pendant, the right hand raised in *abhaya mudra*, the left resting on the left knee. The deity's features are carved with great refinement, with arched brows above downcast eyes, full lips and rounded chin, pendulous ear-lobes and fleshy, creased neck. The hair is drawn up into a high, curled top-knot with tresses falling to each shoulder where they are bound and divide into three wavy strands. The crown has a tall, central point – perhaps once carved with a small Amitabha figure – set with three lotus flowers. The layered garments are depicted with the greatest virtuosity. The upper body is clothed in a tunic with stiff collar and wrapped sleeves, over which is a cape with ruffles at the elbows, rising wing-like on the figure's proper right, as if blown by the wind (the corresponding section on the left now missing). Elaborately knotted sashes or scarves are draped over shoulder, arms and across the chest. The lower body is clothed in a full *dhoti*, falling in deep folds to and around the ankles. A necklace decorated with flowerheads lies at his chest, with a small beaded chain carved with a stupa just below the left breast and wide bracelets at his wrists. The hands and feet are carved with great sensitivity, fully in the round, the splayed toes of his right foot perhaps expressive of deep meditation.

The sculpture still bears large areas of cream, red and green pigments, as well as gilding, and must originally have appeared quite dazzling. A cloud design in a raised gesso technique is clearly visible on the proper left side of the torso. There is a large opening in the back of the hollow body (carved from a section of a large tree-trunk) into which consecratory offerings or scrolls would originally have been placed and sealed.

Provenance:

Probably M. Brummer, France (acquired 4 June 1932).

M. Pierre Raphaël Lépine, Paris.

M. Ernest Cordier, Paris (acquired 10 March 1947).

Cordier family by descent.

Published:

Léon Flagel and Maurice Ader, Hotel Drouot, Paris, *Importante Réunion d'Objets d'Art d'Extrême-Orient,* 3 and 4 June 1932, number 176 (not illustrated, almost certainly the present figure).

Etienne Ader and André and Guy Portier, Hotel Drouot, Paris, *Objets d'Art d'Extrême-Orient,* 10 March 1947, number 99 and plate II (see page 103, figures 1 and 2 of the present catalogue).

Cabinet Portier, *100 Ans 1909 - 2009*, Paris, 2010, number 168.

Christie's, Paris, *Art d'Asie*, 19 December 2012, number 177.

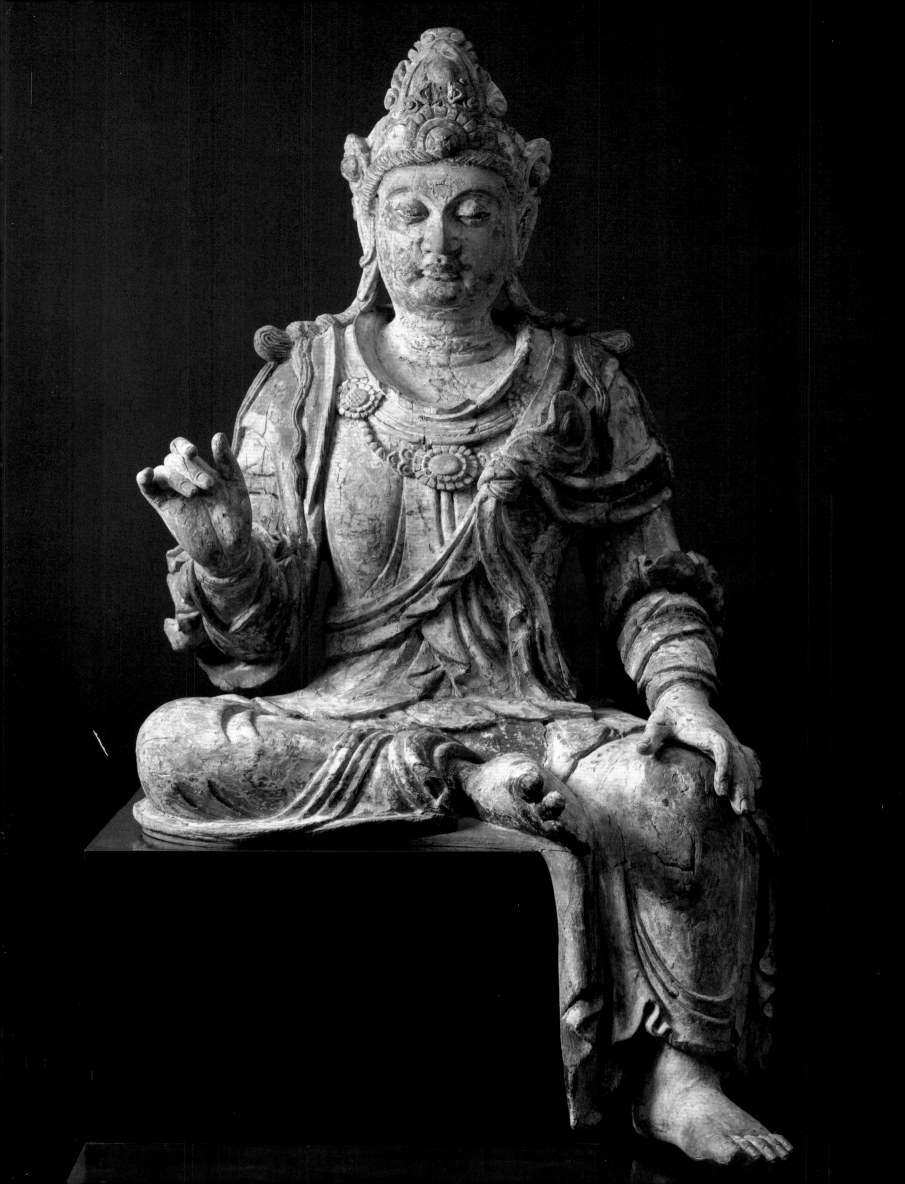

<div dir="rtl">

此像仍保存大部乳色红绿色和镀金处，正是这些最初元素，给人以绚丽的震撼。显而易见，菩萨身体左侧有一朵云纹，是采用石膏工艺塑造的。雕像身体内空，背后有很大的开口（原料是一段完整的树干），最初应是封存贡品和经卷的地方。

</div>

Similar examples:

Paul Houo-Ming-Tse, *Preuves des Antiquités de Chine*, Beijing, 1930, page 308 for a bodhisattva seated in the 'European' position, now in the Ashmolean Museum, Oxford; also, David Piper, *Treasures of the Ashmolean Museum*, Oxford, 1995, number 33; also, Giuseppe Eskenazi with Hajni Elias, *A Dealer's Hand: The Chinese Art World through the Eyes of Giuseppe Eskenazi*, London, 2012, plate 136 (see opposite, figure 3).

Beurdeley et Cie, *Sculptures d'Asie*, Paris, 1977, number 15; also, Giuseppe Eskenazi with Hajni Elias, *A Dealer's Hand: The Chinese Art World through the Eyes of Giuseppe Eskenazi*, London, 2012, plate 137 (see opposite, figure 4).

Kristin A. Mortimer et al., *Harvard University Art Museums, A Guide to the Collections*, Harvard, 1981, page 29, number 23, for an example seated in *rajalilasana* (see opposite, figure 5).

The present figure of Avalokiteshvara or Guanyin, with its remarkable size, imposing presence and richly carved drapery, may be regarded as a masterpiece of eleventh to twelfth century Buddhist sculpture in China.

Although missing its attribute, it is most likely that the present figure is a representation of Guanyin, a deity that has persisted as one of the most popular in Chinese Buddhism, as well being one of the most complex, with numerous manifestations. Over eighty Buddhist texts are related to Guanyin, including the *Lotus Sutra* (*Fahua jing*), the *Avatamsaka Sutra* (*Huayan jing*) and the *Heart Sutra*.[1] In the *Lotus Sutra*, Guanyin is portrayed as an independent 'intercessor', with the ability of:

> saving man from particular disasters and of conferring special benefits. All that was required from the believer was that he call on the name of the Bodhisattva for aid. He could save from fire, flood, storm, demons, the sword of the executioner, the fetters of the jailer, as well as from other dangers. In addition, Kuan Yin stifled carnal passions; yet curiously enough he was also the bestower of children.[2]

The popularity of Guanyin from the Sui period onwards is manifested by the '1100 copies of scriptures from Dunhuang related to Guanyin, including 860 copies of the *Lotus Sutra* and 128 copies of the *Guanyin Sutra*.'[3] A visual reminder of the importance of this deity is the painted banner, from the 'library cave' at Dunhuang and now in the Musée Guimet, illustrating the standing figure of Guanyin.[4] In this context, Guanyin was seen as a spiritual guide, leading souls to the Western Paradise.

Guanyin/Avalokiteshvara is closely associated with the Amitabha Buddha. According to some accounts, it was during meditation that the Amitabha Buddha caused a ray of light to shine from his right eye, which brought the bodhisattva into existence. The Amitabha Buddha is often represented together with Guanyin and Mahasthamaprapta (Dashizhi), the former embodying his compassion and the latter his wisdom, the three holy figures of the Pure Land, a cult that was at its height in seventh century China. It is for this reason that the figure of Amitabha is usually found as an attribute in the headdress of Guanyin. However, the popularity and the importance of the latter was such that the deity was often worshipped in his or her own right and the use of the Chinese name of Guanyin seems to have taken precedence over the Indian name of Avalokiteshvara. The cult of Guanyin, as the Goddess of Mercy, is one that gathered momentum during the Ming and Qing periods and still is prevalent today.

Although missing the identifying attribute in the headdress, the position in which the figure is seated – *lalitasana* or the relaxation posture – with one leg folded in front of the body and the other pendant, suggests that the deity might be Guanyin in the 'Water-Moon' manifestation (Shuiyue Guanyin), seated in his island paradise, Potalaka, later closely identified with Mount Putuo, an island off Zhejiang province. This seated position is also sometimes associated with bodhisattvas placed on support animals, such as Manjushri on the back of a lion.

The gradual transformation of Avalokiteshvara from the original male form to a female version occurred over a long period of time from the Song period onwards and has been subject to much research. Tang images of the deity found at Dunhuang include a male figure with a moustache, while later feminized versions sometimes appear as the Water-Moon Guanyin, the White-Robed Guanyin and the Guanyin of the South Sea. Chün-fang Yü has suggested that 'each major form of the feminine Guanyin was originally anchored

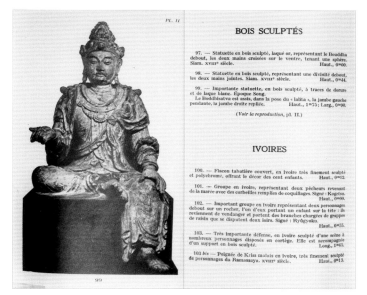

Figs. 1 and 2. After Etienne Ader and André and Guy Portier, Hotel Drouot, Paris, *Objets d'Art d'Extrême-Orient,* 10 March 1947.

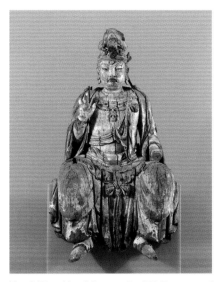

Fig. 3 Wood bodhisattva, h. 172.7cm, now in the Ashmolean Museum, Oxford. After Giuseppe Eskenazi with Hajni Elias, *A Dealer's Hand: The Chinese Art World through the Eyes of Giuseppe Eskenazi*, London, 2012.

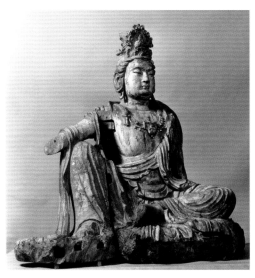

Fig. 5 Wood Guanyin, h. 124.0cm, Harvard Art Museums/Arthur M. Sackler Museum, Gift of Friends of the Fogg, 1928.110. Imaging Department © President and Fellows of Harvard College.

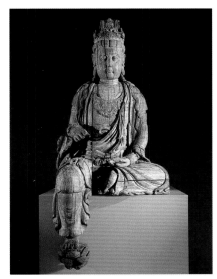

Fig. 4 Wood Guanyin, h. 167.6cm, private collection. After Giuseppe Eskenazi with Hajni Elias, *A Dealer's Hand: The Chinese Art World through the Eyes of Giuseppe Eskenazi*, London, 2012.

in one specific place, connected with one life story and depicted with one type of iconography….In this way Guanyin, originally a foreign, male deity, was transformed into a female savior with distinctive Chinese identities.'[5] Frequently, Guanyin is also presented as an androgynous figure, neither obviously male nor female.

After the twelfth century, wood replaced stone as the main material used for Buddhist sculpture. The present sculpture was carved from paulownia wood (also called foxglove), valued for its lightness and stability. Two types of paulownia were particularly important timber trees in China: the fortune paulownia (*baihua paotong*), found mostly in the south; and the royal paulownia (*mao paotong*) which reaches twenty metres in height and grows in a number of provinces including Anhui, Gansu, Hebei, Shaanxi, Shandong and Shanxi.[6] Only a few seated wood bodhisattvas of this very large size and date are known in museum and private collections, as cited in the similar examples above. It is likely that the present figure would have been created for a temple or cave complex in the Shanxi region in north China.

[1] Chün-fang Yü, 'Guanyin: The Chinese Transformation of Avalokiteshvara' in Marsha Weidner et al., *Latter Days of the Law, Images of Chinese Buddhism, 850 - 1850*, Kansas, 1994, page 152.

[2] J. Leroy Davidson, *The Lotus Sutra in Chinese Art, A Study in Buddhist Art to the Year 1000*, New Haven, 1954, page 66.

[3] Chün-fang Yü, 'Guanyin: The Chinese Transformation of Avalokiteshvara' in Marsha Weidner et al., *Latter Days of the Law, Images of Chinese Buddhism, 850 - 1850*, Kansas, 1994, page 152.

[4] Zhang Hongxing et al., *Masterpieces of Chinese Painting 700-1900*, London, 2013, number 11.

[5] Chün-fang Yü, 'Guanyin: The Chinese Transformation of Avalokiteshvara' in Marsha Weidner et al., *Latter Days of the Law, Images of Chinese Buddhism, 850 - 1850*, Kansas, 1994, page 175.

[6] Denise Patry Leidy and Donna Strahan, *Wisdom Embodied: Chinese Buddhist and Daoist Sculpture in the Metropolitan Museum of Art*, New York, 2010, pages 216 - 217 for an analysis of wood species in the collection.

We would like to thank Thierry Portier and Alice Jossaume of the Cabinet Portier, Paris, for their help in tracing the twentieth century history of this sculpture.

The sample taken from the sculpture and sent to Rijksuniversiteit, Groningen dates the figure to the period AD 1033 - 1165 with 95% confidence.

The wood of the sculpture has been confirmed as a species of paulownia by the Royal Botanic Gardens, Kew.

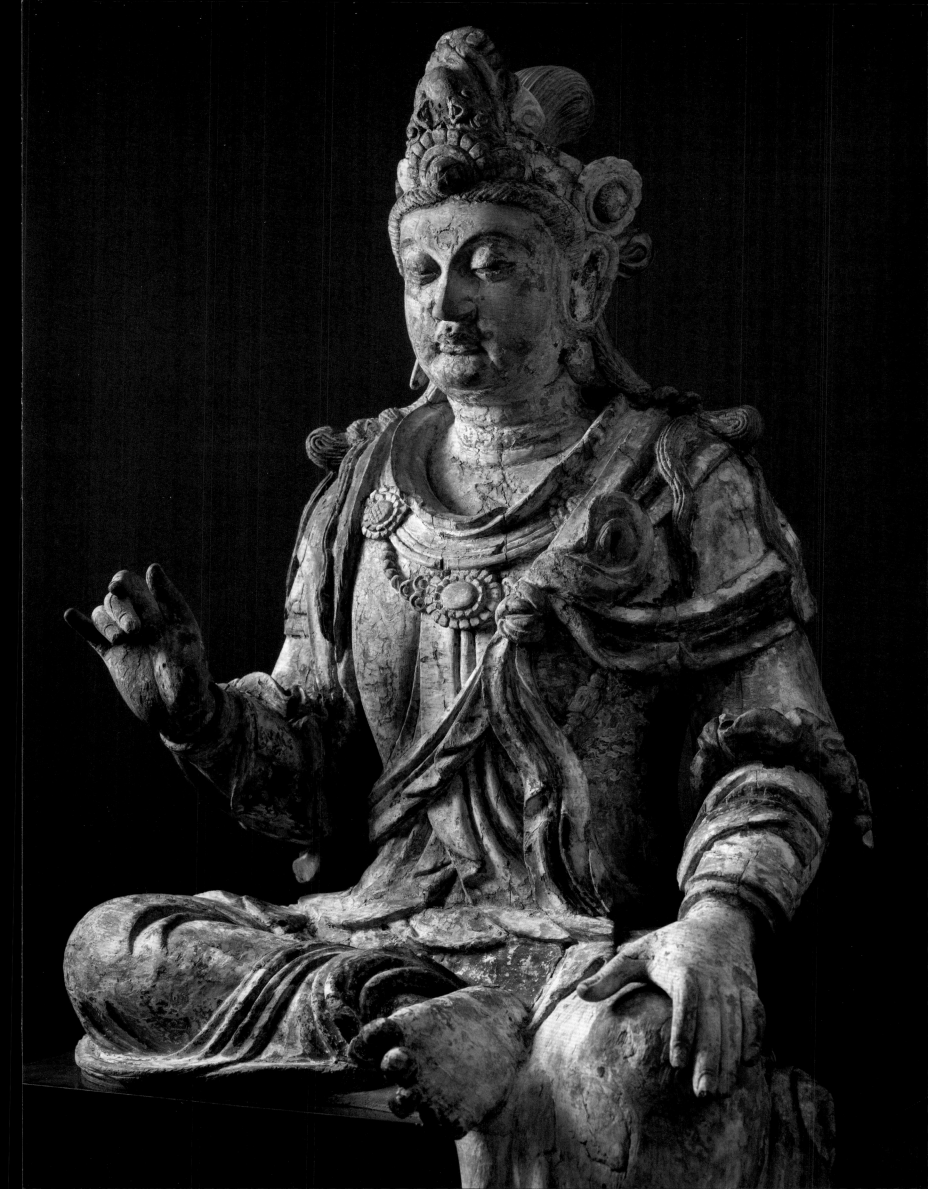

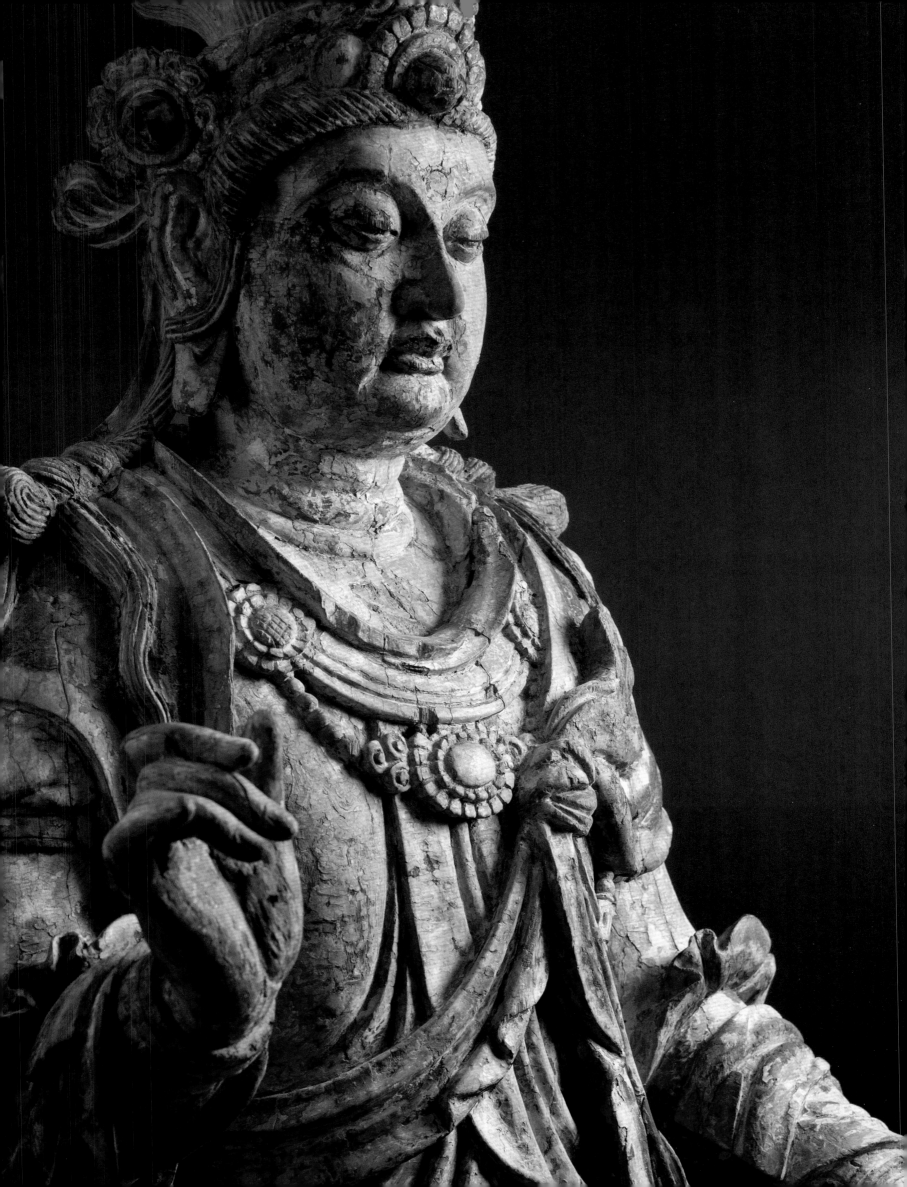

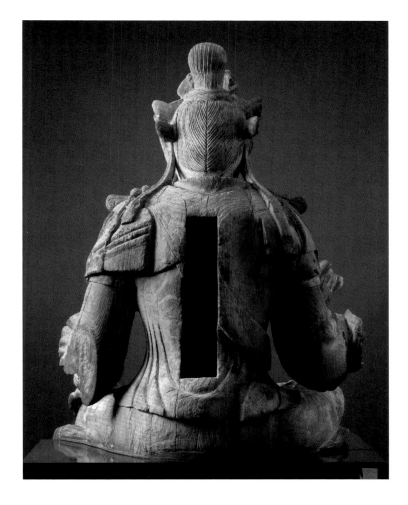

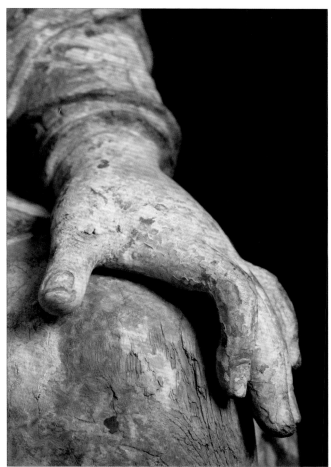

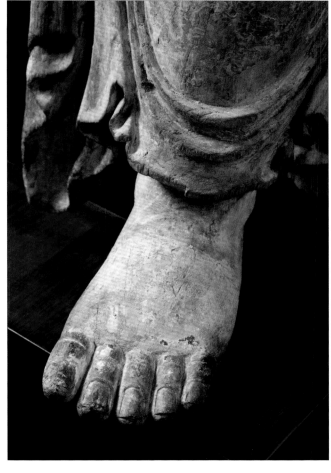

19

一九 木雕观音头像 金或元早期 公元十三世纪

高 九一・〇公分

19
Wood Head of Avalokiteshvara (Guanyin)
Jin or early Yuan period, 13th century
Height: 91.0cm

Massive wood head of a bodhisattva, probably Avalokiteshvara (Guanyin). The rounded face is framed by arching eyebrows over half-closed, contemplative eyes with glass pupils, a broad nose and a small bud-like mouth over a rounded chin. The hair is neatly arranged in waves over the brow and pulled up into a high top-knot, with tresses looped over the large ears and descending in braided locks behind. The deity wears a high, foliate diadem, once centred with a figure, presumably Amitabha Buddha, seated on a lotus throne, backed by elaborate trefoil petals and flanked by large loose scrolls. The head is decorated with extensive areas of black, red and white pigments.

Provenance:

Gallery Otto Burchard, Berlin.

Private collection, Germany (acquired in the 1920s from the above).

Published:

Christie's, Paris, *Art d'Asie*, 15 December 2010, number 285.

Similar examples:

Oswald Sirén, 'Studien zur Chinesischen Plastik der Post-T'angzeit', (A Study on Chinese Sculpture of the Post-Tang Period), *Ostasiatische Zeitschrift*, New Series, volume 4, Berlin, 1927, plate 14, figure 11.

National Palace Museum, *Hai-Wai Yi-Chen*, (Chinese Art in Overseas Collections, Buddhist Sculpture), Taibei, 1986, page 149, number 139 for an example in the Detroit Institute of Arts.

Palace Museum ed., *Compendium of Collections in the Palace Museum, Figures in Wood, Bamboo and Dry-Lacquer*, volume 9, Beijing, 2011, numbers 59 and 60.

The size of this head would suggest that it originally formed part of a bodhisattva figure of giant proportions, perhaps twice as large as life.

The C14 test dates the head itself, with as much certainty as the test can provide, within a small window of some six decades in the thirteenth century. Surprisingly, both the diadem and the chignon or top-knot have tested to a slightly earlier date, despite their surface appearance suggesting the opposite. It may be that these elements are replacements, carved from old wood, painted at the time they joined the head.

The samples taken from the sculpture and sent to RCD RadioCarbon Dating have given the following results with 95% confidence:

Top-knot	AD 1025 to AD 1155
Headdress	AD 988 to AD 1152
Head (behind ear)	AD 1224 to AD 1286

木雕菩萨头，魁伟硕大，应是观音。面相圆润，眉毛拱形，睐眼沉思，琉璃目瞳，宽鼻小嘴，口唇丰腴，下巴饱满。头发梳理整齐，波浪式沿，收敛上聚，结成高髻，秀发盘桓于耳廓上，垂落编辫，系于脑后。观音戴叶状高冠，中心曾有化佛，想必是弥勒，端坐莲台，衬有精致的三叶背光，两侧饰以大型缠枝纹。头像广施黑色，红色和白色。

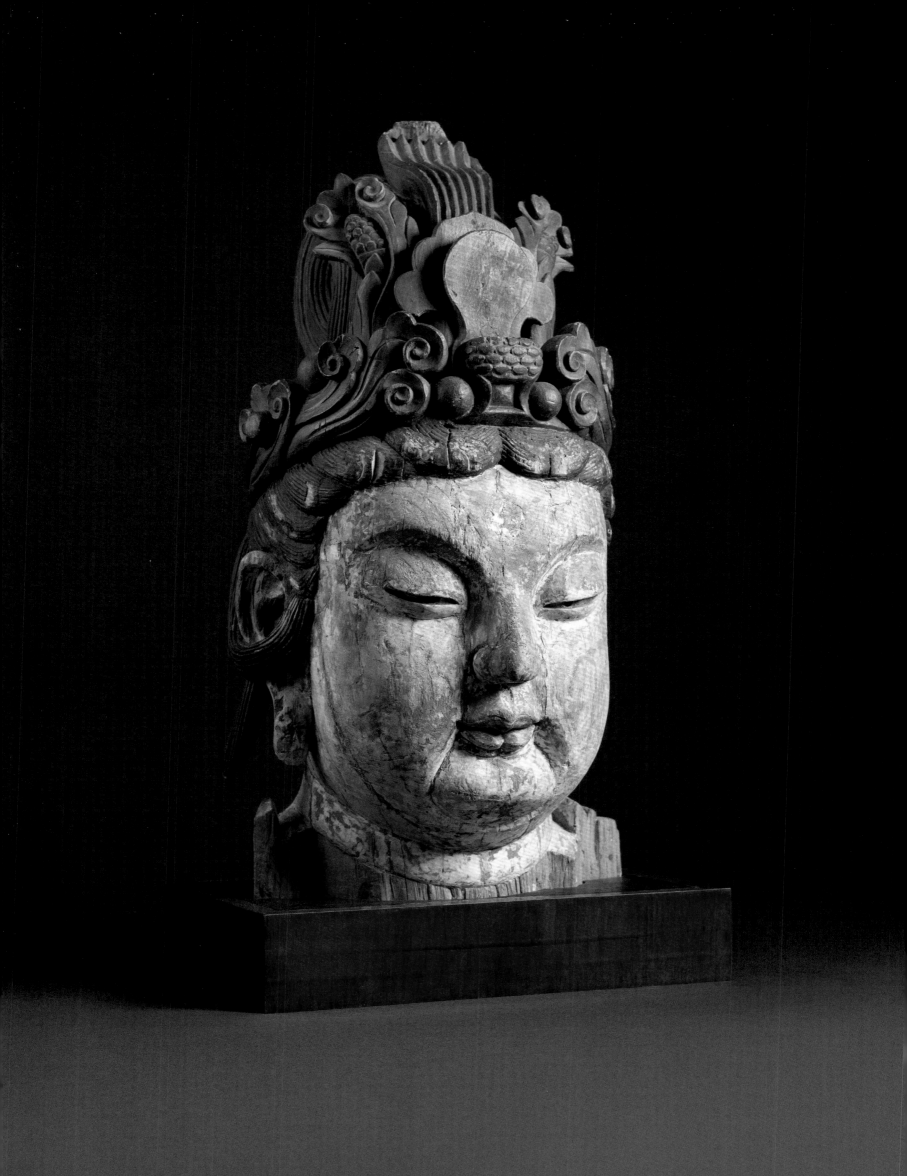

20
Limestone Head of Avalokiteshvara (Guanyin)
Yuan period, 1279 - 1368
Height: 40.1cm

Limestone head of the bodhisattva Avalokiteshvara. The large head is finely carved with a plump, rounded face framed by arching eyebrows over half-closed, contemplative eyes. The nose is neat and the mouth small and bud-like over a dimpled chin. The hair is neatly arranged in crisp waves along the forehead, above the protruding *urna*, and looped over the ear-lobes, descending in braids behind the ears. The deity wears an elaborate foliate diadem centred by the figure of Amitabha Buddha seated on a lotus base against a leaf-shaped mandorla, flanked by seated Buddhas, all against a scrolling ground. The diadem is edged by a beaded band studded with florettes at intervals, extending to the back of the head, with ribbons descending behind the ears. One elongated ear-lobe (the other now missing) is ornamented with a tasselled, rosette-shaped earring. The back of the head is uncarved except for the band of the crown and a rectangular projection, presumably for the attachment of a mandorla. The dark grey limestone has some inclusions and the surface bears areas of red and yellow pigments and gilding.

Provenance:

Private collection, Argentina.

Renato de Benedictis, Buenos Aires (acquired in 2002).

Maie-Lee Chen, New York, (acquired in 2003).

Exhibited:

Buenos Aires, 1939, Museo Nacional de Bellas Artes.

Buenos Aires, 1967, Museo Nacional de Arte Oriental.

Published:

Exposicion de Arte de China y Japon, Buenos Aires, 1939, number 338.

Arte de la China, Buenos Aires, 1967, number 207.

Similar examples:

William Watson and Marie-Catherine Rey, *L'Art de la Chine*, Paris, 1979/1997, plate 116, for a larger example in the Musée Guimet.

Robert D. Jacobsen, *Appreciating China, Gifts from Ruth and Bruce Dayton*, Minneapolis, 2002, number 31, for a larger bodhisattva head with a double crown fronted by a Phags-pa character meaning 'Amitabha Buddha', now in The Minneapolis Institute of Arts; also, Giuseppe Eskenazi with Haijni Elias, *A Dealer's Hand, The Chinese Art World through the Eyes of Giuseppe Eskenazi*, London, 2012, plate 129.

二〇

石灰岩观音头像　元　公元一二七九年——一三六八年

高 四〇・一公分

石灰岩观音头，硕大且工细，面容圆满，拱形眉线，双目半眯，若有所思。鼻形优雅，小嘴丰润，酒窝下巴。头型齐整，额前波浪发际，刻纹清晰，白毫凸起。卷发盖耳，垂落耳后成辫。头戴精美的叶状高冠，中心弥勒端坐莲台之上，后依叶形背光，两侧辅以佛陀，缠枝纹为地。冠盖以珠饰带缘，带中团花云集，延至脑后，有条带悬挂耳后。耳垂长延（一边残损），饰团花流苏耳环。头像后部，除了冠带和长方榫头外，未经雕琢，榫头想必是固定之用。深灰石料含些许杂质，表面部分结有红黄色块，也有鎏金可见。

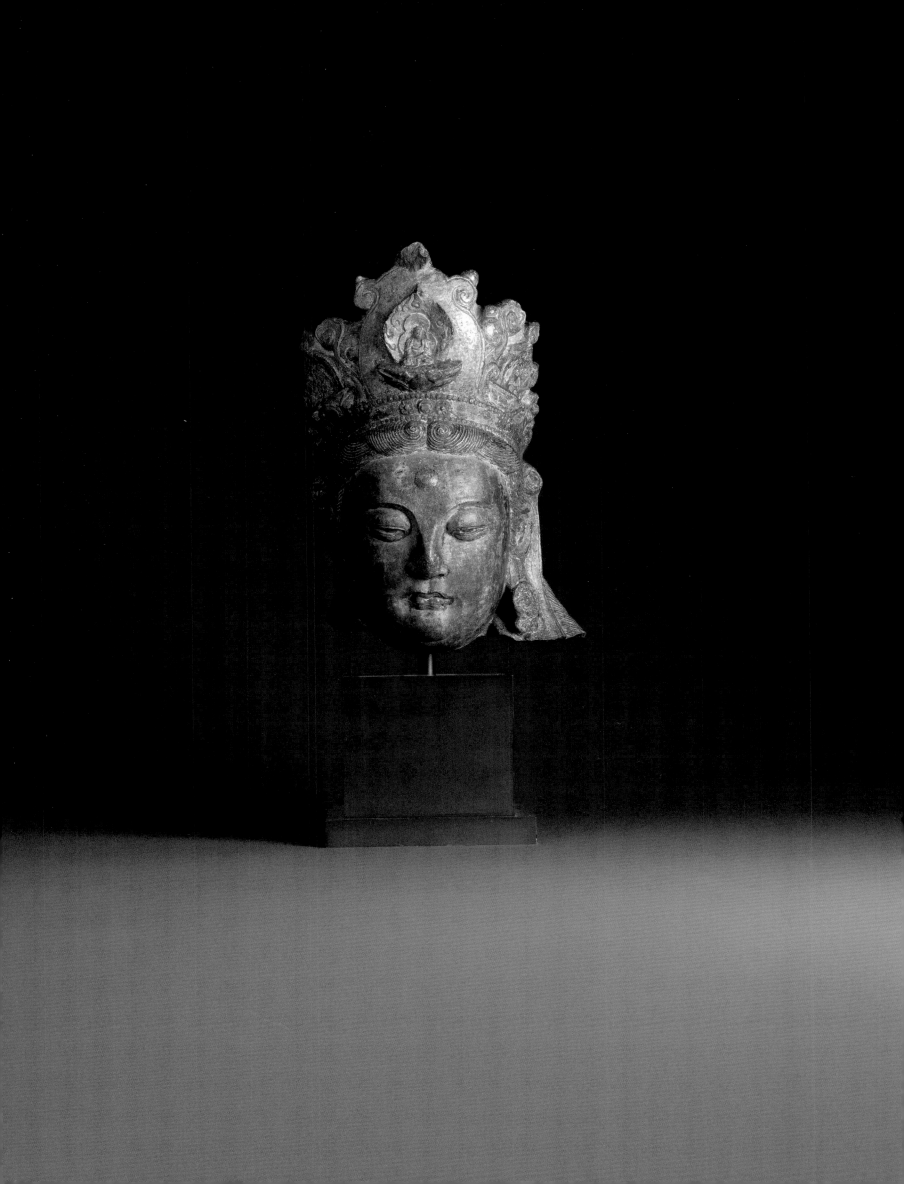

There is a small group of similar bodhisattva heads, two of which are cited: all seem to be carved of the same kind of stone and stylistically are very close. They vary in size and in the elaborateness of the crown. The foliate crowns may be related to earlier gilt-copper examples, comprising layers of openwork panels, found in Qidan royal burials in north China.[1] The presence of Amitabha Buddha in the crown of the bodhisattva indicates that this is a representation of Avalokiteshvara (Guanyin).

[1] Jenny F. So ed., *Noble Riders from Pines and Deserts, The Artistic Legacy of the Qidan*, Hong Kong, 2004, pages 74 - 75, number 1:7, for an openwork crown from the Mengdiexuan collection.

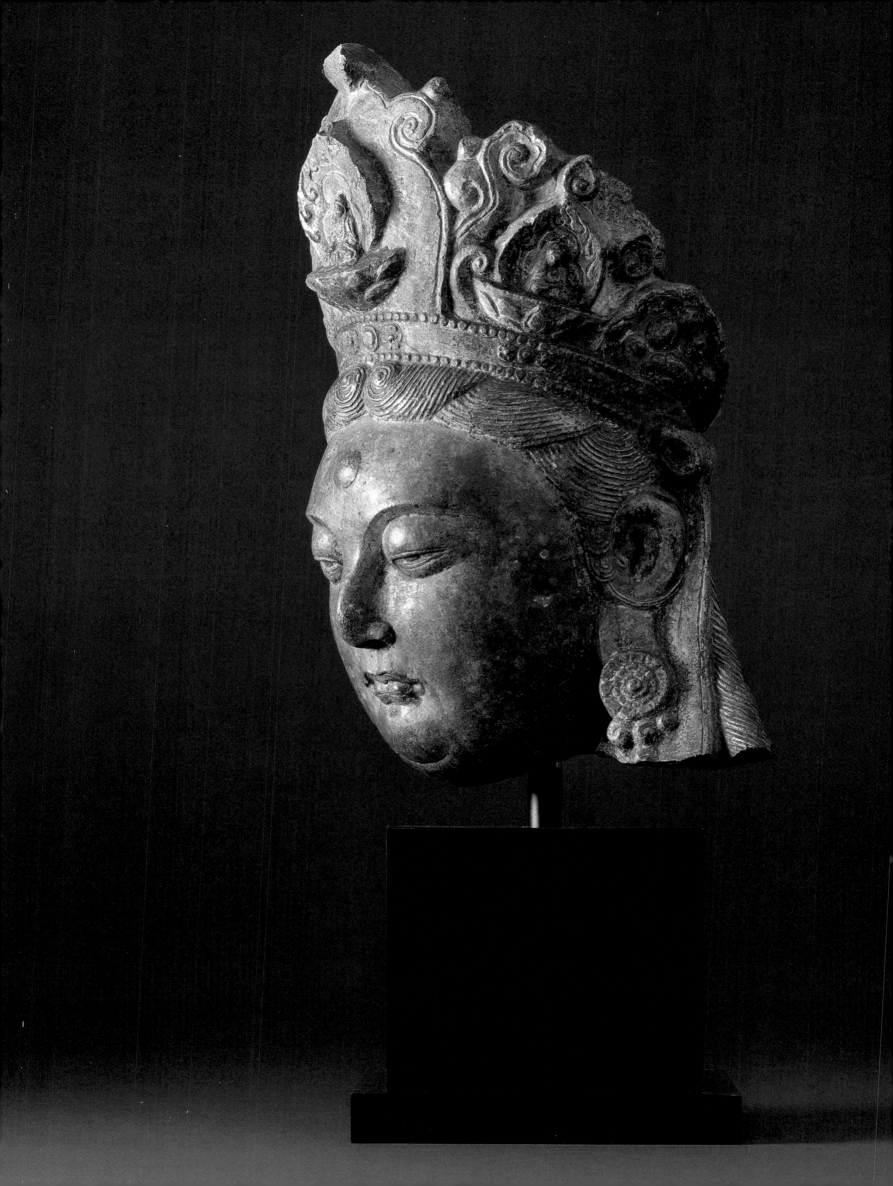

21
Gilt Lacquered Bronze Figure of a Luohan
Yuan - early Ming dynasty, 14th - 15th century
Height: 80.3cm

Large gilt lacquered bronze figure of a luohan, seated cross-legged in *padmasana*, with the soles of both feet visible and hands held in loose fists at the chest with thumbs touching. The figure has a rounded, shaven head, high cheekbones, long ear-lobes pierced for earrings and a fleshy neck. His brow is deeply furrowed, denoting an expression of intense concentration, with thick brows framing large protruding eyes. His mouth is set in a firm expression and the lips bear traces of red cinnabar. He is dressed in monk's clothing, the soft collar of the undergarment visible at the neck, over which a robe is fastened diagonally with a sash. A shawl is draped over both shoulders, descends in fluid folds over the arms, covers the legs and cascades down in front of the knees in thick pleats, the central finer pleats probably from the inner garment. The interior of the figure is cast on the underside with two pierced lugs for attachment and, on the proper right, is incised with three characters, *shisi hao*, 'number fourteen'.

Provenance:

Fritsche collection, Berlin, 1930s.

Private collection, U.S.A.

Published:

Christopher Bruckner, *Chinese Imperial Patronage, Treasures from Temples and Palaces*, London, n.d., number 9.

Christie's, New York, *Fine Chinese Ceramics and Works of Art*, 27 November 1991, number 42.

Christie's, New York, *Fine Chinese Ceramics and Works of Art*, 21 March 2002, number 53.

Similar examples:

E. Fuhrmann, *China, Erster Teil: Das Land der Mitte*, volume I, Hagen, 1921, plate 133, top and bottom images showing the interior of the Yiguang Temple (West Beijing) with two walls, each lined with nine luohans.

Lubor Hajek, *Chinesische Kunst in Tschechoslowakischen Museen*, (Chinese Art in Czechoslovakian Museums), Prague, 1954, number 115.

二一

鎏金漆銅羅漢

元—明代早期 公元十四世紀—十五世紀

高 八〇・三公分

鎏金漆銅羅漢，體態偉岸，腿部交叉，結蓮花坐，腳掌雙露，手握鬆拳，拇指相觸，置於胸前。羅漢面如滿月，剃度光潔，顴骨高起，長垂穿孔，以懸耳環，脖頸豐腴。眉宇緊鎖，表情極為專注，而濃眉之下，雙目圓睜。嘴巴緊閉，態度堅定，唇口有朱砂跡。身穿僧衣，內裝軟領，外袍覆蓋，斜挎身前，飾帶繫之。帔帛經雙肩而下，過手臂，蓋腿部，摺紋流暢，瀑落膝前，形成厚折，而中心部細膩衣紋，應為內襯所致。像內由底部澆鑄，有兩穿孔耳柱，以連接之用，最右側刻有三字：十四號。

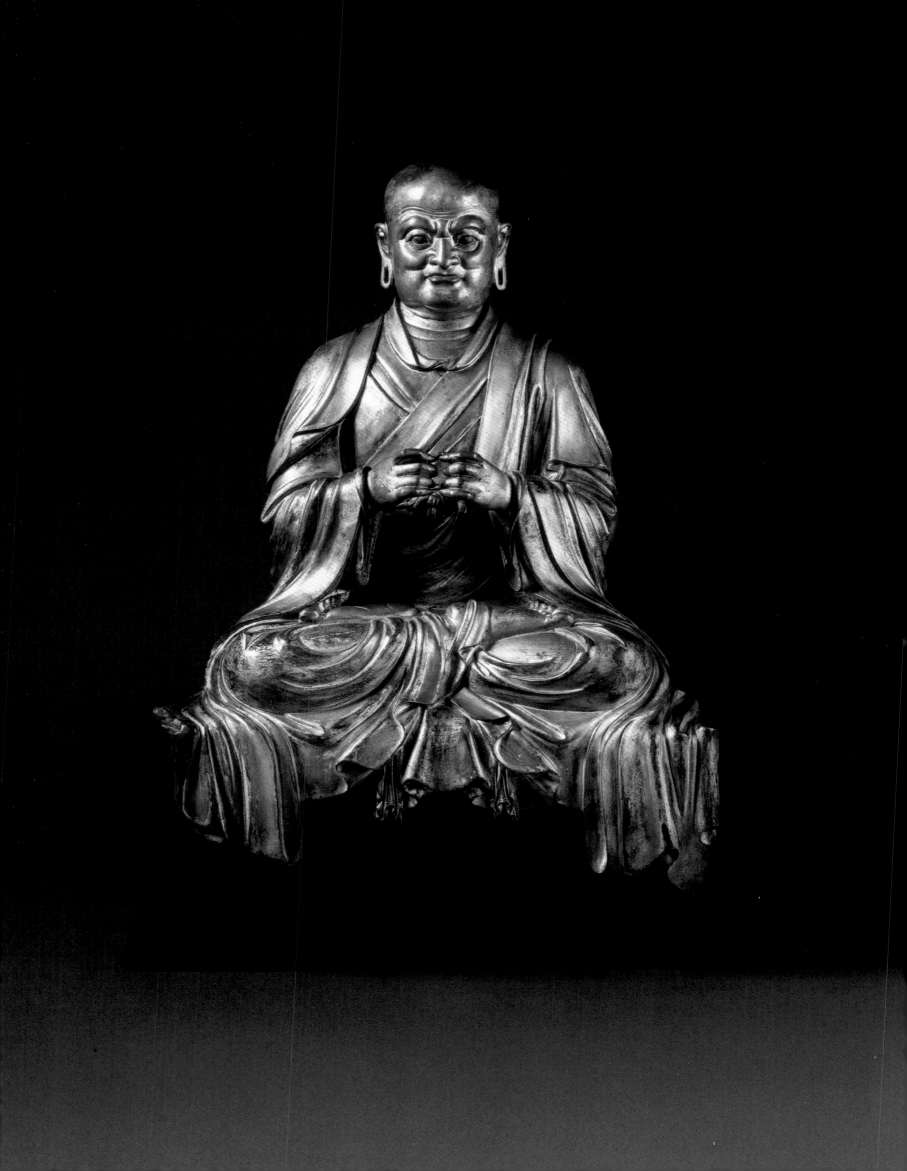

The present figure was most likely one of a set of sixteen or eighteen luohans, placed in a prescribed order on the east and west walls of a Buddhist hall, within a temple complex. As the present figure is not holding any attributes, ascertaining his identity is not entirely straightforward. However, the interior base of the figure is incised with a number – 'number fourteen' – suggesting he is the fourteenth luohan. The identity of the fourteenth varies according to which listing of luohans is used. One of the earliest lists, derived from a third to sixth century text, was translated by the pilgrim monk, Xuanzang, in the mid seventh century and the fourteenth luohan on this list is named as Vanavasi(n). However, a later, Tibetan list provided a different order, with some different names; the fourteenth on that list is Nagasena (who is twelfth on the Chinese list).

For further discussion on monks and luohans, see pages 18 - 27 of this catalogue for the essay, *Buddhist Worthies: Sculptural Depictions of Luohans and Disciples in Chinese Art, c. 500 - 1500*.

Gilt Bronze Seated Luohan
Ming dynasty, 15th century
Height: 50.8cm

Gilt bronze figure of the luohan Pindola Bharadvaja, seated cross-legged in *virasana* on a stepped, rectangular base, his right hand extended holding an inscribed sutra, his left lowered, cradling an alms bowl. He is depicted in realistic fashion as a young monk, slightly smiling, with shaven head and regular features, apart from the customary elongated ear-lobes and fleshy creases around the neck. He wears a monk's robe that is draped over his left shoulder, leaves his right arm and chest bare, falls in elegant folds to his exposed right foot and is wound around his waist where tucked in to stand in stiff pleats. The robe is engraved with a border of scrolling flowers. The stepped base is cast at the corners with open flowerheads and tendrils. It is covered in front by a mat decorated with a shaped reserve containing fruiting and flowering plants on a chequered ground edged with a border of scrolling pattern. The rich gilding of figure and base is slightly worn in areas, with scattered additional fire-gilt rectangles and the outline of rectangular patches, probably the finishing done to the figure after casting and before gilding. The underside of the base is closed by a sheet of bronze engraved with a *vajra*. The sutra, the lower part of the base in the front and the reverse of the base are inscribed in Tibetan; the reverse of the base also bears a three-character inscription in Chinese (see overleaf).

Provenance:

Private collection, U.S.A.

Published:

Christie's, Hong Kong, *Fine Chinese Ceramics, Works of Art, Jade and Jadeite Carvings and Snuff Bottles*, 1 - 3 May, 1994, number 539.

Jin Shen, *Fojiao diaosu mingpin tulu*, (Catalogue of Famous Buddhist Sculpture), Beijing, 1997, page 595, number 569.

Other examples almost certainly from the same set (see images on pages 24 and 25 of the present catalogue):

William Watson and Marie-Catherine Rey, *L'Art de la Chine*, Paris, 1979/1997, plate 117 for the luohan Gopaka in the Victoria and Albert Museum, London; also, William Watson, *Art of Dynastic China*, London, 1981, plate 107; also, Rose Kerr, *Later Chinese Bronzes*, London, 1990, page 86, number 70; also, Rose Kerr ed., *The T. T. Tsui Gallery of Chinese Art: Chinese Art and Design*, London, 1991, pages 102 - 103, figure 39; also, *Hai-Wai Yi-Chen*, (Chinese Art in Overseas Collections: Buddhist Sculpture), Taibei, 1986, page 196, number 180.

Hans-Joachim Klimkeit et al., *Kunst des Buddhismus entlang der Seidenstrasse*, (Buddhist Art along the Silk Road), exhibition catalogue, Munich, 1992, number 104 and back cover, for the luohan Kanakavatsa in the Museum für Völkerkunde, (State Museum of Ethnology), Munich.

Christie's, Hong Kong, *Fine Chinese Ceramics, Works of Art and Snuff Bottles*, 24 - 25 October 1993, number 543 for the luohan Bakula.

Christie's, Paris, *Art d'Asie*, 11 June 2008, number 258 for the luohan Angaja.

Sotheby's, Paris, *Arts d'Asie*, 16 December 2010, number 78 for the luohan Ajita and number 79 for Cudapanthaka.

二二 鎏金銅羅漢坐像 明 公元十五世紀

高 五〇．八公分

金銅羅漢－賓頭盧尊者，雙腿交叉坐於疊澀座，座台束腰，長方形。右手外展，握住經卷，左手低置，捧定缽盂。除通常表現佛教神韻的長耳垂及豐滿頸部外，此像塑造呈現世風范，年輕和尚，微笑相向，頭頂剃度，五官清秀。身穿僧袍，覆蓋左肩，右臂前胸袒露，衣紋優雅，纏繞腰間，右腳外露，皺褶垂掩台面。僧袍衣襟邊緣處，均刻飾纏枝花紋。台基從座角鑄起，各角有綻放花蕾及卷須紋。座前墊子覆蓋，上有圖案花地，內含格子紋地，纏枝花卉果木。此像鎏金厚實，座台有輕微磨損，附加的長方金片散飾，長方補丁的外廓應是鎏金前鑄件整形所留。座底銅箔密封，上刻金剛杵。經卷上，座底前部和座後都刻有藏文經句，座底還有三個漢字。

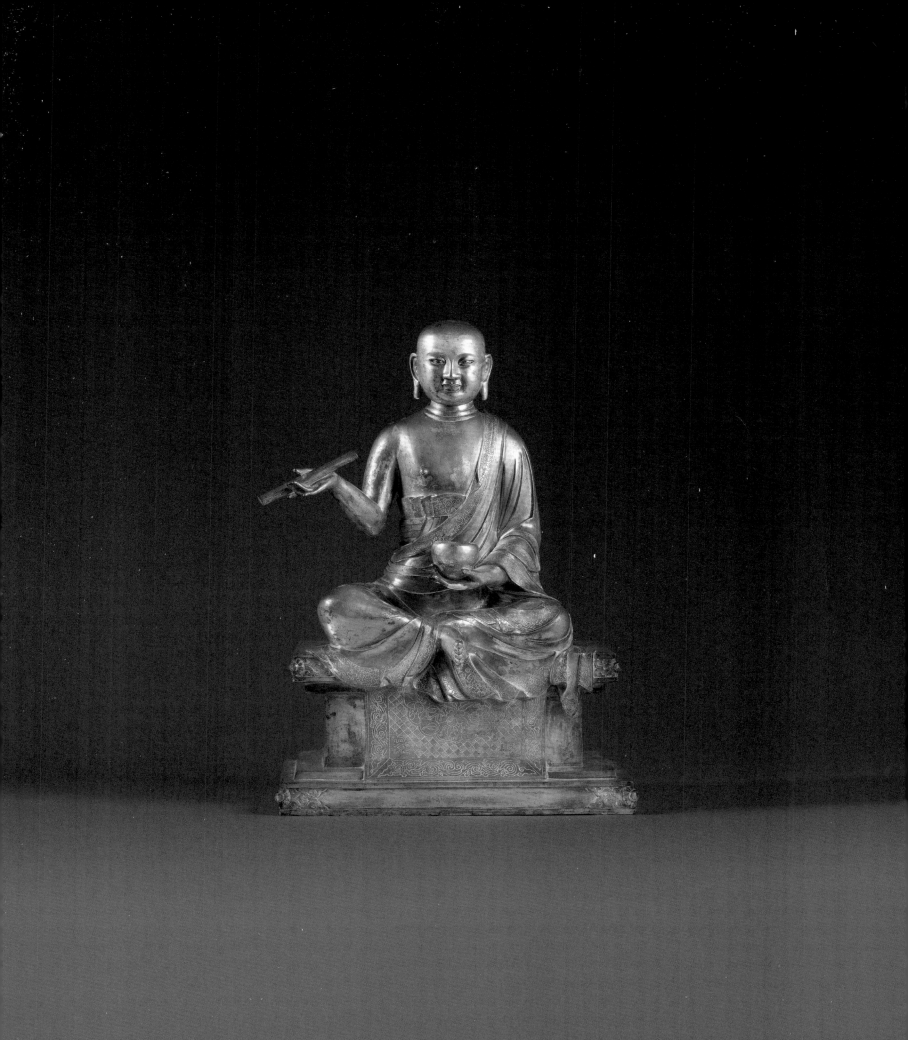

The present figure, along with the six other gilt bronze figures cited, are so closely related in size and detail, that they most likely formed part of a set of sixteen luohans that were housed together on the east and west walls of a Buddhist hall, flanking a central figure of Shakyamuni, within a larger temple complex. In keeping with their fifteenth-century date, all the figures are finely and crisply cast, with sensitively modelled facial features. On each figure, great detail has been paid to the layers of robes, edged with incised floral scroll, falling in elegant folds to the ground. The figures are seated on almost identical stepped bases with floral studs at the corners, many also on a prayer mat.

The figures are all incised with their intended place of location within a particular hall, the present figure of Pindola Bharadvaja being inscribed 'Fourth to the East'. The location also corresponds with a specific, ordered listing of the sixteen luohans. One of the earliest of these lists is derived from *A Record of the Abiding of the Dharma Spoken by the Great Luohan Nandimitra (Da Luohan Nandimiduoluo suo shuo fazhuji)*, written sometime in the third to sixth centuries and translated into Chinese in 654 by the pilgrim monk Xuanzang (602 - 664). Later, a Tibetan list of the sixteen luohans was compiled – with only some of the same names, and in a different order – and it is clear from the numbering that the present set of luohans conforms to the Tibetan list.

A luohan or arhat is considered to be an 'enlightened being' – a follower of Buddha who, at the end of his life, will be released from the cycle of rebirth. However, the luohan is also one who has chosen, or has been chosen, to remain on earth to protect Buddha's Law, until the arrival of the Buddha of the Future, Maitreya. Pindola Bharadvaja was numbered the first on the list of the sixteen luohans derived from *A Record of the Abiding of the Dharma Spoken by the Great Luohan Nandimitra* and was also one of the few luohans that developed his own cult in China. Pindola was the son of a brahman priest and was himself a teacher of the Vedas. It was said that he decided to follow the Buddha because he was naturally gluttonous and he was impressed by the food offerings made to Buddha's disciples. A particularly large alms bowl is often amongst his attributes. Upon attaining the status of enlightenment, a luohan was said to utter a 'lion's roar' or *simhanada.* Pindola uttered his 'lion's roar' in the presence of Buddha and was declared the 'foremost lion's roarer' (*simhanadin*) amongst the disciples and thus was listed as the first.

Another story associated with Pindola is one in which he is taken to task by Buddha for performing a miracle – retrieving a valuable sandalwood alms bowl from the top of a pole by rising in the air – in front of a large crowd. As a result, Buddha passed a law forbidding the display of such powers in front of lay people. Pindola was commanded by Buddha to remain on earth after his death to provide a 'field of blessings' and is known in Chinese as 'World-Dwelling Arhat' (*Zhushi* Luohan).[1]

Pindola's popularity was confirmed in the fifth century when a text called *The Method of Inviting Pindola* was translated into Chinese. In it is cited a 'rite of hospitality' that 'consists of inviting Pindola to the monastic assembly and offering him things: food and/or a bath.' The basis of this ritual was the Buddhist belief in giving alms to Buddhist monks – whereby the giver benefits by receiving 'karmic merits' for his or her generosity as much as the monk receiving the alms.[2]

For further discussion on monks and luohans, see pages 18 - 27 of this catalogue for the essay, *Buddhist Worthies: Sculptural Depictions of Luohans and Disciples in Chinese Art, c. 500 - 1500*.

[1] Robert E. Buswell Jr and Donald S. Lopez, *The Princeton Dictionary of Buddhism,* Princeton, 2014, pages 645 - 646 for a detailed account of Pindola's life.

[2] Marsha Weidner ed., *Latter Days of the Law, Images of Chinese Buddhism 850 - 1850*, Kansas, 1994, page 260.

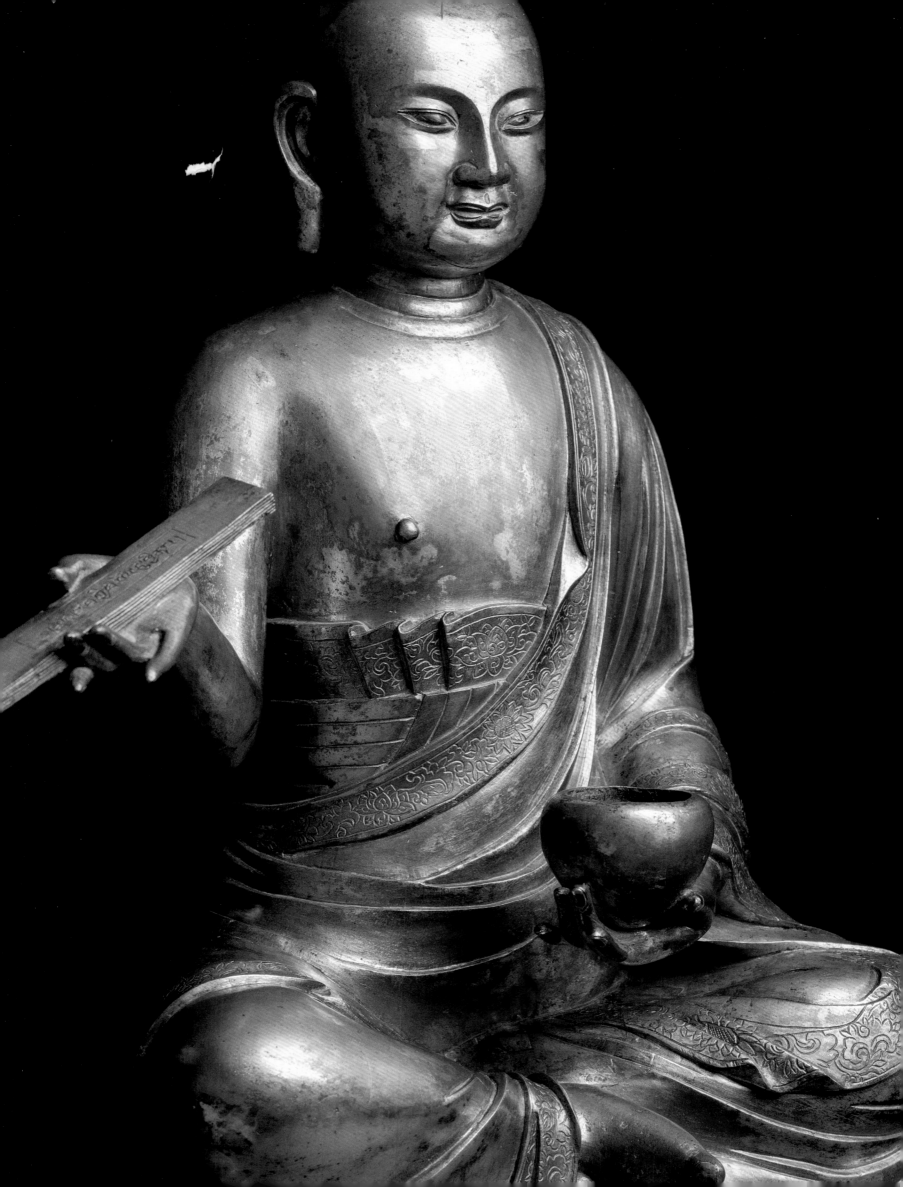

The Tibetan inscriptions are as follows:

Inscription on the front of the base:
bha. ra. dho. tsa. bsod. snyoms. la. na. mo.

which may be translated as:
Homage to Bharadvaja.

Inscription on the sutra:
shes. rab. gyi. pha. rol. du. phyin. pa

which may be translated as:
Prajnaparamita.[3]

Inscription on the back of the base (in verse):
shar. bzhi. pa.
shar. gyi. lus. 'phags. gling. na. ni
bha. ra. dho. tsha. bsod. snyoms. len
dgra. bcom. stong. phrag. gcig. gis. bskor
glegs. bam. lhung.bzed. 'dzin. phyag. 'tshal
bstan. pa. rgyas. par. byin. gyis. rlabs

which may be translated as:

Fourth to the East.
Salutations to Pindola Bharadvaja (who resides) on the island of Shar. gyi.
lus 'phags. gling, surrounded by a thousand arhats, and bearing a book
and begging bowl. Blessed be the doctrine.

The three-character Chinese inscription on the back of the base:
dong disi

which may be translated as:
Fourth to the East.

[3] Prajnaparamita may be translated as 'perfection of wisdom'. This may refer to a special
wisdom required to achieve buddhahood. It is also the sixth of the 'six perfections'.
Prajnaparamita is also 'used to designate the genre of Mahayan sutras that sets forth
the perfection of wisdom.' See Robert E. Buswell Jr and Donald S. Lopez, *The Princeton
Dictionary of Buddhism*, Princeton, 2014, pages 656 - 657.

We are grateful to Dr. Philip Denwood for his transcription and translation of the
Tibetan text.

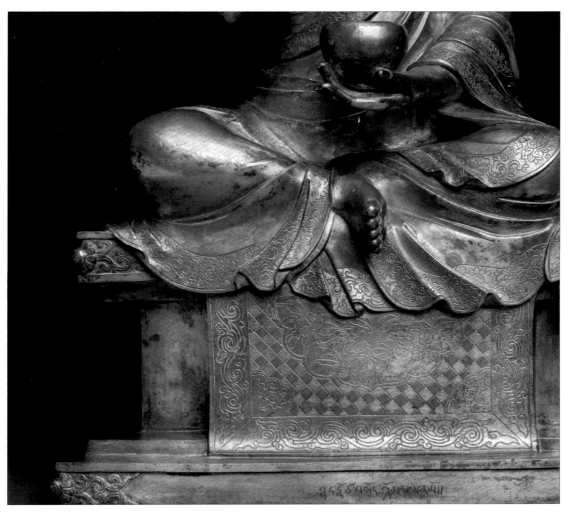

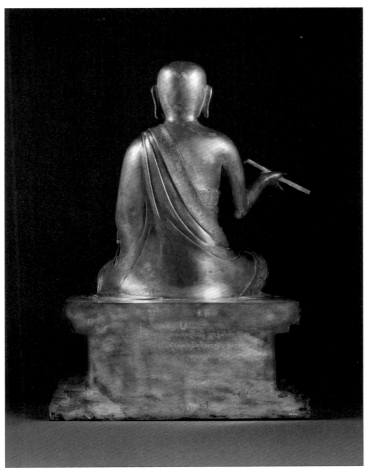

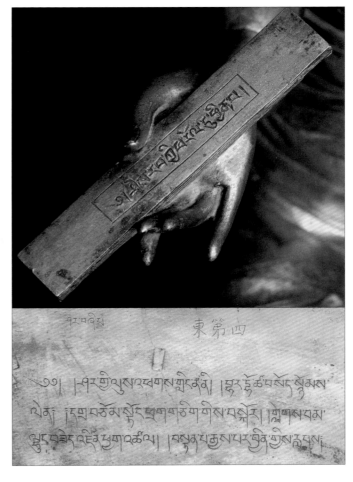

Select bibliography

Akiyama, T. and Matsubara, S.: *Arts of China, Buddhist Cave Temples, New Researches*, Tokyo, 1969.

Janet Baker: 'Foreigners in Early Chinese Buddhist Art: Disciples, Lohans and Barbarian Rulers', in *Marg*, volume 5, number 2, December 1998.

Buddhist Sculpture of Shanxi Province, Beijing, 1991.

Buswell Jr, R. E. and Lopez, D. S.: *The Princeton Dictionary of Buddhism,* Princeton, 2014.

Capon, E. and Liu Yang: *The Lost Buddhas, Chinese Buddhist Sculpture from Qingzhou*, Sydney, 2008.

Ch'en, K.: *Buddhism in China*, Princeton, 1964.

d'Ardenne de Tizac, H.: *L'Art Bouddhique au Musée Cernuschi*, Paris, 1913.

d'Argencé, R.-Y. L. ed.: *Asian Art, Museum and University Collections in the San Francisco Bay Area*, Montclair, New Jersey, 1978.

d'Argencé, R.-Y. L.: *Chinese, Korean and Japanese Sculpture in The Avery Brundage Collection*, Japan, 1974.

De Visser, M. W.: *The Arhats in China and Japan*, Connecticut, 2007.

Dong Yuxiang: *Zhongguo meishu quanji, diaosu bian 9, Binglingsi deng shiku diaosu* (The Great Treasury of Chinese Art, Sculpture 9, Bingling Temple and Other Caves), Beijing, 1988.

Eskenazi, G. with Elias, H.: *A Dealer's Hand, The Chinese Art World through the Eyes of Giuseppe Eskenazi*, London, 2012.

Eskenazi Ltd., *Ancient Chinese Sculpture*, London, 1978.

Eskenazi Ltd., *Ancient Chinese Sculpture*, London, 1981.

Eskenazi Ltd., *Ancient Chinese Sculpture from the Alsdorf Collection and others*, London, 1990.

Eskenazi Ltd., *Sculpture and ornament in early Chinese art*, London, 1996.

Eskenazi Ltd., *Chinese Buddhist Sculpture*, London, 1997.

Eskenazi Ltd., *Chinese Buddhist Sculpture from Northern Wei to Ming*, London, 2002.

Eskenazi Ltd., *Chinese Works of Art from the Stoclet Collection*, London, 2003.

Eskenazi Ltd., *Chinese Buddhist Figures*, London, 2004.

Wen Fong: *The Lohans and a Bridge to Heaven*, Freer Gallery of Art Occasional Papers, volume 3, number 1, Washington, 1958.

Fuhrmann, E.: *China, volume I: Das Land der Mitte*, Hagen, 1921.

Gray, B.: *Buddhist Cave Paintings at Tun-Huang*, Chicago, 1959.

Gridley, M. L.: *Chinese Buddhist Sculpture Under the Liao*, New Delhi, 1993.

Hôtel Drouot, *Objets d'Art de la Chine: Collection Paul Houo-Ming-Tse*, Paris, 15, 16 and 17 February 1932.

Houo-Ming-Tse, P.: *Preuves des Antiquités de Chine*, Beijing, 1930.

Howard, A. F. et al.: *Chinese Sculpture*, Yale, New Haven, 2006.

Hsu, E. H.-L. et al.: *Treasures Rediscovered: Chinese Stone Sculpture from the Sackler Collections at Columbia University*, New York, 2008.

Jacobsen, R. D.: *Appreciating China, Gifts from Ruth and Bruce Dayton*, Minneapolis, 2002.

Jin Shen: *Fojiao diaosu mingpin tulu,* (Catalogue of Famous Buddhist Sculpture), Beijing, 1997.

Jin Shen: *Zhongguo lidai jinian foxiang tudian*, (Illustrated Chronological Dictionary of Chinese Buddhist Figures), Beijing, 1994.

Juliano, A. et al.: *Monks and Merchants, Silk Road Treasures from Northwest China*, New York, 2001.

Kerr, R.: *Later Chinese Bronzes*, London, 1990.

Kuboso Memorial Museum of Art, *Tokubetsu Tenji Rijucho Jidai no Kondobutsu* (Gilt Bronze Buddhist Sculpture of the Six Dynasties), Izumi, 1991.

Kunihiko, K.: *Rikucho No Bijutsu*, (Arts of the Six Dynasties), Osaka Municipal Museum, Osaka, 1976.

Leidy, D. P. and Strahan, D.: *Wisdom Embodied, Chinese Buddhist and Daoist Sculpture in the Metropolitan Museum of Art*, New York, 2010.

Lévi, S. and Chavannes, E.: 'Les Seize Arhat Protecteurs de la Loi', in *Journal Asiatique*, July - August 1916.

Lin Shuzhong ed.: *Zhongguo meishu quanji, diaosu bian 3, Wei Jin Nanbeichao diaosu*, (The Great Treasury of Chinese Art, Sculpture 3, Six Dynasties), Beijing, 1988.

Matsubara, S.: *A History of Chinese Buddhist Sculpture*, 4 volumes, Tokyo, 1995.

Miho Museum, *Longmen Caves*, catalogue, Shigaraki, 2001.

Miho Museum, *Buddhist Sculptures from Shandong Province*, China, Shigaraki, 2007.

Mizuno, S. and Nagahiro, T.: *Yun-Kang: The Buddhist Cave-Temples of the Fifth Century A.D. in North China*, 16 volumes, Kyoto, 1954.

Munsterberg, H.: *Chinese Buddhist Bronzes*, Tokyo, 1967.

Murata, S.: *Shokondoubutsu no miryoku chugoku chosenhantou nihon*, (The Attraction of Small Gilt Bronze Buddhist Statues, China, North and South Korea, Japan), Tokyo, 2004.

National Museum of Chinese History, *Masterpieces of Buddhist Statuary from Qingzhou City*, Beijing, 1999.

National Palace Museum, *The Art of Contemplation – Religious Sculpture from Private Collections*, Taibei, 1997.

National Palace Museum, *Hai-Wai Yi-Chen*, (Chinese Art in Overseas Collections, Buddhist Sculpture), Taibei, 1986.

Nickel, L. ed.: *Return of the Buddha: The Qingzhou Discoveries*, London, 2002.

Osaka Municipal Museum of Art, *Chinese Buddhist Stone Sculpture: Veneration of the Sublime*, Osaka, 1995.

Osaka Municipal Museum of Art, *Chugoku Bukkyo Chozo*, (Chinese Buddhist Sculpture), Osaka, 1984.

Palace Museum ed., *Compendium of Collections in the Palace Museum, Sculpture 7*, (Buddhist Figures Unearthed at the Site of Xiude Temple in Quyang, Hebei Province), Beijing, 2011.

Paludan, A.: *Chinese Sculpture, A Great Tradition*, Chicago, 2006.

Percival David Foundation of Chinese Art, *Mahayanist Art after A. D. 900*, Colloquies on Art and Archaeology in Asia, no. 2, London, 1971.

Poly Art Museum, *Selected Works of Sculpture in the Poly Art Museum*, 2000, Beijing, 2000.

Priest, A.: *Chinese Sculpture in the Metropolitan Museum of Art*, New York, 1944.

Salles, G. A. and Lion-Goldschmidt, D.: *Collection Adolphe Stoclet*, Brussels, 1956.

Saunders, E. D.: *Mudra, A Study of Symbolic Gestures in Japanese Buddhist Sculpture*, London, 1960.

Shaanxi Provincial Museum ed., *Shaanxi sheng bowuguan cang shike xuanji*, (Selected Sculptures from the Shaanxi Provincial Museum), Beijing, 1957.

Shanghai Museum, *Ancient Chinese Sculpture Gallery, The Shanghai Museum*, Shanghai, 1996.

Shi Yan ed.: *Zhongguo meishu quanji, diaosu bian 5, Wudai Song diaosu*, (The Great Treasury of Chinese Art, Sculpture 5, Five Dynasties and Song), Beijing, 1988.

Sirén, O.: *Chinese Sculpture from the Fifth to the Fourteenth Century*, 4 volumes, London, 1925

Sirén, O.: *Kinesiska Och Japanska, Skulpturer Och Målningar I Nationalmuseum*, Malmö, 1931.

Sirén, O.: 'Studien zur Chinesischen Plastik der Post-T'angzeit', (A Study on Chinese Sculpture of the Post-Tang Period), *Ostasiatische Zeitschrift*, New Series, volume 4, Berlin, 1927.

Su Bai and Li Zhiguo ed.: *Zhongguo meishu quanji; diaosu bian 10; Yungang shiku diaoke*, (The Great Treasury Of Chinese Art; Sculpture, volume 10; the Yungang Caves), Beijing, 1988.

Sun Fuxi: *Buddhism Statue*, Xi'an, 2010.

Tokyo National Museum, *Kindo Butsu; Chugoku Chosen Nihon* (Special Exhibition; Gilt Bronze Buddhist Statues, China, Korea, Japan), Tokyo, 1987.

Tsiang, K. R.: *Echoes of the Past, The Buddhist Cave Temples of Xiangtangshan*, Chicago, 2010.

Wang Huaqing et al. eds.: *Qingzhou Longxingsi fojiao zhaoxiang yishu*, (Buddhist Imagery Art at Longxing Temple of Qingzhou), Ji'nan, 1999.

Watson, W. and Rey, M.-C.: *L'Art de la Chine*, Paris, 1979/1997.

Watt, J. C. Y. and Leidy, D. P.: *Defining Yongle, Imperial Art in Early Fifteenth-Century China,* New York, 2005.

Weidner M. et al.: *Latter Days of the Law, Images of Chinese Buddhism, 850 - 1850*, Kansas, 1994.

Wen Yucheng, ed.: *Zhongguo meishu quanji; diaosu bian 11: Longmen shiku diaoke*, (The Great Treasury of Chinese Art: Sculpture, volume 11: Longmen Caves), Beijing, 1988.

Xiaoneng Yang ed.: *New Perspectives on China's Part, Chinese Archaeology in the Twentieth Century*, volume 2, New Haven and London, 2004.

Yamanaka and Osaka Arts Society, *Grand Exhibition of Ancient Chinese and Korean Works of Art*, Tokyo, 1934.

Yamato Bunkakan Museum, *Tokubetsu-Ten; Chugoku No Kindo Butsu* (Special Exhibition; Chinese Gilt Bronze Statues Of Buddhism From Japanese Collections), Nara, 1992.

Zwalf, W. ed.: *Buddhism: Art and Faith*, London, 1985.

**Works of art purchased from Eskenazi Ltd.
London, are now in the following museum collections:**

Ackland Art Museum, North Carolina
Arita Porcelain Park Museum, Saga
Art Gallery of New South Wales, Sydney
Art Gallery of South Australia, Adelaide
Art Institute of Chicago, Chicago
Arthur M. Sackler Gallery, Washington, DC
Art Museum, Princeton University, Princeton
Ashmolean Museum, Oxford
Asia House, Mr and Mrs John D Rockefeller 3rd
Collection, New York
Asian Art Museum of San Francisco, San Francisco
Asian Civilisations Museum, Singapore
Baltimore Museum of Art, Baltimore
Birmingham Museum of Art, Alabama
British Museum, London
Brooklyn Museum, New York
Chang Foundation, Taibei
Chung Young Yang Embroidery Museum, Sookmyung
Women's University, Seoul, Korea
Cincinnati Art Museum, Cincinnati
Cleveland Museum of Art, Cleveland
Columbus Museum of Art, Columbus
Corning Museum of Glass, Corning
Dallas Museum of Fine Arts, Dallas
Dayton Art Institute, Dayton
Denver Art Museum, Denver
Didrichsen Art Museum, Helsinki
Fitzwilliam Museum, Cambridge
Flagstaff House Museum of Teaware, Hong Kong
Freer Gallery of Art, Washington, DC
Fuji Art Museum, Tokyo
Hagi Uragami Museum, Hagi
Hakone Museum of Art, Hakone
Harvard Art Museums, Cambridge, Massachusetts
Hetjens Museum, Düsseldorf
Hong Kong Museum of Art, Hong Kong
Honolulu Museum of Art, Honolulu
Idemitsu Museum of Arts, Tokyo
Indianapolis Museum of Art, Indianapolis
Israel Museum, Jerusalem
Istituto Italiano per il Medio ed Estremo Oriente, Rome
Kimbell Art Museum, Fort Worth
Kuboso Memorial Museum, Izumi City, Osaka
Los Angeles County Museum, Los Angeles
Louvre Abu Dhabi, Abu Dhabi
Matsuoka Museum of Art, Tokyo
Metropolitan Museum of Art, New York
Miho Museum, Shigaraki
Minneapolis Institute of Arts, Minneapolis
MOA Museum of Art, Atami
Musée Ariana, Geneva
Musée des Arts Asiatiques, Nice
Musée Guimet, Paris

Musées Royaux d'Art et d'Histoire, Brussels
Museum für Kunst und Gewerbe, Hamburg
Museum für Lackkunst, Münster
Museum für Ostasiatische Kunst, Berlin
Museum für Ostasiatische Kunst, Cologne
Museum of Decorative Art, Copenhagen
Museum of Fine Arts, Boston
Museum of Fine Arts, Houston
Museum of Islamic Art, Doha
Museum of Oriental Ceramics, Osaka
Museum Rietberg, Zurich
National Gallery of Australia, Canberra
National Gallery of Canada, Ottawa
National Gallery of Victoria, Melbourne
National Museum, Singapore
National Museum, Tokyo
Nelson-Atkins Museum of Art, Kansas City
Nezu Institute of Fine Arts, Tokyo
Norton Simon Museum of Art at Pasadena, Pasadena
Östasiatiska Museet, Stockholm
Royal Ontario Museum, Toronto
State Administration of Cultural Heritage, Beijing
St. Louis Art Museum, St. Louis
Seattle Art Museum, Seattle
Shanghai Museum, Shanghai
Speed Art Museum, Louisville
Toguri Museum of Art, Tokyo
Tsui Museum of Art, Hong Kong
Victoria & Albert Museum, London
Virginia Museum of Fine Arts, Richmond
Worcester Art Museum, Worcester

Previous Exhibitions

March 1972	Inaugural exhibition Early Chinese ceramics and works of art.
June 1972	Georges Rouault, an exhibition arranged by Richard Nathanson.
June 1973	Ancient Chinese bronze vessels, gilt bronzes and early ceramics.
November 1973	Chinese ceramics from the Cottle collection.
December 1973	Japanese netsuke formerly in the collection of Dr Robert L Greene.
June 1974	Early Chinese ceramics and works of art.
November 1974	Japanese inrō from the collection of E A Wrangham.
May 1975	Japanese netsuke and inrō from private collections.
June 1975	Ancient Chinese bronzes from the Stoclet and Wessén collections.
June 1976	Chinese jades from a private collection.
June 1976	Michael Birch netsuke and sculpture.
June 1976	Japanese netsuke and inrō from private collections.
June 1977	Ancient Chinese bronze vessels, gilt bronzes and sculptures; two private collections, one formerly part of the Minkenhof collection.
June 1978	Ancient Chinese sculpture.
June 1978	Michael Webb netsuke.
June 1978	Eighteenth to twentieth century netsuke.
June 1979	Japanese netsuke from private collections.
June 1980	Japanese netsuke from private collections and Michael Webb netsuke.
July 1980	Ancient Chinese bronzes and gilt bronzes from the Wessén and other collections.
December 1980	Chinese works of art from the collection of J M A J Dawson.
October 1981	Japanese netsuke and inrō from the collection of Professor and Mrs John Hull Grundy and other private collections.
December 1981	Ancient Chinese sculpture.
October 1982	Japanese inrō from private collections.
November 1983	Michael Webb, an English carver of netsuke.
October 1984	Japanese netsuke, ojime, inrō and lacquer-ware.
June 1985	Ancient Chinese bronze vessels, gilt bronzes, inlaid bronzes, silver, jades, ceramics – Twenty five years.
December 1986	Japanese netsuke, ojime, inrō and lacquer-ware.
June 1987	Tang.
June 1989	Chinese and Korean art from the collections of Dr Franco Vannotti, Hans Popper and others.
November 1989	Japanese lacquer-ware from the Verbrugge collection.
December 1989	Chinese art from the Reach family collection.
May 1990	Japanese netsuke from the Lazarnick collection.
June 1990	Ancient Chinese sculpture from the Alsdorf collection and others.
November 1990	The Charles A Greenfield collection of Japanese lacquer.
June 1991	Inlaid bronze and related material from pre-Tang China.
November 1992	Japanese lacquer-ware – recent acquisitions.
December 1992	Chinese lacquer from the Jean-Pierre Dubosc collection and others.
June 1993	Early Chinese art from tombs and temples.
June 1993	Japanese netsuke from the Carré collection.
June 1994	Yuan and early Ming blue and white porcelain.
June 1995	Early Chinese art: 8th century BC – 9th century AD.
October 1995	Adornment for Eternity, loan exhibition from the Denver Art Museum.
June 1996	Sculpture and ornament in early Chinese art.
November 1996	Japanese inrō and lacquer-ware from a private Swedish collection.
March 1997	Ceramic sculpture from Han and Tang China.
June 1997	Chinese Buddhist sculpture.
June 1997	Japanese netsuke, ojime and inrō from the Dawson collection.
November 1997	Japanese netsuke – recent acquisitions.
March 1998	Animals and animal designs in Chinese art.

June 1998	Japanese netsuke, ojime and inrō from a private European collection.
November 1998	Chinese works of art and furniture.
March 1999	Ancient Chinese bronzes and ceramics.
November 1999	Ancient Chinese bronzes from an English private collection.
March 2000	Masterpieces from ancient China.
November 2000	Chinese furniture of the 17th and 18th centuries.
March 2001	Tang ceramic sculpture.
November 2001	Chinese ceramic vessels 500 – 1000 AD.
March 2002	Chinese Buddhist sculpture from Northern Wei to Ming.
November 2002	Two rare Chinese porcelain fish jars of the 14th and 16th centuries.
March 2003	Chinese works of art from the Stoclet collection.
November 2003	Song: Chinese ceramics, 10th to 13th century.
March 2004	Chinese Buddhist figures.
November 2004	A selection of Ming and Qing porcelain.
March 2005	Ancient Chinese bronzes and sculpture.
November 2005	Song ceramics from the Hans Popper collection.
March 2006	A selection of early Chinese bronzes.
June 2006	Recent paintings by Arnold Chang.
November 2006	Chinese porcelain from the 15th to the 18th century.
March 2007	Song: Chinese ceramics, 10th to 13th century (part 3).
November 2007	Mountain landscapes by Li Huayi.
March 2008	Chinese sculpture and works of art.
October 2008	Chinese ceramics and stone sculpture.
October 2009	Seven classical Chinese paintings.
March 2010	Trees, rocks, mist and mountains by Li Huayi.
November 2010	Fiftieth anniversary exhibition: twelve Chinese masterworks.
March 2011	Early Chinese metalwork in gold and silver; works of art of the Ming and Qing dynasties.
November 2011	Chinese huanghuali furniture from a private collection.
November 2011	The twelve animals of the zodiac by Li Huayi.
November 2012	Qing porcelain from a private collection.
October 2013	Junyao.
October 2013	Bo Ju Gui: an important Chinese archaic bronze.